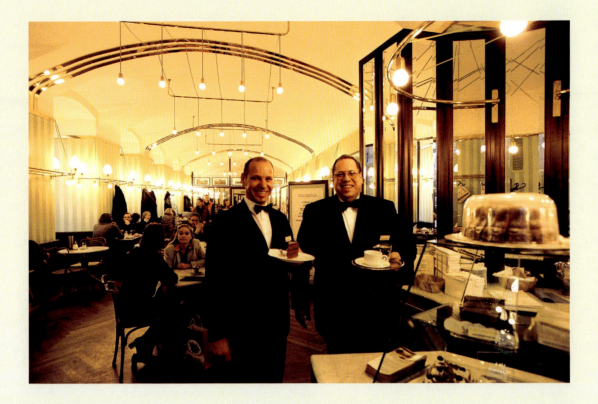

Journey through

VIENNA

Photos by
János Kalmár

Texts by
Dodo Kresse

Stürtz

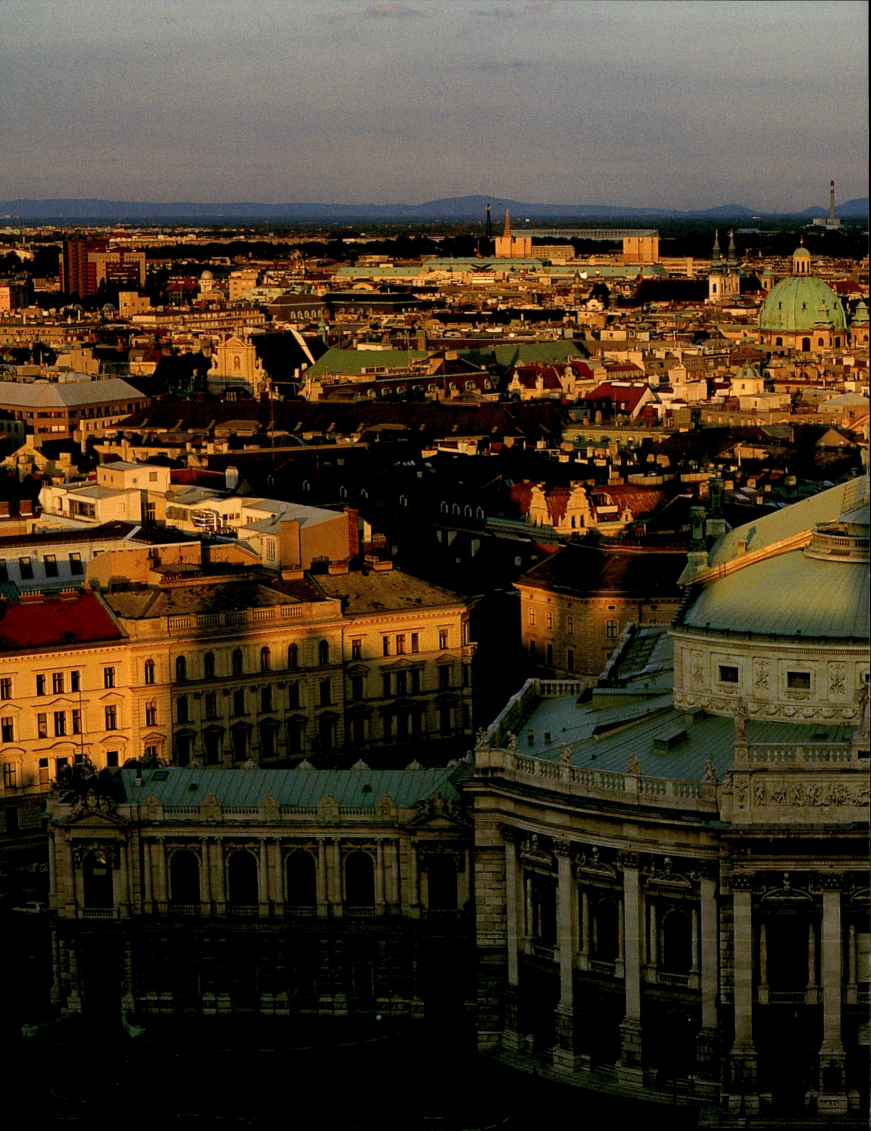

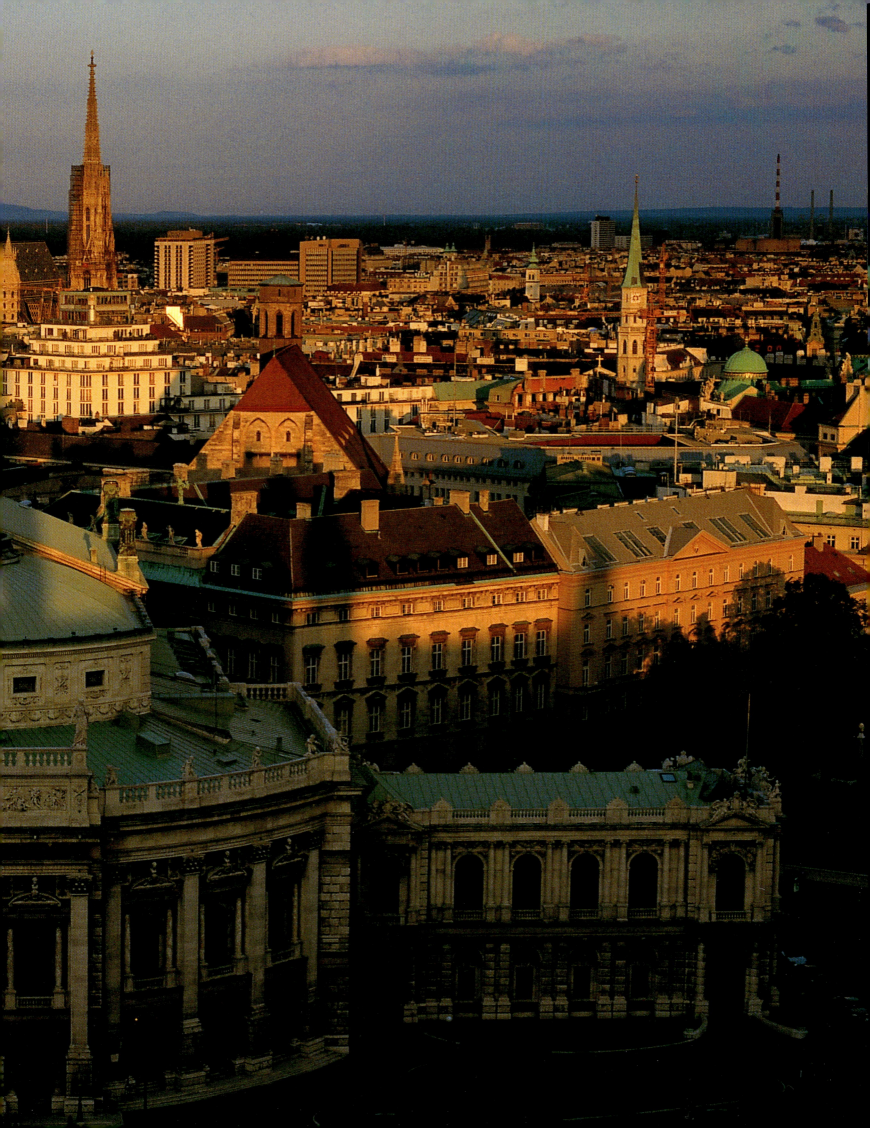

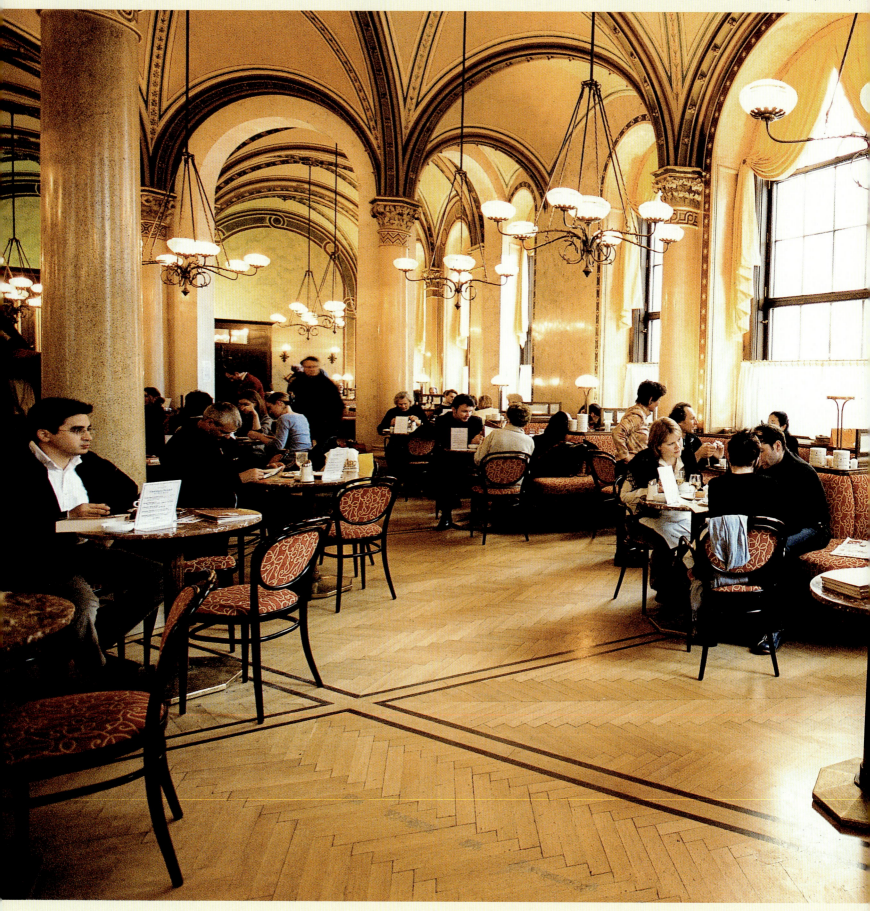

First page:
Café Museum was opened in 1899. Architect of world renown Alfred Loos decked

out the interior in a simplicity and objective functionality hitherto unheard of.

Previous page:
This how the statue at the tip of the City Hall spire

would see the Burgtheater in enchanting twilight.

Below:
One of the many chess players to frequent Café Central at the beginning of the 20th century was

Russian emigrant Bronstein. According to one famous anecdote he was not thought capable of

rovoking a revolution
n his homeland; as Leo
Trotsky he was to prove
therwise.

Page 10/11:
The internationally
esteemed painter
Friedensreich Hundert-

wasser caused fierce
debates on architecture
with the unusually
cheerful façade design

of the Spittelau district
heating plant in the
9th District.

Contents

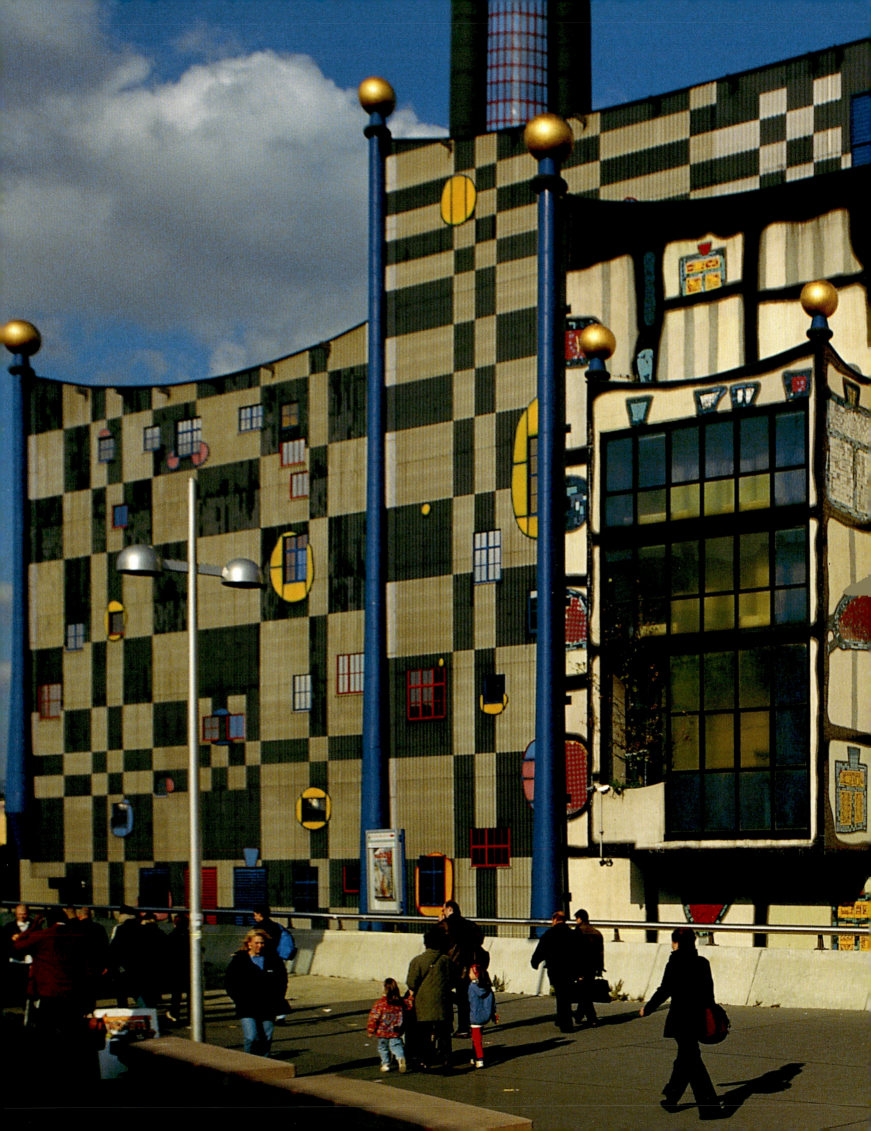

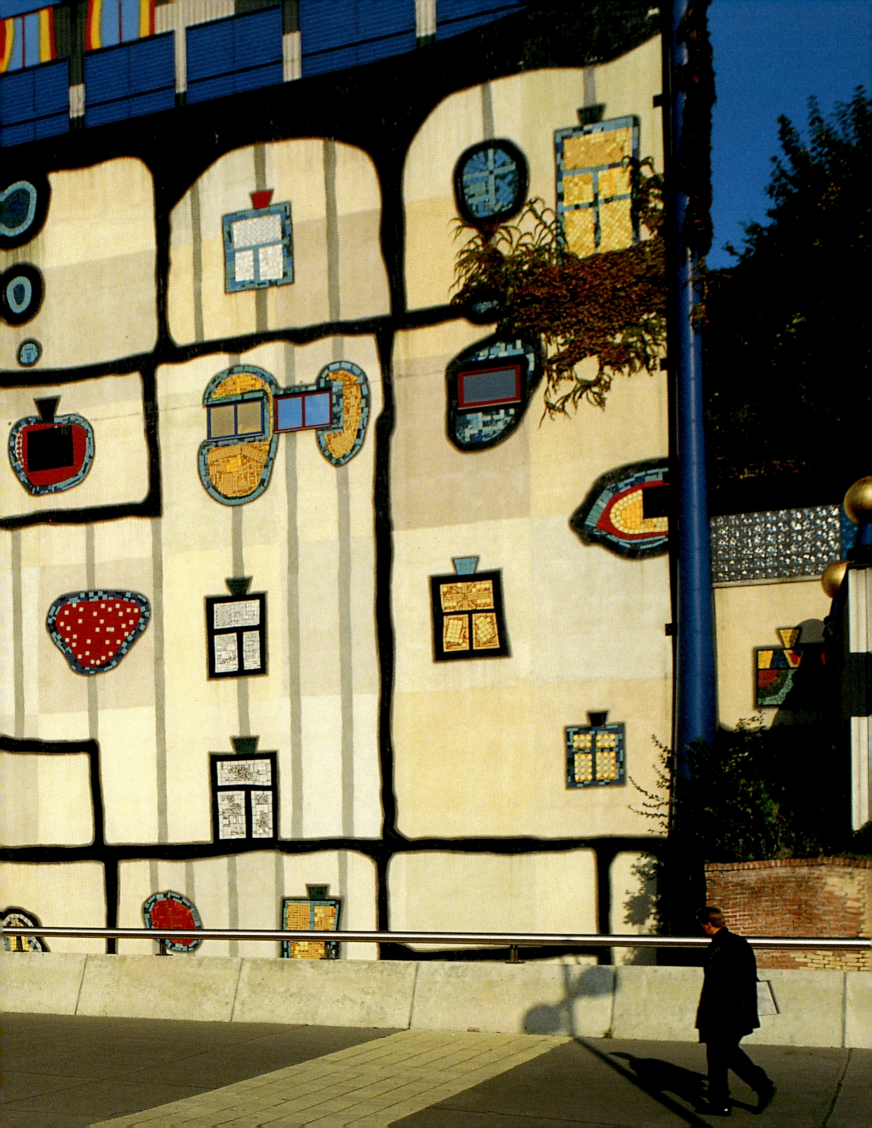

Vienna – from the romantic fairy-tale city to the elegant world metropolis

»I no longer know who I'm building the castle for!« Emperor Francis Joseph is said to remarked with a sigh during the long years of the construction of the Hofburg at Heldenplatz.

When the majestic building finally shone out in its whole splendour, both the Emperor and the Viennese were proud of this unique gem of a building.

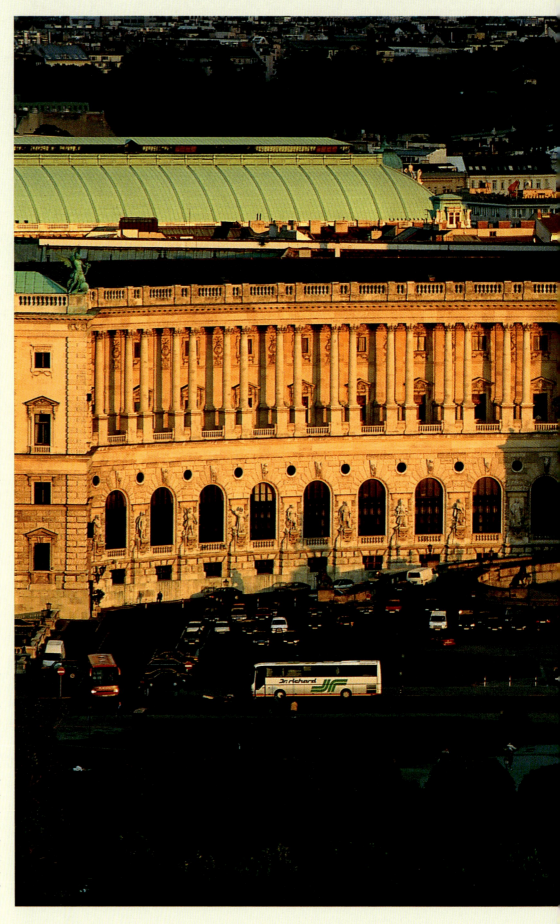

Vienna has woken up. Even twenty years ago, the city presented itself to its visitors reserved and sullen. After midnight, there were just three bars open, two of them discotheques. A meal after midnight? What an audacious idea! At night the pavements were really folded away – a puzzle for Londoners and Parisians or the residents of other large cities. And Vienna was also not exactly an El Dorado for shopping fans. Whereas in Milan trendy fashion and in New York zippy gags wandered across the sales counters, in Vienna visitors found at most a few fine antique pieces of jewellery or copperplate engravings. But that was then it. Even the Viennese preferred to travel to Italy or Southern France for shopping.

Now, however, the unpreposing caterpillar has transformed into a shimmering butterfly. The ugly »duckling« has become a self-confident, noble swan. Vienna puts the saying about the medal with a bright and a dark side properly in doubt. Because normally, a dynamic, effervescent large city with over one million inhabitants also entails nasty phenomena, such as a sharp rise in criminality and deficits in the social field. But that is not the case with Vienna. After Zurich, Vienna is the second safest city in the world with an excellently functioning city administration. Refuse on the street, on the pavements – that may be the case in other large cities. Vienna is slowly developing into a clean city and is already competing a little with the Swiss. The age of grey-painted façades, delay and hesitation in carrying out necessary restoration is past. Renovation, repairs, revitalisation are in progress. Bright, Schönbrunn-yellow and creamy-white are in use again for painting façades. Even if everyone knows that it will not stay white for long, one treats oneself and Vienna's visitors to a bright, friendly city. The »Third Man« has finished playing his

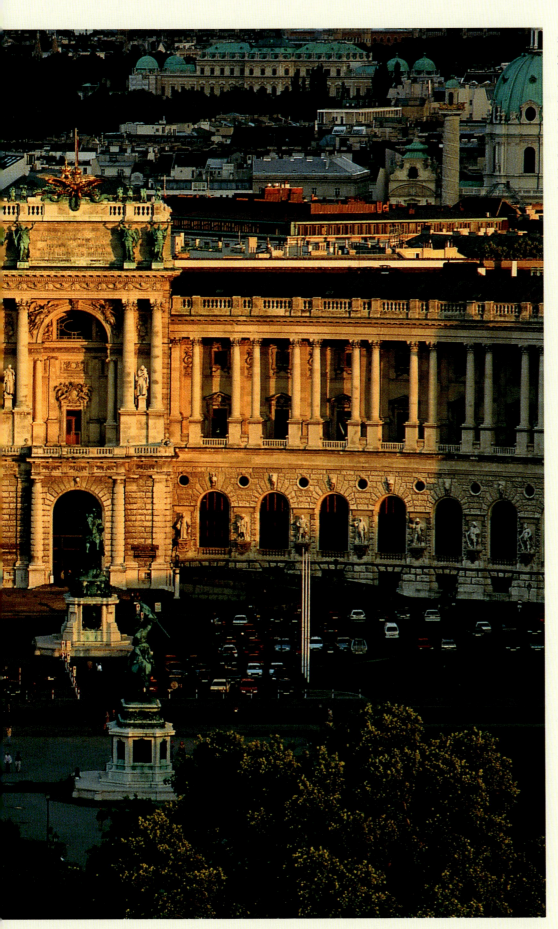

zither, uneven, badly lit alleyways are being asphalted over and well illuminated. Attics are being cleared out and converted into cheerful apartments, flooded with light. Inner courtyards and roof gardens are being greened and the city gardens department is brightening up Vienna's streets and squares in a sometimes really profuse manner with delightful, floral creations. The theatres, cinema centres, museums and leisure spaces offer entertainment for a city which could have double as many inhabitants. Of course, with the »clearing out« and »lighting up«, the »uncanny«, the mystical and darkness of this city with its rich tradition also vanishes a little. But the Viennese no longer want to see their past as the sole centre of all interest, but devote themselves, full of excitement, to the future and all the possibilities which it can offer them. Vienna and the future are no longer a pair of words which give cause for amusement and the shaking of heads. The clattering tram-cars, which ran uneasily on their tracks and screeched horribly through the rubbing of metal wheels on metal rails, are making way for comfortable, quiet low-floor vehicles allowing passengers to board almost on the level. The Underground railway network is expanding ever further so that the recreation areas – whether the Vienna Woods, the Danube Island or Lobau – are practically no more than a stone's throw away from one's front door. Internet columns are growing out of the ground at the most important intersections in the city. The Viennese finds high-tech and the new communication media fun, and so he appreciatively sniffs the air heavy with »sms«. Sometimes, so many mobiles ring in the tram at once, that nobody knows where the ringing is coming from. The Viennese have become downright fanatical mobile users. They are beaten only by the Finns, all other large city dwellers use the mobile telephone more discreetly and less often. The gossip by the »Bassena« (the former water basin in the staircase of houses constructed at the turn of the twentieth century) gave way swiftly to a chatter on the mobile.

The Viennese as such

The Viennese does not like talking? What a fallacy! Seldom do you find such a garrulous people as in this city. It probably takes a little while before a stranger gains the confidence for such »discussions«, but this period is getting shorter and shorter. The Viennese, who in his nostalgic-melancholy manner was also always a bit morbid and a little depressive, now no longer automatically makes his way after work to the nearest pub, but bravely tackles his

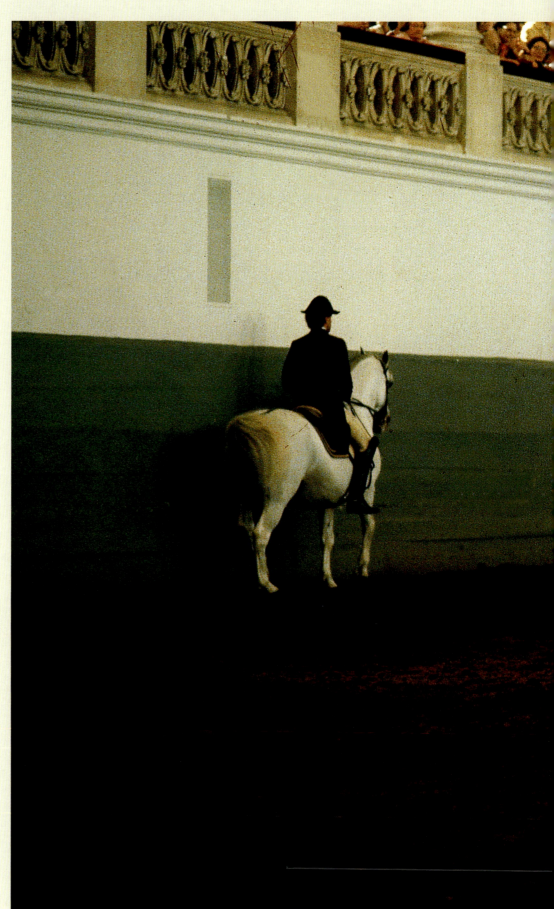

»Levade« is the name of this typical and extremely difficult figure which the rider of the Spanish Riding School is performing here on one of the world-famous Lippizzaners to the time, of course, of Viennese music.

Gösser (Beer) paunch in the fitness centre. If he afterwards nevertheless enjoys his beer and his wine, then he does so slightly more optimistically than the generation before him did. Moaning, slaving away and groaning are no longer modern – the Viennese enjoy themselves in the theatre or cinema and adore going out for meals – whether in the pizzeria round the corner, in the smart, small sushi bar or in the posh restaurant. Try things out is the motto. A multitude of the most varied restaurants court the customers' favour. Scarcely has one restaurant shut down than the opening of a new café is being celebrated at the next corner. Of course, the typical grumbler still exists, who can get extremely worked up about an American »Coffee House« in the city centre and conjures up a vision of the decline of the Viennese café culture. But slowly these »ranters« are no longer taken so seriously. The good, old café continues its ponderous, leisurely life in the good-natured vicinity of the ultra-modern coffee shop next door. Anyone wanting to enjoy a strong »Schwarzen« (a cup of black coffee) and at the same time »read through« ten newspapers steps into the café and anyone who is in a hurry and just wants to drink a sip of »anything hot« serves himself in the coffee shop.

Lopsided »Steffl« and a regent made of marzipan

After a coffee, you can unhurriedly devote yourself to culture. And there is so much of that in Vienna that you could almost become pressed for time. If there were not the »Wiener Gemütlichkeit« – Viennese unhurried, informal atmosphere – reminding you to tarry for a while every so often between the cultural highlights to enjoy a »Gugelhupf«, »Sachertorte« and »Melange mit Schlagobers« (a cake and gateau with a white coffee with whipped cream). The visitor to Vienna is best advised not to ask »Where to first?« and just to start trudging – who's to say whether the Rathaus (City Hall) is a more important sight than the Parliament building?

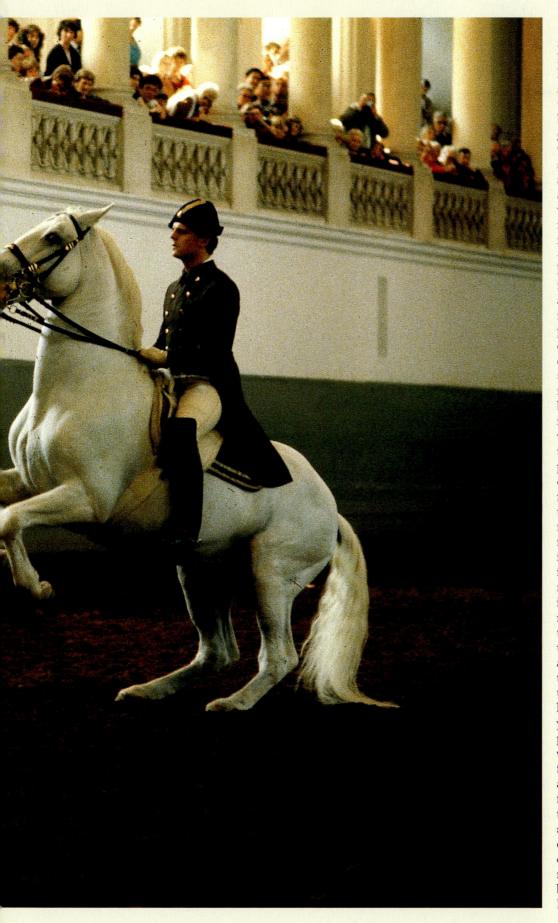

The starting point for our stroll is
St. Stephen's Cathedral (Stephansdom) at the heart of the city. This is a good place to get to know the »Viennese weather« from its typical side. This wide square is entirely governed by the motto »Gone with the wind«. In summer, it blows in hot gusts, sometimes even bringing grains of yellow sand from Africa with it. In winter, however, it bites into your face and shows itself from its cold, damp and inclement side. There is almost never no wind blowing at all in Vienna – at the most briefly before a violent thunderstorm, and then it really does rage, only belatedly. Perhaps that is why there is one hairdresser next to the other in this city – after all gentlemen (and ladies in particular) have to have their dishevelled hair put back into reasonable shape again. However, the advantage of this wind-battered city lies in the fact that the constant wind sweeps away any possible smog in no time and the air is thus, in contrast to other large cities, astonishingly clean.

»Steffl«, as the Viennese lovingly call their most famous landmark, has a long history behind it. This huge, Gothic cathedral houses a multitude of art treasures which can only be visited in part within the scope of a guided tour. Unfortunately, absolutely nothing at all is preserved of the oldest structure of the church of St. Stephen from the 12th century. The west façade with the Giants' Gate (Riesentor) and the Heathens' Towers (Heidentürme) dates from the second, late-Romanesque structure from 1230–1263. The south tower with its impressive, 136.7 metre height was completed in 1433. »Steffl's« characteristic appearance results from the fact that the two towers differ in height. This was not intended. At the beginning of the 16th century, work on the north tower was simply stopped – at a height of 68 metres. In 1578, the tower was just crowned with a roof in Renaissance style. However, in order that the »Unfinished« should not feel neglected, the »Pummerin«, Austria's largest bell, was hung in it, which rings in the New Year every year on December 31 with its heavy, majestic peals. Anyone wanting to get up in the world, who is in good condition and does not suffer from dizziness, can ascend the south tower up a narrow spiral stairway and then peer down from the 72 metre high »watchman's room« to the »ants« down below, or take delight in the superb panoramic view of the city. For all the others who prefer the depths, the stairway down to the catacombs next to the lift of the north tower is recommended. Down below is the bishops' crypt with the sarcophaguses of Duke Rudolf the Founder and further Hapsburgs.

In the Art History Museum (opposite the Natural History Museum), in Room VI Italian masters impress with their timeless genius. The Viennese have to thank two Hapsburgs in particular for the masterpieces from Italy, Archduke Leopold Wilhelm and Emperor Rudolf II.

A »sweet« history of Vienna

But now up into the air again and to more cheerful areas. If you walk along the Graben and down the Kohlmarkt, in ten minutes at the most you reach the former Imperial and Royal Court Confectioner's (K.u.K. Hofzuckerbäckerei) Demel which was founded in 1786. Here you can not only enjoy delicious coffee creations, tea and hot chocolate, as well as excellent cakes and pastries from the habitually friendly »Demel ladies«, but also improve your historical education. Because the sweet history of the house is unrolled in the Demel Museum. It is possible to marvel at exhibits such as »ice cartridges« and »antique« chocolate boxes. In the marzipan museum, finest works of arts let your mouth water. But beware: Nibbling is forbidden. Even the legendary Anna Demel, who was the »regent« of the confectioner's until the nineteen-fifties, is modelled out of almonds, icing sugar and eye whites.

From the marzipan art we make our way to the plastic arts and visit the Academy of Art (Kunstakademie) at Schillerplatz. It was constructed at the end of the 19th century to a design by Theophil von Hansen and now enjoys college status. The Academy's picture gallery possesses valuable works by Dutch and Flemish painters of the 17th century, including the mysterious and sensuous glow of the figures by Rubens and Van Dyck.

Even more extensive is the art collection in the Art History Museum (Kunsthistorisches Museum) at Maria-Theresien-Platz. The museum was constructed – just like its architectural vis-à-vis, the Natural History Museum (Naturhistorisches Museum) – to plans by Gottfried Semper and Karl von Hasenauer for the then Imperial collections. The picture gallery, opened in 1891, shows major works of western art history, including Raphael's »Madonna in Green«, Vermeer's »Allegory of Painting«, the portraits of royal children by Velasquez, masterpieces by Rembrandt, Dürer, Titian and Tintoretto. In addition, the largest Bruegel collection in the world is to be found here.

After enjoying the classics, the view of the modern, wilder exhibits in the Museum Quarter (Museumsquartier), to which the violet-coloured U4 Underground line brings you in

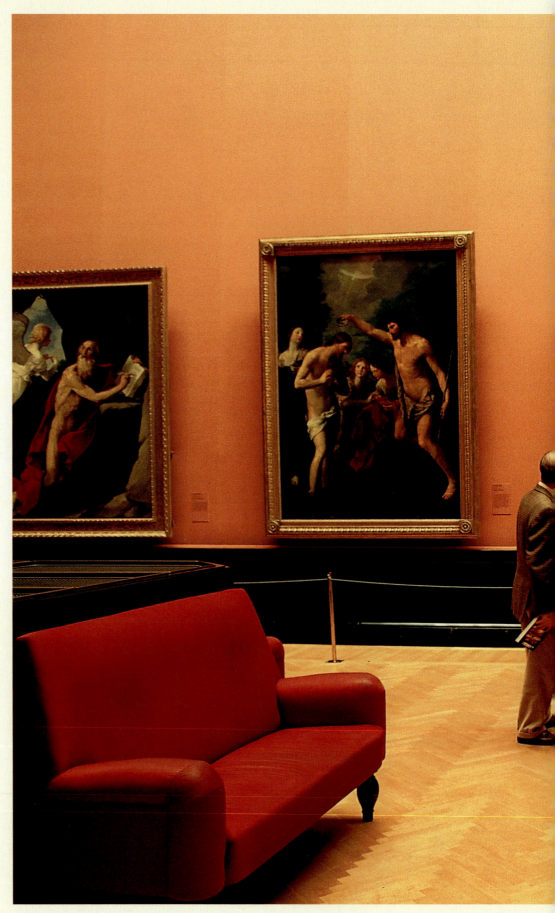

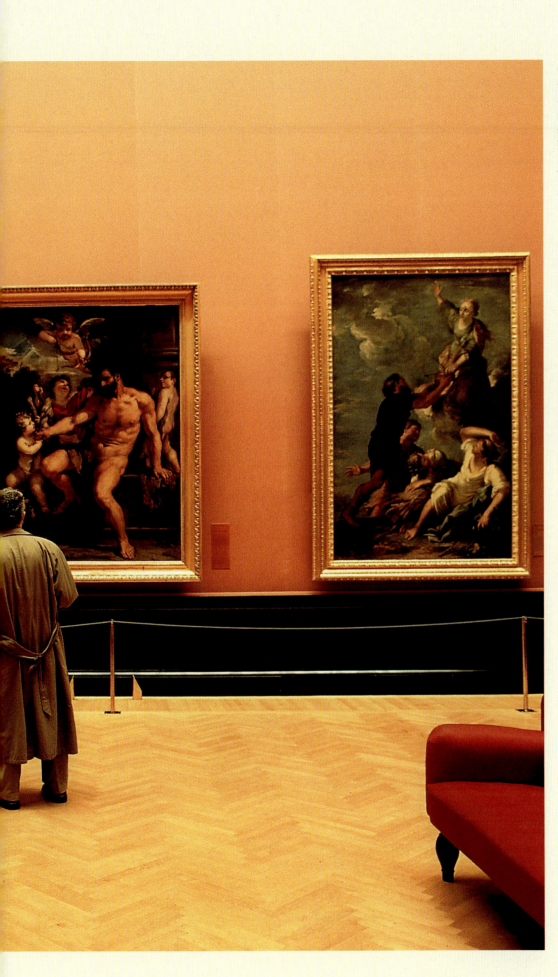

three minutes, will stimulate you. This sensational culture area on the edge of the old city is one of the eight largest museum precincts in the world: The revitalised Baroque wings once used to accommodate the Imperial court's horses, now one exhibition room follows the other here. The museum quarter was planned by the architects Laurids and Manfred Ortner and Manfred Wehdorn.

Laurels for natural history and hay for white horses

Directly opposite waits the Natural History Museum which was elected one of the ten best museums in the world by museum experts for the London »Sunday Times«. It was not only the »case« constructed at the end of the 19th century which induced the jury to make this choice, but the »undusty« atmosphere of the museum: on the one hand, the management allows the collectors' and exhibition spirit of past centuries to live on but, on the other hand, it does justice to the requirements of the present by means of entertaining exhibitions. Whether a large scale dinosaur exhibition or a bear collection, this museum is an especially inspiring place and very impressive, particularly for children.

Anyone out with children in matters of culture will turn thankfully to the Spanish Riding School (Spanische Hofreitschule) in the middle of the city. It is the oldest and last court riding school in the world. It is called »Spanish« because Spanish horses were used at the time of its foundation in 1572. The handsome, white Lipizzaners, the oldest breed of cultivated horses in Europe, come from the village of Lipizza, near which the former Imperial and Royal Court Stud Farm was founded in 1580. Emperor Charles VI had the splendid riding course, the Winter Riding School in the Imperial Palace, designed by Josef Emanuel Fischer von Erlach, in which the horse-breakers of the Spanish Riding School train the horses and give their expert performances.

Heated debates within historic walls

The Parliament building on Dr.-Karl-Renner-Ring is worth a visit. The architect, Theophil von Hansen, let himself be influenced here by the forms of Greek architecture. In front of the balanced building, which is simply yearning for the blue July sun of a Greek island, stands the goddess Pallas Athena in a fountain designed sensitively by Karl Kundmann and others. If you turn your gaze from the Parliament to the right, the sunlight already shines through the many panes of the windows of the City Hall (Rathaus). From a height of nearly 100 metres,

the »Rathaus Man« looks down over the city. He may look small from below, but actually he measures an imposing 3.40 metres in height, with his standard in fact six metres. The City Hall, one of the most important, non-sacral buildings in neo-Gothic style, was completed by Friedrich von Schmidt at the end of the 19th century. In the meantime, the square in front of the City Hall and the arcaded inner courtyard are nearly constantly booked for events. Thus in winter, the Viennese ice skate there, in summer operas are shown on a huge screen, various festivals fill the square with colourful variety until the events climax with the Christmas Fair (Christkindlmarkt) in December. The whole of the Rathauspark is included for this, the high trees are decorated with illuminated objects, roundabouts and a children's railway are installed. The adults warm themselves with a powerful punch and delicious Christmas mulled wine, while the children's cheeks turn fiery red from all the excitement.

»Who am I actually building the castle for?«

Vienna's richly varied architectural styles and magnificent buildings are due not least to Emperor Francis Joseph. The wonderful Heroes' Square (Heldenplatz) was created during his reign. Hardly anyone can resist the square's awe-inspiring effect. Whether in the gentle glow of twilight, in blazing summer sunlight or beneath a grey, overcast November sky, this space has an incomparable atmosphere. Perhaps precisely because the Imperial Palace (Hofburg) was the Emperor's »problem child«. The Palace was originally actually a medieval castle (Burg), of which only the Castle Chapel (Burgkapelle) still reminds us. All the plans submitted for reconstruction and extension did not find His Majesty's aesthetic approval. Again and again he had the plans and drawings changed. Finally, he even wanted to have it torn down again during construction. He is said to have observed at times: »God knows who I am building the castle for!« The construction time was terribly long and the Emperor's adjutants observed that the Emperor would always turn away from the castle when travelling past as he could not bear the fact that it was un-

completed for so long. But one day it was ready and everybody was satisfied. Today, among other things, the official residence of the Federal President, a congress centre, the Court Chapel, where the Vienna Boys Choir (Wiener Sängerknaben) perform, the Spanish Riding School with its Lipizzaners, the Silver Treasury as well as the Imperial Apartments, well worth a visit, are located within the Imperial Palace. If you stroll along the Ringstrasse (which is six kilometres long altogether) from the City Hall and the Castle Theatre (Burgtheater) located opposite, past the Imperial Palace you will finally reach the State Opera (Staatsoper), one of the first of the splendid buildings to be erected along the Ring between 1863 and 1869. The plans for the then Imperial and Royal Court Opera Theatre came from the architects August Sicard von Sicardsburg and Eduard van der Null. When the Emperor made a disparaging remark about the opera's appearance, this had terrible consequences for the architects. From then on, the Emperor made it is habit to always say: »Thank you, it was very nice, it gave me great pleasure,« instead of passing any judgement. Even today, the Viennese joke with this quotation if they having nothing good to say about something.

Two thousand sculptures and one golden kiss

The Augarten Park in the second district is one of Vienna's many green lungs. The Atelier Augarten was established there in honour of the sculptor Gustinus Ambrosi where today the Austrian Galerie Belvedere presents much-noted special exhibitions. Ambrosi created no less than 2000(!) sculptures. The building complex, constructed by Georg Lippert in 1956, nowadays includes, apart from the Gustinus Ambrosi Museum, also an enchanting sculpture garden, an artist's apartment for active artists, the so-called »Artist in Residence«, and a café. There are in fact two palaces in the Belvedere at Prinz-Eugen-Strasse 27. The said prince, commander and art lover, had this garden palace constructed by Johann Lukas von Hildebrandt as his summer residence outside the gates of the then city. Austrian and international art of the 19th and 20th centuries can be admired in the Upper Belvedere. The largest collection of works by Klimt, Schiele and Kokoschka awaits art connoisseurs here. In an ecstatic sequence of works of art, Klimt's »The Kiss« and his wonderful »Judith« are the climax. The works exhibited in the Lower Belvedere lead into the Baroque and Middle Ages. The Baroque Museum possesses the largest collection of works by Maulbertsch, Messerschmidt

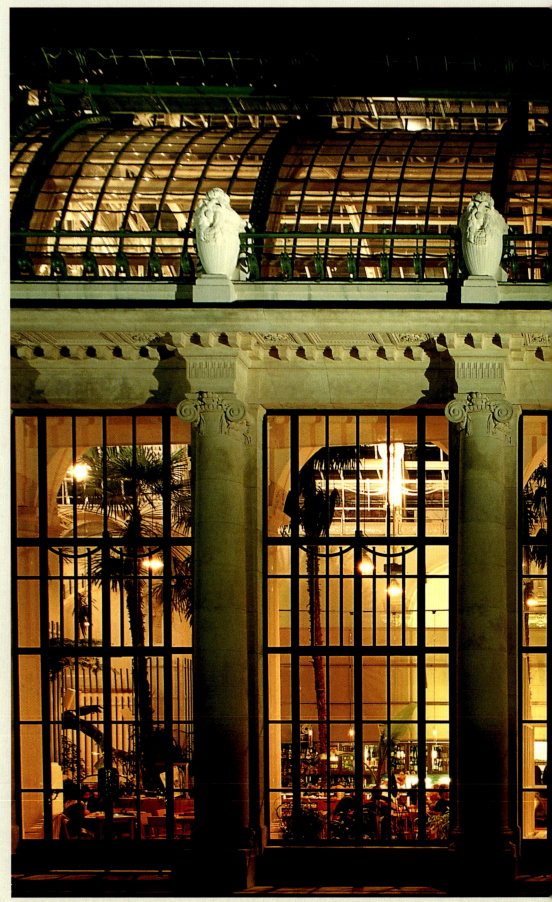

After careful revitalisation and renovation, the Palmhouse in the Burggarten at Burgring shines in new brilliance.

and Donner, including the original figures from the Thunder Fountain at Neuer Markt. The Museum of Medieval Art is located in the orangerie of the Lower Belvedere which used to serve as a greenhouse where the emperor's orange trees and other exotic plants were kept in winter.

In Vienna's largest green lung stands one of its most amusing landmarks, the Big Wheel. The engineer Walter Basset erected it in 1897 and since that time its gondolas have been turning slowly in a circle, offering great pleasure to residents and visitors alike. The Viennese may even marry there, if they have a special permit. With a rotation speed of 0.75 metres per second, the Big Wheel is not one of the fun »super-drive devices« such as can be used in the adjoining Wurstelprater funfair, but is quite suitable for »delicate tummies« too. The view across the green Prater then shows the astonishing size of this area which invites you to picnic on wonderful meadows, stroll through extensive woods and ride, skate and cycle – in the Prater everyone can indulge in their favourite sport. And even if they only go into the »Lusthaus« to look at the chestnut trees blossoming above while drinking a coffee.

You have to take time for the grounds of Schönbrunn Palace in Hietzing. Emperor Francis Joseph was born here in 1830 and also spent his last years in the halls of the palace. That was not always pleasant, because the large rooms could not be properly heated so that the emperor suffered from a troublesome cold every winter. Neither the beautiful location nor the outstanding architectural achievement helped with that! Nowadays, visitors are better off: It is warm. Of the 1441 rooms, »only« 45 are visited. In the Chinese Round Cabinet, Maria Theresa conferred with her State Chancellor Prince Kaunitz. In the Vieux Lacque Room there were talks with Napoleon. In the Blue Chinese Salon, Emperor Charles I signed his renunciation of rule and thus the end of the monarchy. In the Million Room, which is panelled with rosewood, valuable miniatures from India and Persia are to be seen. In the Great Gallery, the Congress of Vienna danced in 1814/15 – even today, people are convinced that without wine and waltzes no agreement could have been reached.

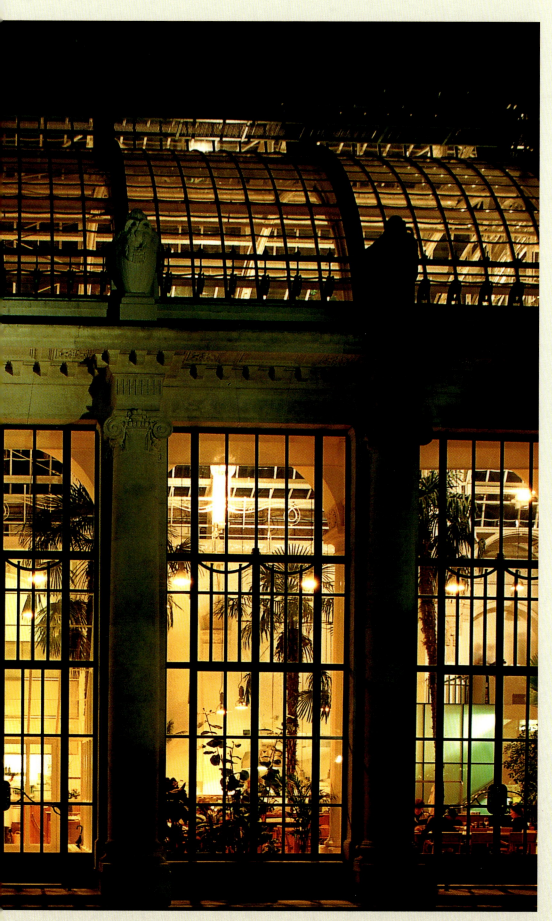

Far outside, in the east of Vienna, where the flat countryside arouses the sentimentality slumbering in the Viennese, at Simmeringer Hauptstrasse 234, is the Central Cemetery (Zentralfriedhof). A still and awe-inspiring world opens itself to the visitor over two square kilometres. If you pass through the first gate, you come to the old Israelite Section. Arthur Schnitzler and Friedrich Torberg have their last resting place here. If you go through the main gate, decorated in Jugendstil, you can already see the large dome of the Dr. Karl Lueger Memorial Church (Dr.-Karl-Lueger-Gedächtniskirche), built by Max Hegele between 1908 and 1910. To the right and left of this broad pathway you will find the probably largest collection of tombs of honour in the world. Gluck, Beethoven Schubert, Hugo Wolf, Johann Strauss father and son, Lanner, Brahms, Arnold Schönberg, Hans Moser, Robert Stolz, Theo Lingen, Curd Jürgens, the list of famous names is unending. But also the graves of now-adays unknown, but then very prosperous families impress with their extravagant architecture. Innumerable marble angels seem to watch over the peace of the dead here, and on one tablet »Expired at last« is inscribed in golden letters, a very excellent adage for Vienna of that time. In the 3rd millennium, however, even the Viennese are changing, sighing for a last time when looking back over a long history and smiling towards the future as proud Europeans.

Page 22/23:
Seldom is the view from the Hellenistically inspired Parliament to the proud, neo-Gothic City Hall on the Ringstrasse revealed to the visitor. Friedrich Schmidt, the architect involved in the completion of Cologne and Vienna cathedrals, built his most important work from 1872 to 1883.

Page 24/25:
Already the stairway of the Art History Museum with its richly coloured frescoes and sculptures is a work of art in itself. The marble group of figures »Theseus in combat with the Centaurs« is by Antonio Canova.

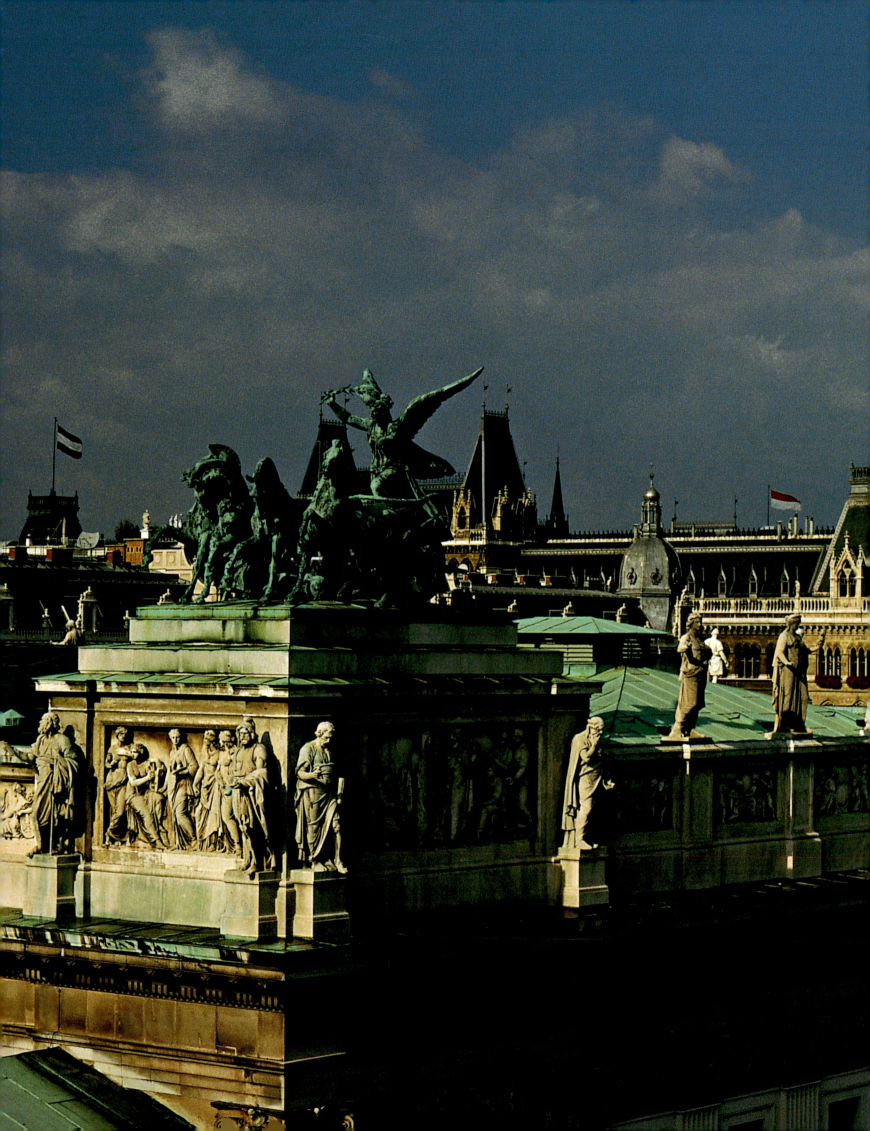

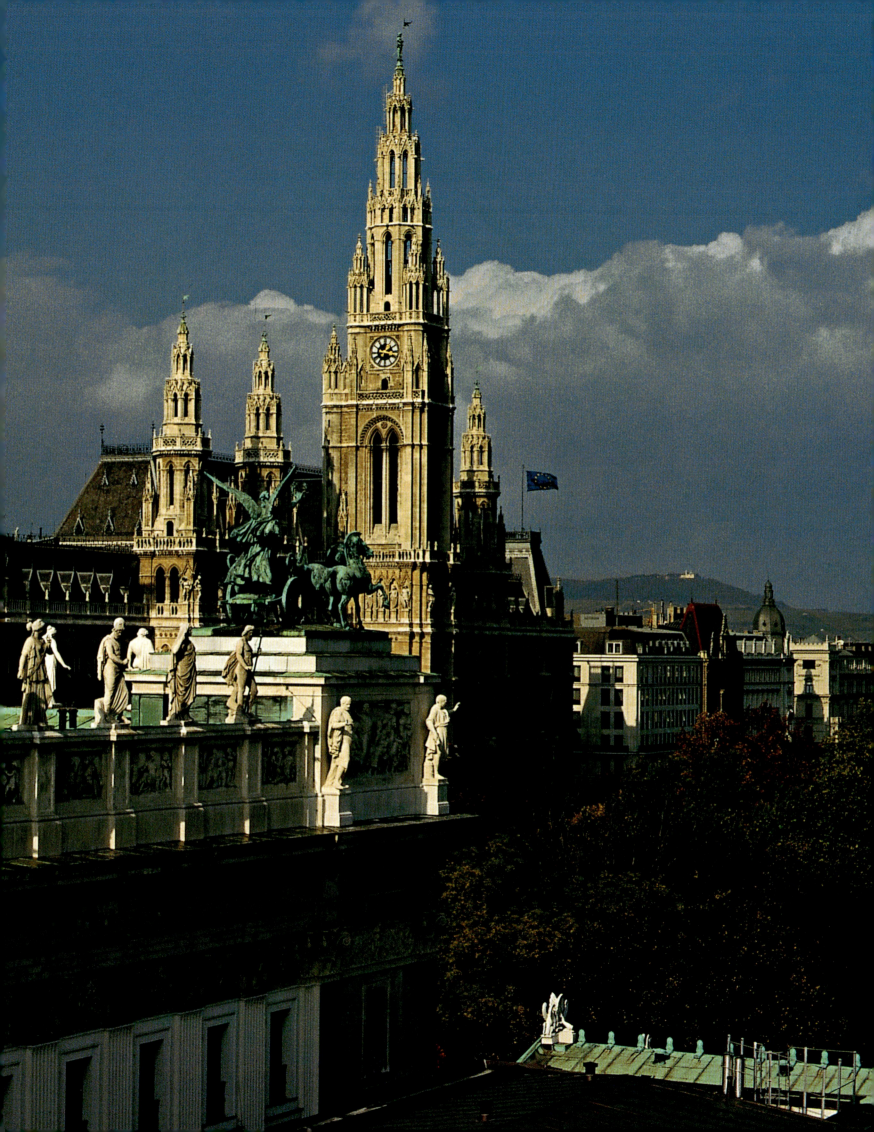

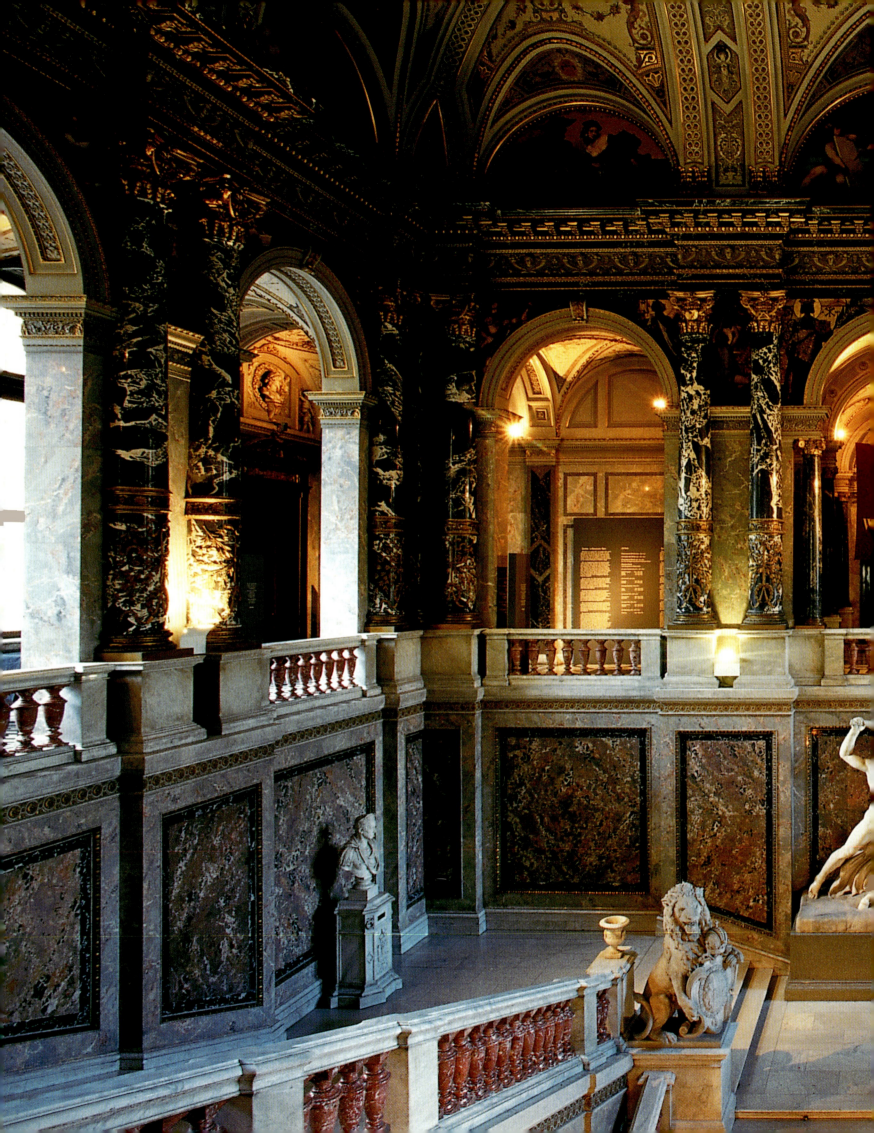

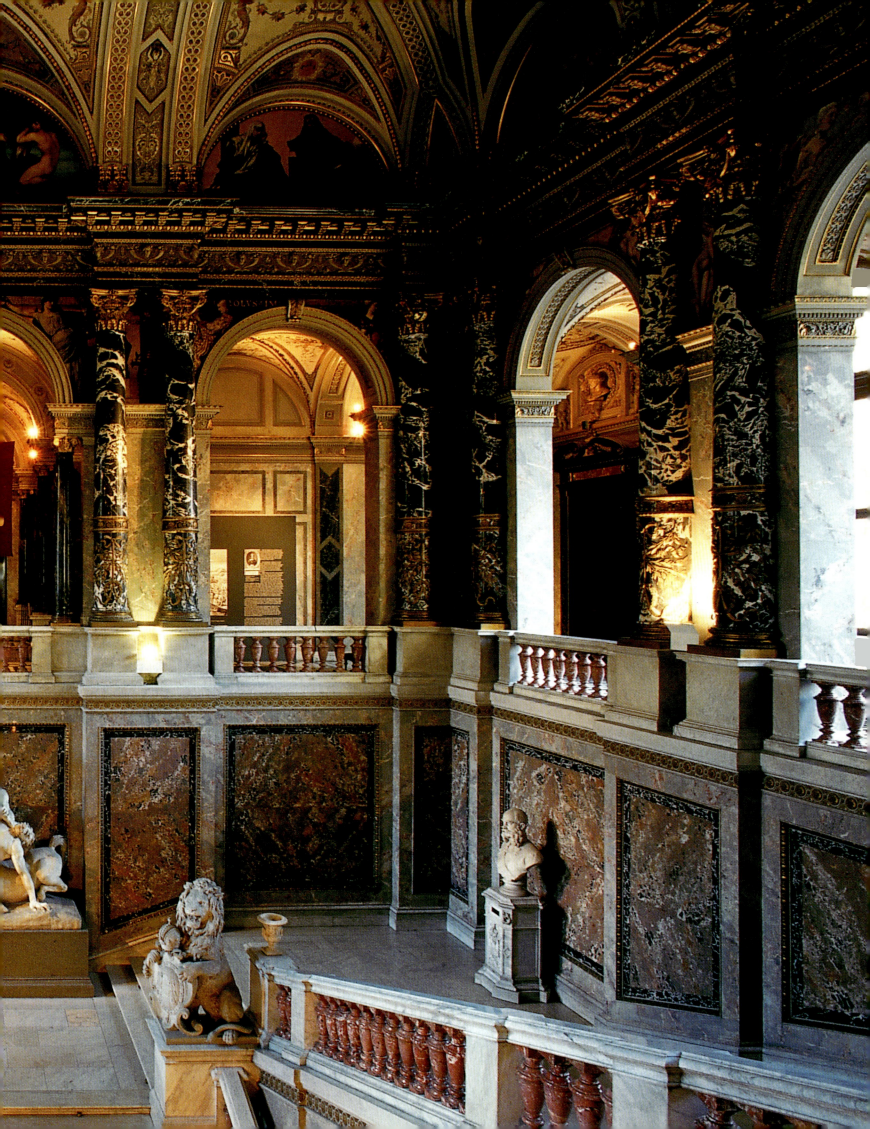

Inside the Ring – the heart of Vienna

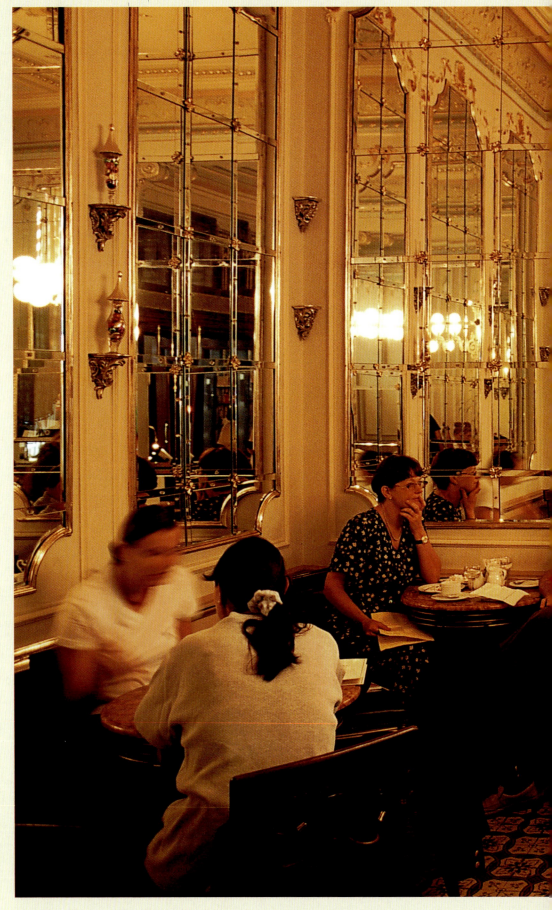

In the Imperial and Royal Court Confectioner's Demel at Kohlmarkt, the »Demel Ladies«, who are renowned for their courtesy, serve hot chocolate and small snacks. In the basement you can also visit the »Demel Museum«.

Then St. Stephen's Cathedral was constructed, the Roman city walls were still standing. The »Roman stone« below the organ gallery in the northern Heathens' Tower (Heidenturm) still refers back to this distant past today. The Viennese have a close, affectionate relationship to their cathedral, for the constant restoration works for which collections are held every year, during which no genuine Viennese can keep his purse shut. When the foundation stone of the Eagle Tower (Adlerturm) was laid, the vintners had a particularly bad harvest – the wine was too sour to be enjoyed. Emperor Frederick III had the idea of using this wine for »Steffl« and quickly issued the order that all the sour wine should be brought to St. Stephen's so that a new mortar could be mixed with the wine. The addition of the wine gave the mortar an incredibly hardening effect – who knows how St. Stephen's Cathedral might have looked otherwise today? The Viennese city centre is grouped around the mighty cathedral. Small, crooked alleys and pretty squares alternate. In between runs the splendid Kärntner Strasse which can certainly keep up with the Parisian shopping boulevards; just a little shorter, but more leisurely and personal – the Graben with the Plague Monument (Pestsäule) and St. Peter's Church (Peterskirche), the Kohlmarkt with the confectioner's Demel and elegant shops, the Wollzeile, a small, more dainty version of the Kärntner Strasse, where choice tea, delicious chocolate and outstanding literature are offered – and the less elegant but also interesting Rotenturmstrasse. Turn off in good time and discover the tiny, secluded lanes with their small cafés, jewellers' shops and antique shops. Many a fine souvenir can be purchased there which – back home – is intended to remind you: »Come back again to this city that is so gently able to link the past and future.«

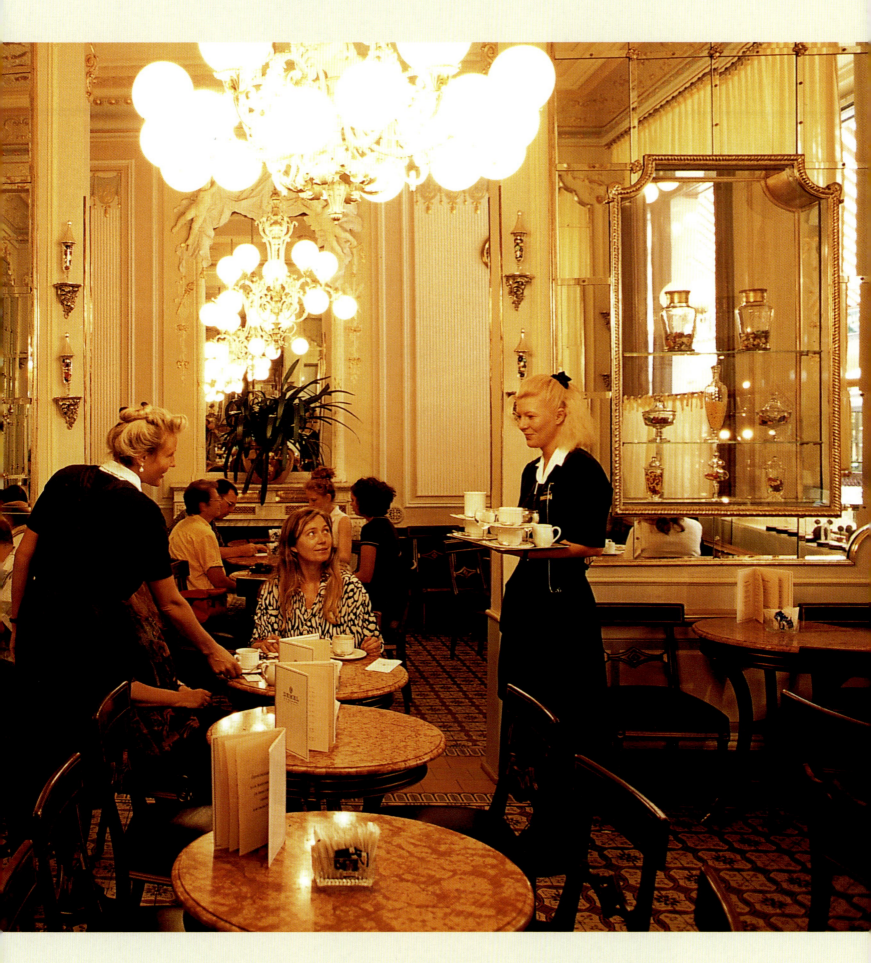

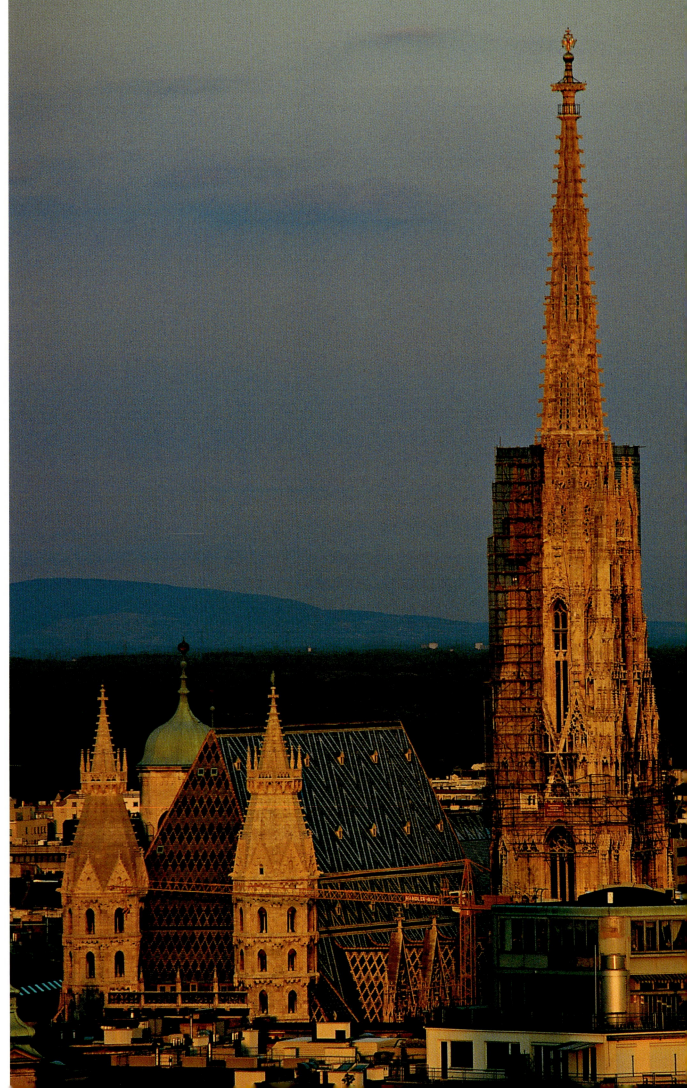

Right:
The typical, asymmetrical silhouette of St. Stephen's Cathedral, known lovingly as »Steffl« to the Viennese, was caused by the abrupt stop to the construction of the north tower at 68 metres. Instead the completed tower is all the more handsome.

Right page top:
Works of art of inestimable value can be admired inside St. Stephen's Cathedral. The master builder Anton Pilgram from Brünn created the pulpit in 1514 with the busts of the four Fathers of the Church.

Right page bottom:
The mortal remains of many famous Hapsburgs are to be found in the catacombs under St. Stephen's. In addition to 15 sarcophaguses, there are also 56 urns with the entrails of the Hapsburg dynasty. Since 1953, the archbishops of Vienna have also been buried there.

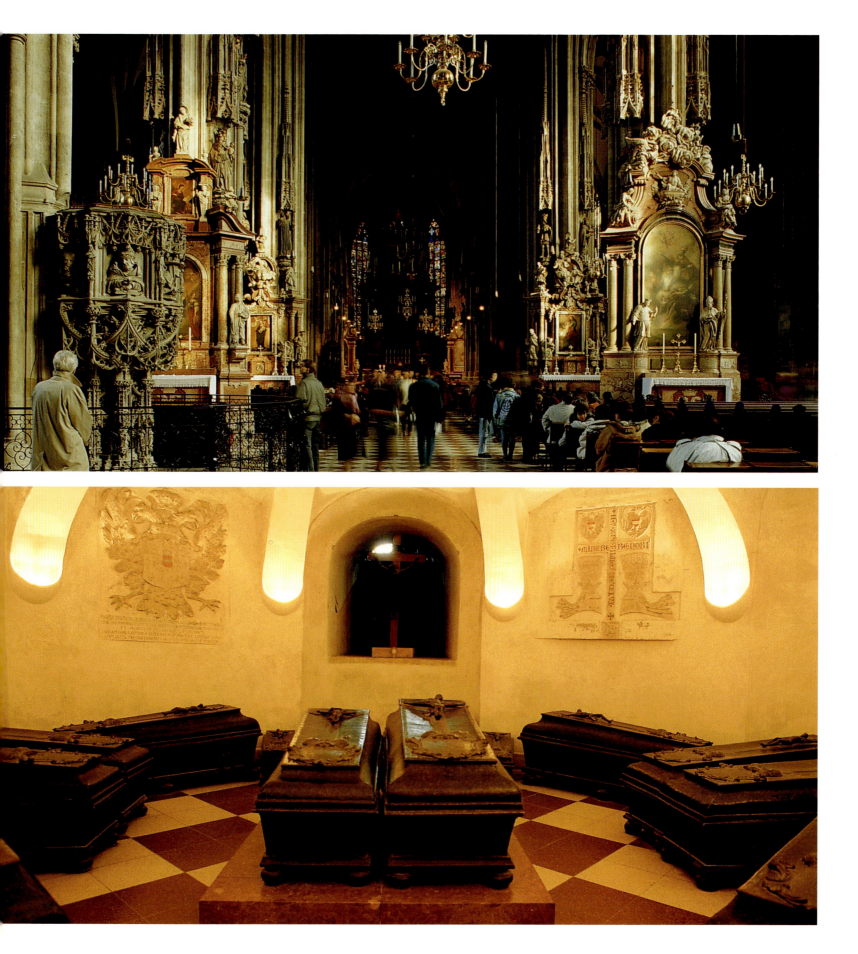

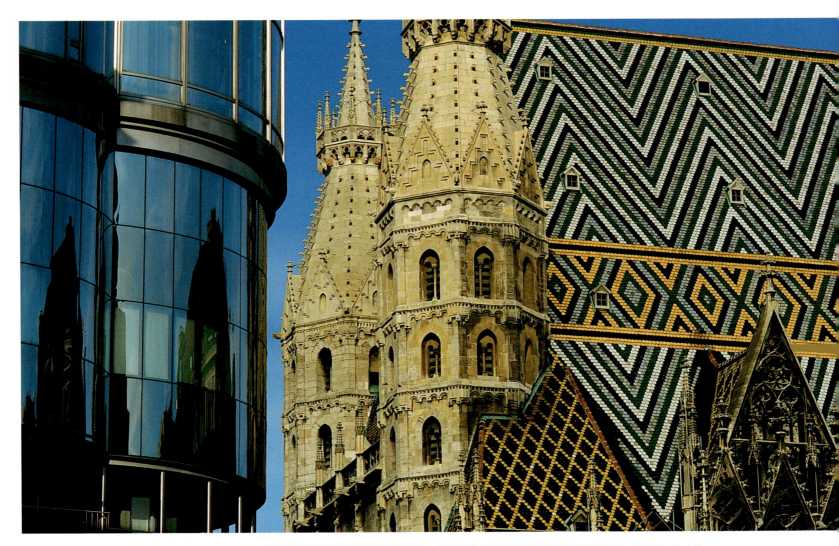

Above:
History and future merge into a harmonious overall picture: the ultra-modern Haas-Haus with St. Stephen's Cathedral, the »renovation works« on which have never come to a complete halt since 1147.

Right:
Many interesting details can be discovered in St. Stephen's. Master Anton Pilgram has im-mortalised himself under the pulpit as the peeper from the window.

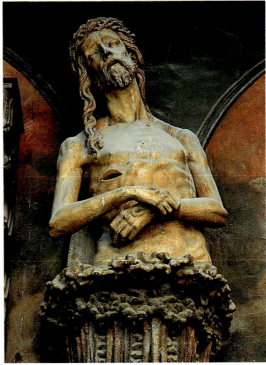

Right page:
Star architect Hans Hollein has created an internationally praised monument to himself opposite St. Stephen's Cathedral with the Haas-Haus. Elegant stores make the Haas-Haus a popular meeting point.

Left:
The »Lord God with toothache« is the nick-name given to a half figure of the Man of Sorrows at the rear of St. Stephen's on account of its facial expression.

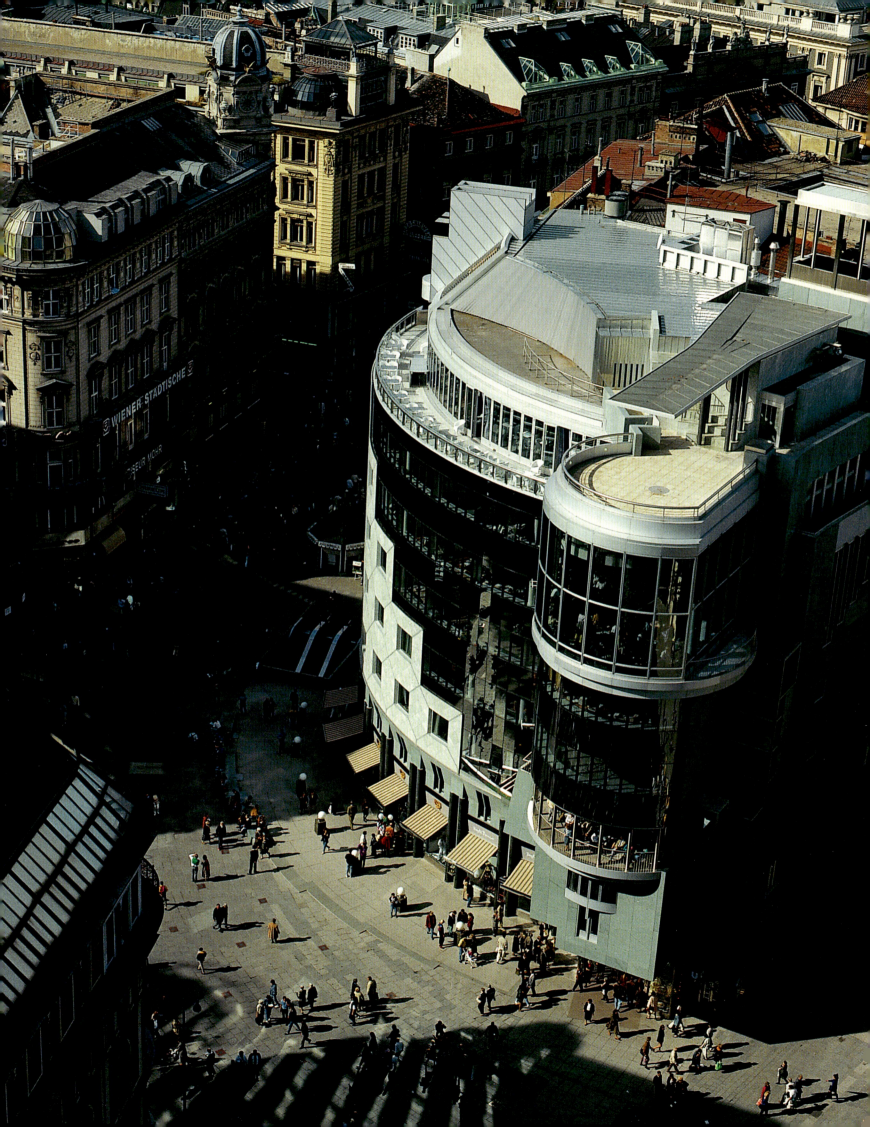

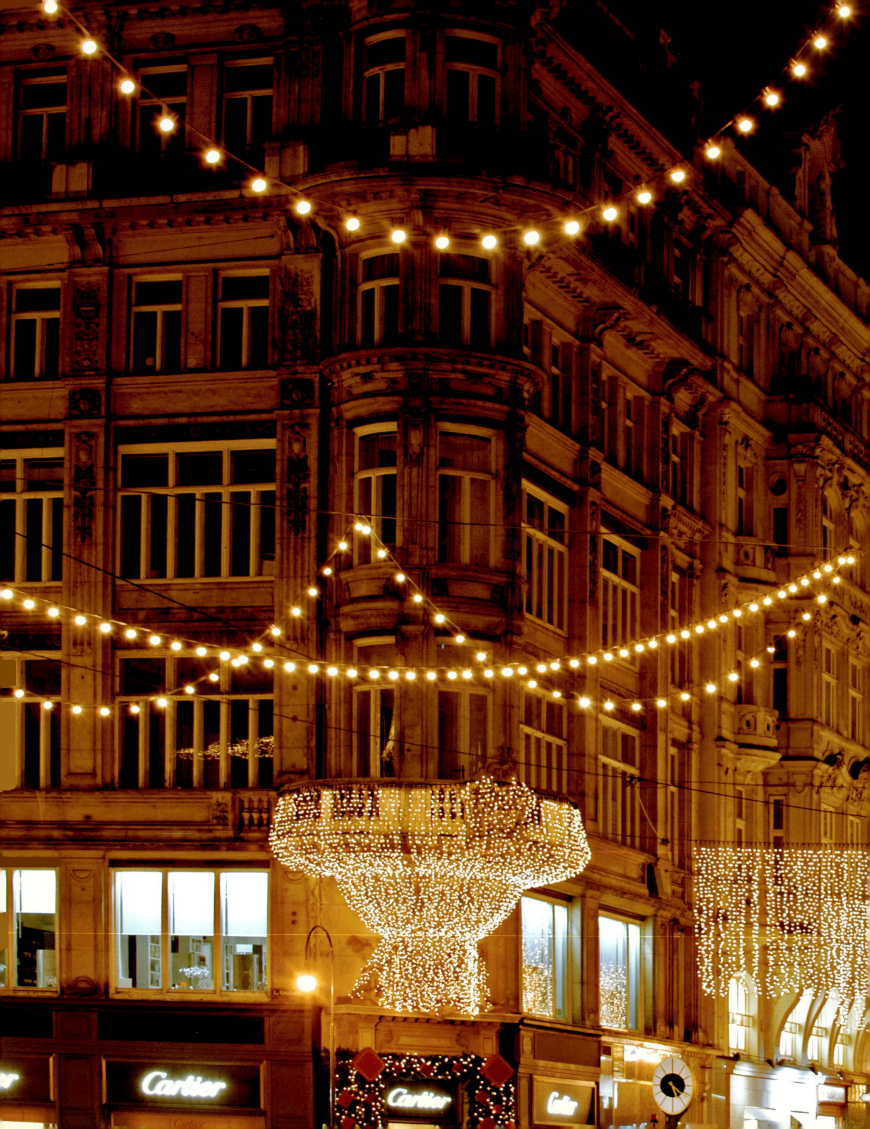

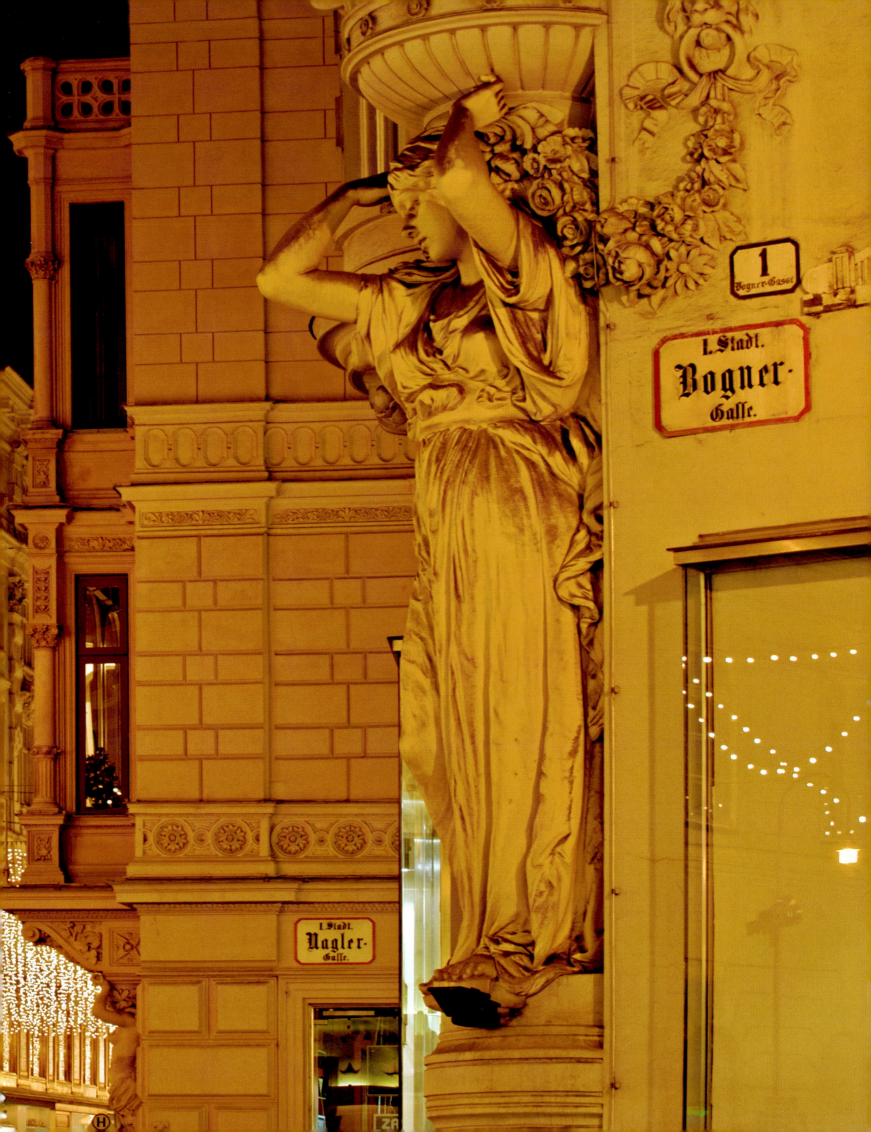

Page 32/33:
In the run up to Christmas
the Graben is especially
ornately decorated (here
the corner of Bognergasse).

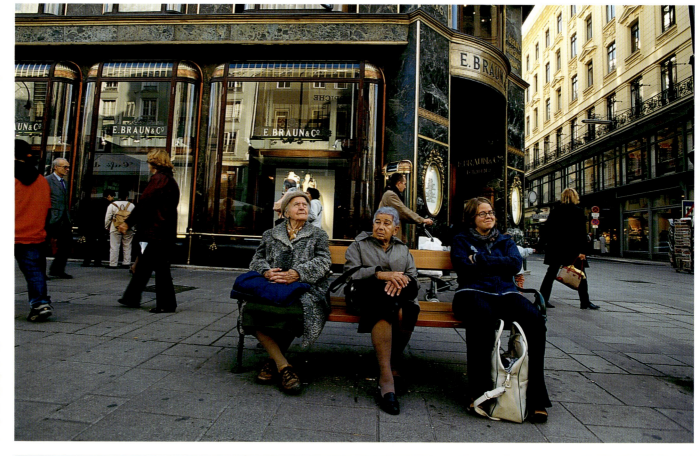

A brief break after a stroll
through the city does good.
Even if one has looked at
all the splendidly designed
house façades along the
Graben, one is grateful for
an opportunity to sit down.

Shopping fans are glad of
a little sustenance on the
Graben – here offered in
the form of roast chestnuts
and potato fritters.

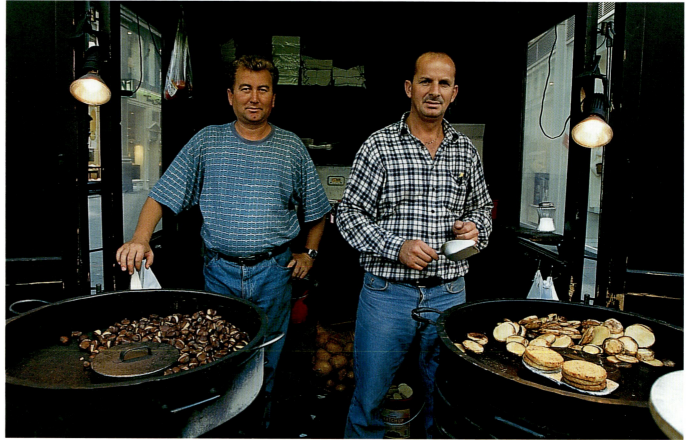

In 1894, Otto Wagner designed the Ankerhaus at Spiegelgasse 2.

Street musicians from all countries of the world transform the Graben into a multicultural stage.

Page 36/37: *Already in 1421, the Jews were expelled for the first time from their ghetto around the present-day Judenplatz. The Holocaust Memorial recalls the more recent atrocities.*

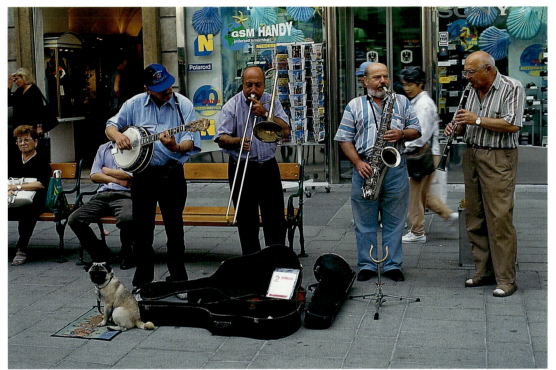

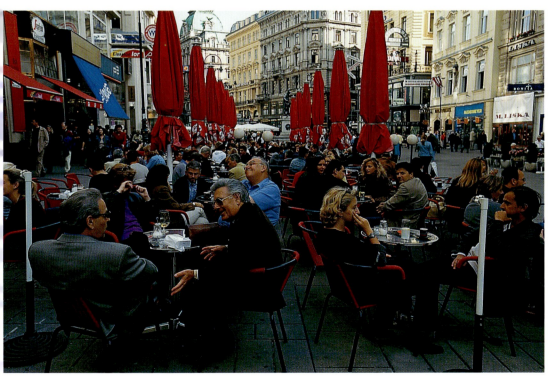

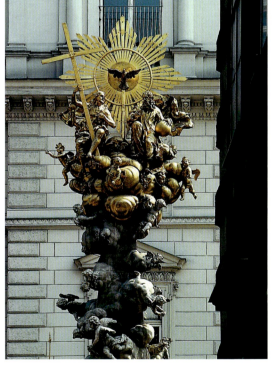

The Viennese like to gossip. Best of all, of course, over a cup of coffee, as here in a street café in the Graben.

This city has survived a great deal: sieges, wars and a terrible outbreak of the plague which cut the number of inhabitants by half. The »Pestsäule« (Plague Column) in the Graben recalls this.

35

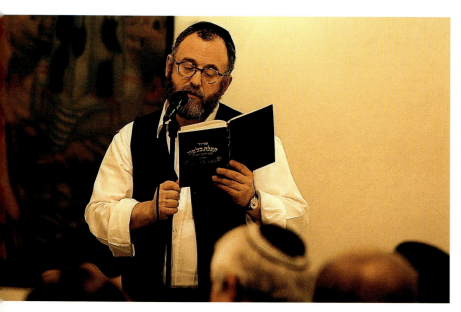

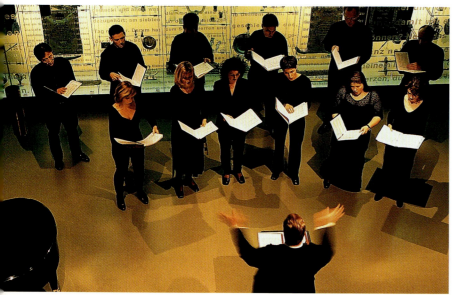

Left top:
Chief Rabbi Paul Chaim Eisenberg reciting during a festival at the Jewish Community Centre.

Left centre:
Events also take place in the auditorium in the Jewish Museum at the heart of the Inner City, for example by the Kantoralensemble Vienna.

Left bottom:
The Jewish Museum is housed in the palace of the banker Bernhard Eskeles who lived here around

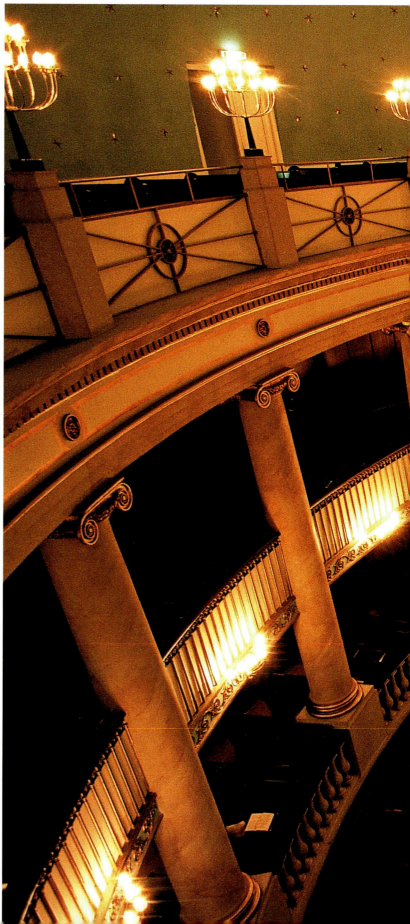

1825. The Museum still possesses items from the world's first Jewish Museum from 1897.

Below:
The City Temple, which Josef Kornhäusel constructed between 1824 and 1826, was the only one to survive the destruction of all Jewish synagogues in 1938. The classicist interior is dominated by the high pillars.

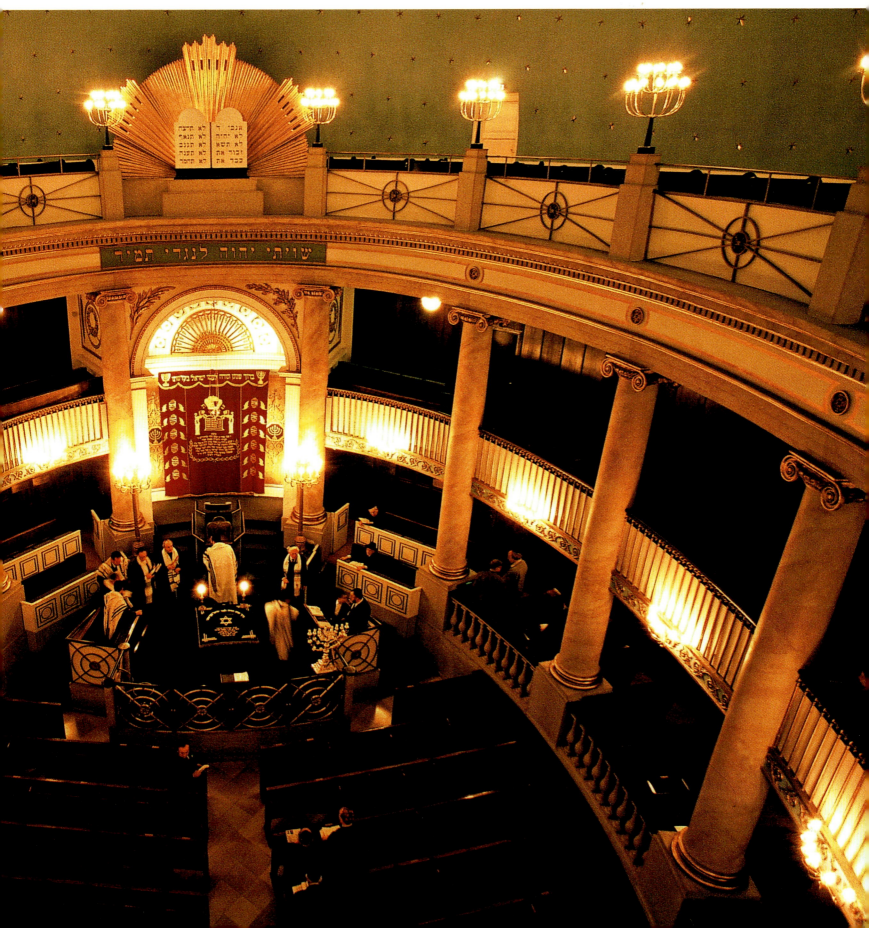

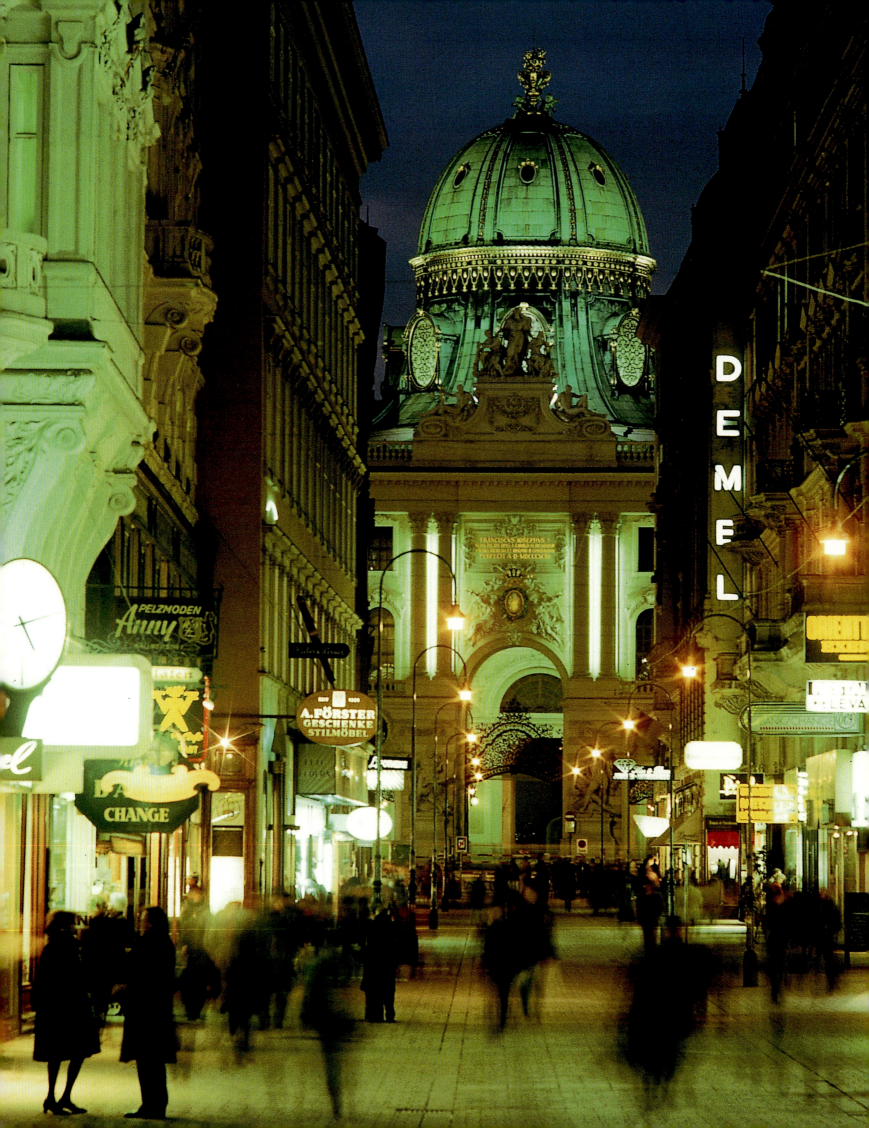

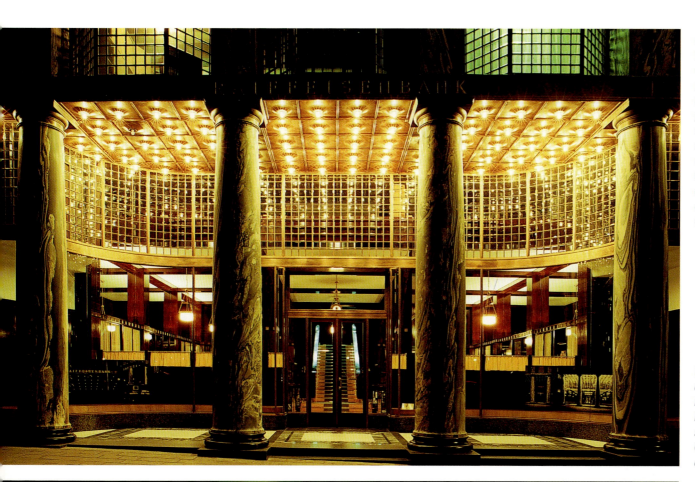

Left page:
When you turn from the Graben into the Kohlmarkt, you are recommended to turn your gaze away from the tempting window displays towards the Michaelertor (St. Michael's Gate). Especially at dusk, the illuminated Baroque dome of St. Michael's tract of the Hofburg radiates in elegant turquoise.

The architectural philosophy of Adolf Loos finds its expression in the Looshaus at Michaelerplatz: »Ornament is a crime«. Only the lowest floor is divided up by pillars.

The »Hohe Brücke« (High Bridge) spanning the »Tiefer Graben« (Deep Ditch) in the Inner City is only one example of the numerous testimonies to the art form »Jugendstil«.

Numerous shops have been established in the passage in Palais Perstel offering antique jewellery, trendy shoes, ladies' underwear and all kinds of crafts. Heinrich Perstel constructed the building between 1856 and 1860 for the Austro-Hungarian Bank and the Stock Exchange.

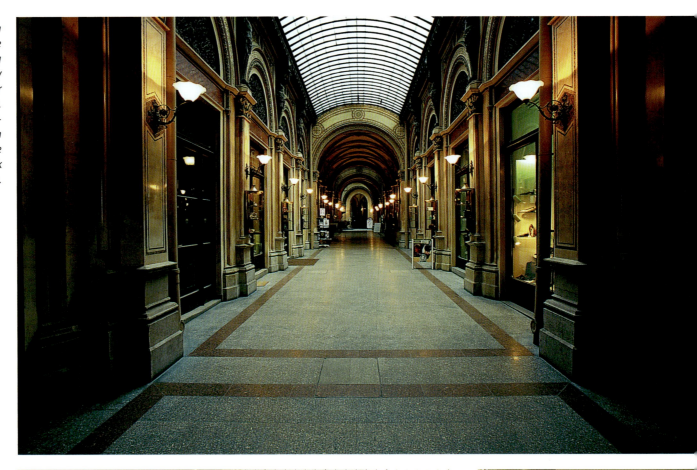

The counter hall in the former Länderbank, Hohenstauffengasse 3, is one of the many works by Otto Wagner, the pioneering architect for building determined by purpose, material and construction.

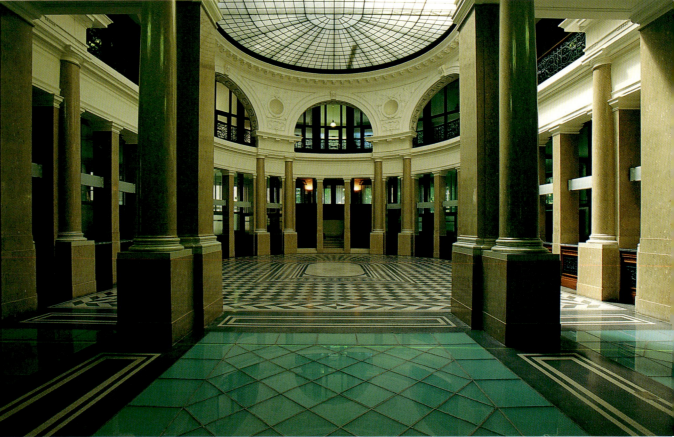

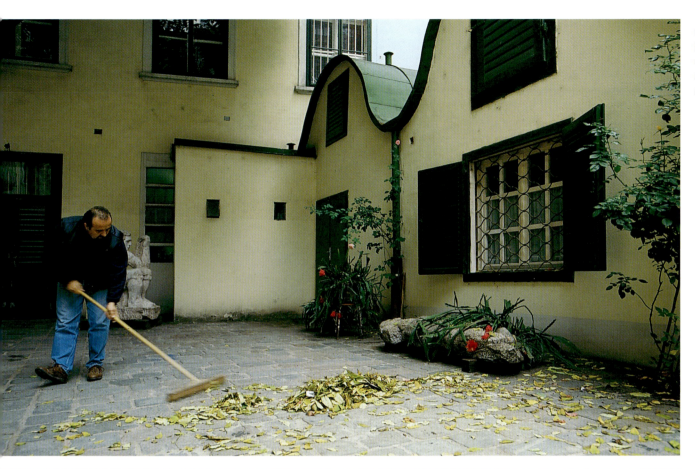

*Many tranquil court-
yards, such as this one
at Kohlmarkt No. 11,
are concealed behind
splendid façades.*

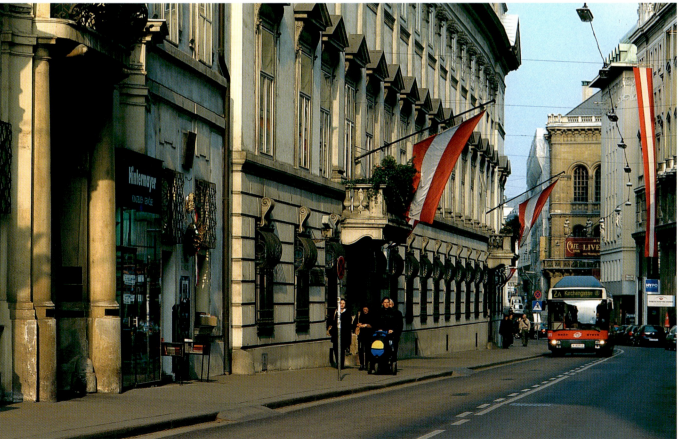

*The Herrengasse
(»Lordships' Lane«):
where barons used to
reside in their splendid
mansions, government
officials and journalists
now work.*

43

THE VIENNESE COFFEE-HOUSE – A LIVING ROOM FOR INSIDERS

Why are the Viennese cafés in particular so legendary? For there were already over 2000 cafés in London in 1700 and in Paris around 1800 some 4000 such institutions invited clients to tarry awhile. In earlier times Vienna did not have anything like so many coffee-houses. However, the few made up for this through a special atmosphere. Because, right from the outset, the café in Vienna was not simply an anonymous place in which one drank one's coffee, paid and went home again. Rather, the majority of guests moved into a kind of »second home« there at a regulars' table and used the room as a workplace, conference room, philosopher's den, gaming room and last, but not least, as a place of peace and relaxation. There was and is music only at a couple of fashionable cafés, such as Dommayer's in Hietzing or the Imperial on the Kärtnerring – and even there only either on Sunday morning or evening. During the day, the guests want to decide for themselves whether they prefer bustle or rather enjoy the quiet at a small marble table located in a secluded corner. As the Viennese »lives« in his café, a soon very close relationship with the head waiter (»Ober«) develops in many cases. The »Ober« knows all about progress at work, about the wife and children, secret passions and, of course, the favourite pastries and preferred way of having coffee prepared.

Philosophise, take a break, play and – drink coffee

Coffee is not simply coffee in Vienna. The »kleiner Brauner« (small cup of coffee with cream) is probably most frequently ordered because it is reasonably priced and good. Immediately after comes the »Melange«, a large cup of milk coffee and in third place – since Italian cafés gave the Viennese the taste for it – a strong »Mocca«. The other specialities, such as the »Einspänner« (one-horse carriage), a double mocca in a glass topped with whipped cream, the »Pharisäer« (Pharisee), a coffee refined with rum and whipped cream, the »Verlängerte« (Stretched), a filter coffee diluted with water, and the »Kaisermelange« (Emperor's melange), a milk coffee with the yellow of an egg, also have their fans. However, if the coffee-house visitor has once been won to over a certain type of coffee, he will usually keep to it – experiments are not something for him. He is just as faithful in the case of cakes and pastries, whether Gugelhupf, Sachertorte, »Zwetschgenkuchen« (plum flan) or »Topfenstrudel« (quark

strudel) – just do not change habits. So it is easy for the »Ober« to know after a couple of visits what the lady or gentleman most likes to consume. And when a month is drawing to a close, then he is also prepared to chalk up the amount of the bill and not to collect it until the next month.

In the 19th century, the Viennese café still differed from those in London and Paris through one detail in particular: Ladies who came unaccompanied would not be served – the café was a purely male preserve; they would smoke fat cigars, drink cognac and talk politics. Individual cafés would quickly specialise in a particular clientele – not intentionally, it just turned out that way. In Café Grienstadl, at that time called »Grössenwahn« (»Megalomania«), the Central and the Herrenhof, the literary men would gather and engage in violent verbal battles. Among them was the famed Karl Kraus who wrote his cynical, outstanding newspaper articles here, criticising his journalist colleagues outright.

Writing and reading, two activities for which the Viennese café seem to have been created. In 1913, the Café Central in the Herrengasse offered more than 150 newspapers and periodicals in various languages. The most important papers, from the Austrian dailies to »The Times«, »Le Monde«, »Corriere della Sera«, »Neue Zürcher Zeitung« and the »Süddeutsche

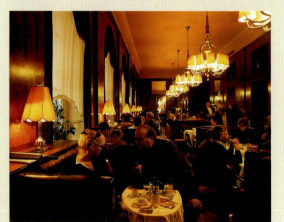

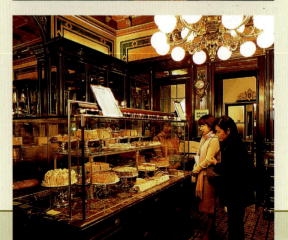

Left:
Every visitor to Vienna should devote one, two hours time to the confectioner's Demel. On the one hand, in order to regale oneself with coffee and fine pastries, on the other in order to inspect

the museum accommodated in the basement (bottom). In the elegant Café Landtmann next to the Burgtheater, one can encounter prominent political figures and well-known actors (top).

Zeitung« are still available there. The Viennese café owes its excellent reputation not least to this range of newspapers and the fact that while reading one may sit for hours over just one cup of coffee and will be served with a fresh glass of water every half hour by the »Ober« with a friendly demeanour. Hectic is an alien term in the Café. Even more authentic is the Café Hawelka in the narrow Dorotheengasse in the city centre. You can still sense the flair of Viennese painters here. The talented young artists would meet in the tiny coffee-house, and nowadays collectors would pay a great deal for many a serviette with a small, quickly scrawled sketch. In those days, however, the »Ober« would collect them and, if they pleased him particularly well, he showed them to the other guests before smilingly throwing them away with a few gugelhupf crumbs. How was he to know that Schiele and Kokoschka would become so famous one day.

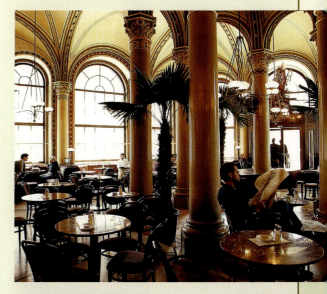

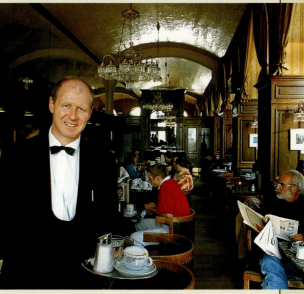

Above:
Young intellectuals and art students prefer the comfortable red leather sofas of Café Museum to all others for discussing and philosophising.

Right bottom:
The venerable Café Central in the Herrengasse. Vienna's most famous literary figures had their 'home' here.

Right:
'Ober' Erwin in the splendidly renovated Café Schwarzenberg always serves a glass of water with the 'Melange': »A matter of course for us here in Vienna«, he says proudly.

45

Below:
In Vienna, nobody needs to wait until their wedding day to ride in a white carriage drawn by two white horses. After the Spanish Riding School, fiacres are the second attraction in which the horses play an important role.

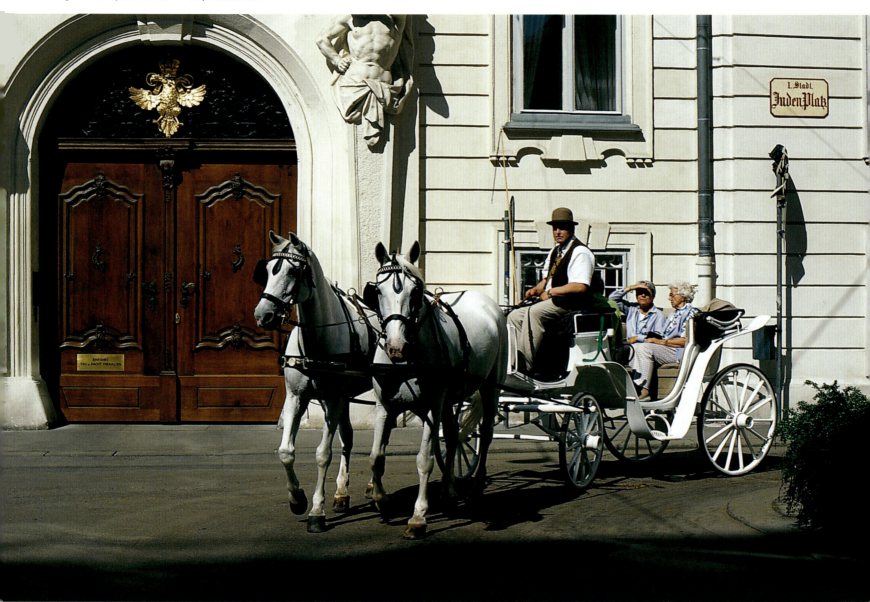

Many of these two-horse
carriages are also under
way in the Inner City to show
visitors the sights. The men
on the coach box, who are
also called »Fiaker« are
able to tell interesting
and amusing tales about
every building. You are
recommended to ask
about the fare before
starting the ride.

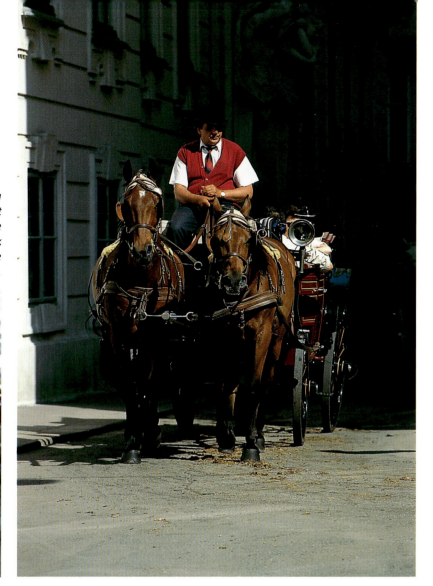

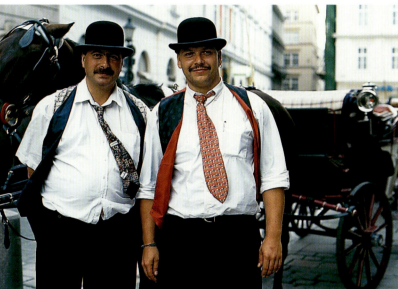

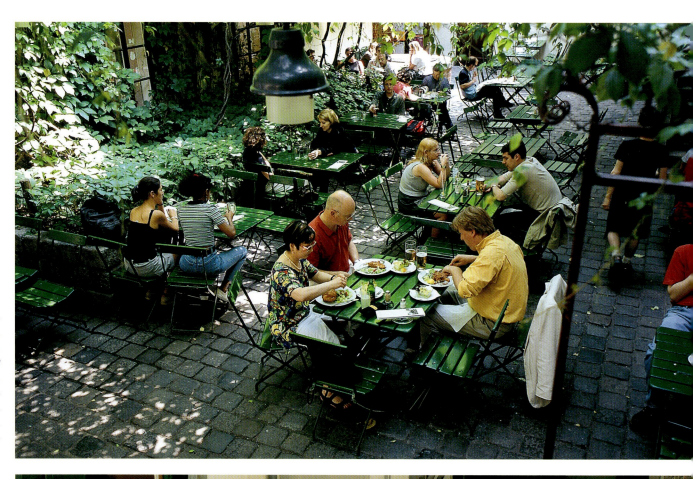

Amerlingbeisl on Stift-gasse is tucked into the courtyard of the Amerling-haus. Thirty years ago an alternative arts and social centre was set up here on Spittelberg which despite – or perhaps because of – the revamping and subse-quent boom of the area has thrived.

Zu den drei Hacken is another popular »Beisl« in the centre of Vienna. In the nooks and crannies of this traditional tavern Viennese cuisine is presented as it was a hundred years ago. And if you're not sure what »Beuschel« are, just ask one of the attentive yet discrete waiters...

*The »Schnitzels« are said
to be legendary in »Figl-
müller« with its inviting
inn sign in Wollzeile.*

*The guest is well cared
for in »Zu den 3 Hacken«
at Singerstrasse 28.*

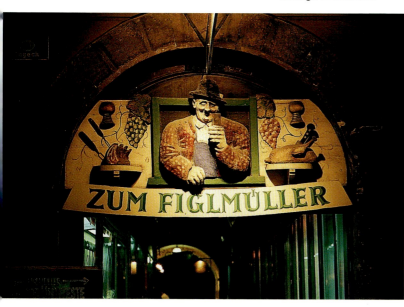

*The extension of the dining
room into the open air is
called »Schanigarten« in
Austrian, here in Nagler-
gasse. With the first rays
of the sun, tables and
chairs are taken outside.*

*You will find Viennese
»Gemütlichkeit« in
addition to good food in
the dining rooms of
Figlmüller in Wollzeile.*

Page 50/51:
*The Albertina in the heart
of Vienna houses one of the
largest and most important
collections of graphic art in
the world, with 60,000 plus*

*drawings and over one
million printed graphics.
The exhibits date from the
late Gothic period to the
present day.*

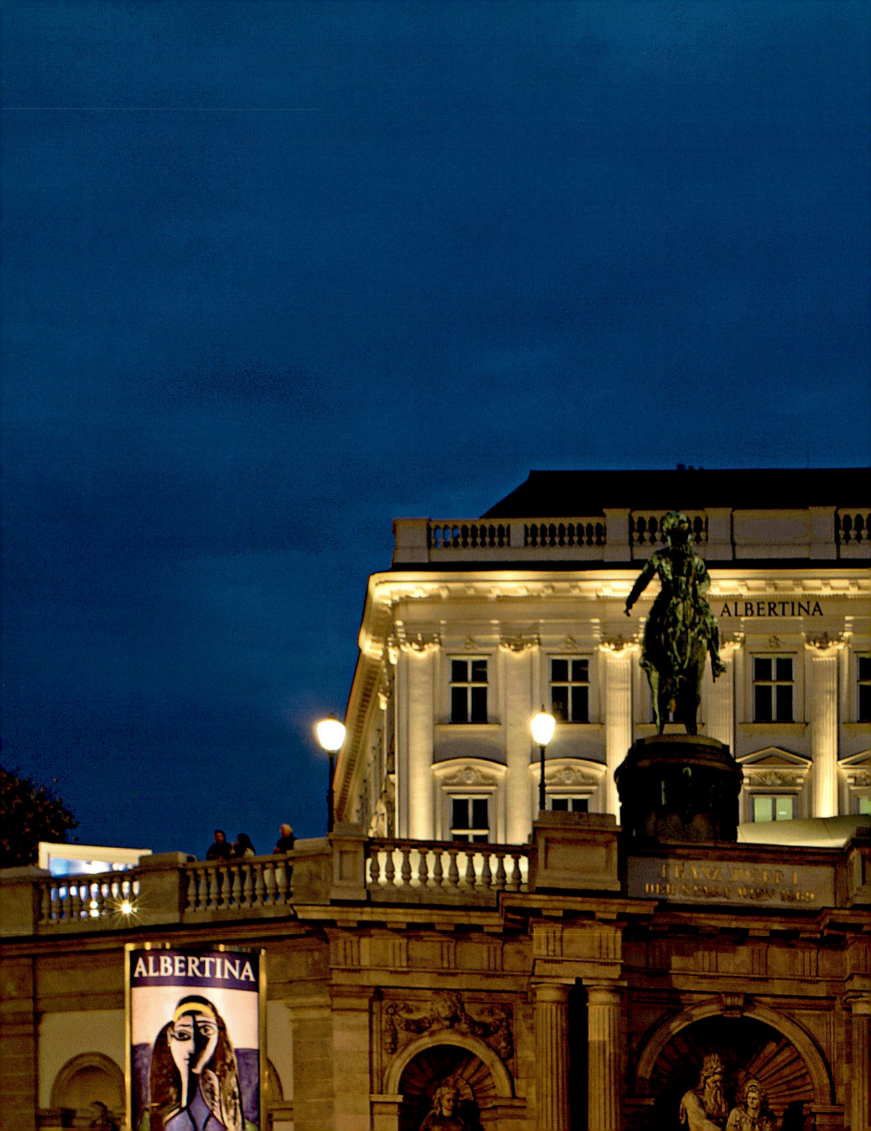

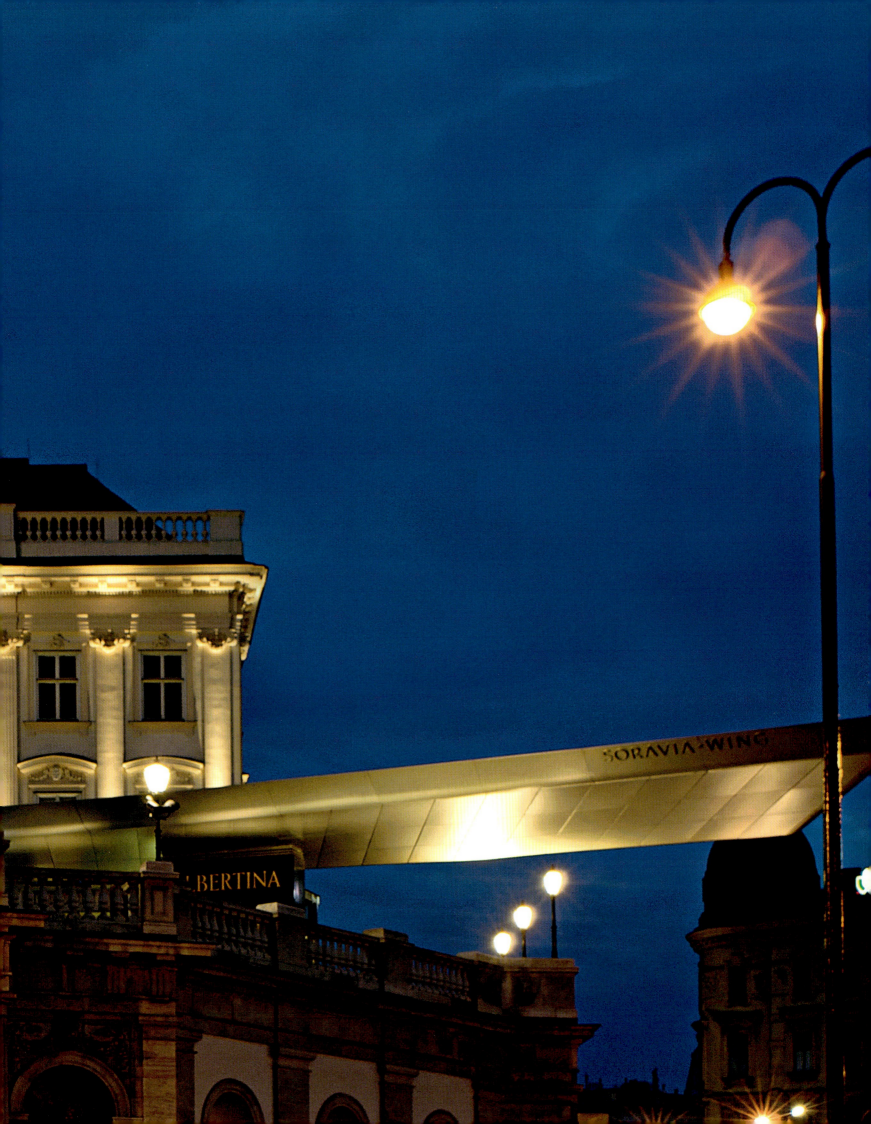

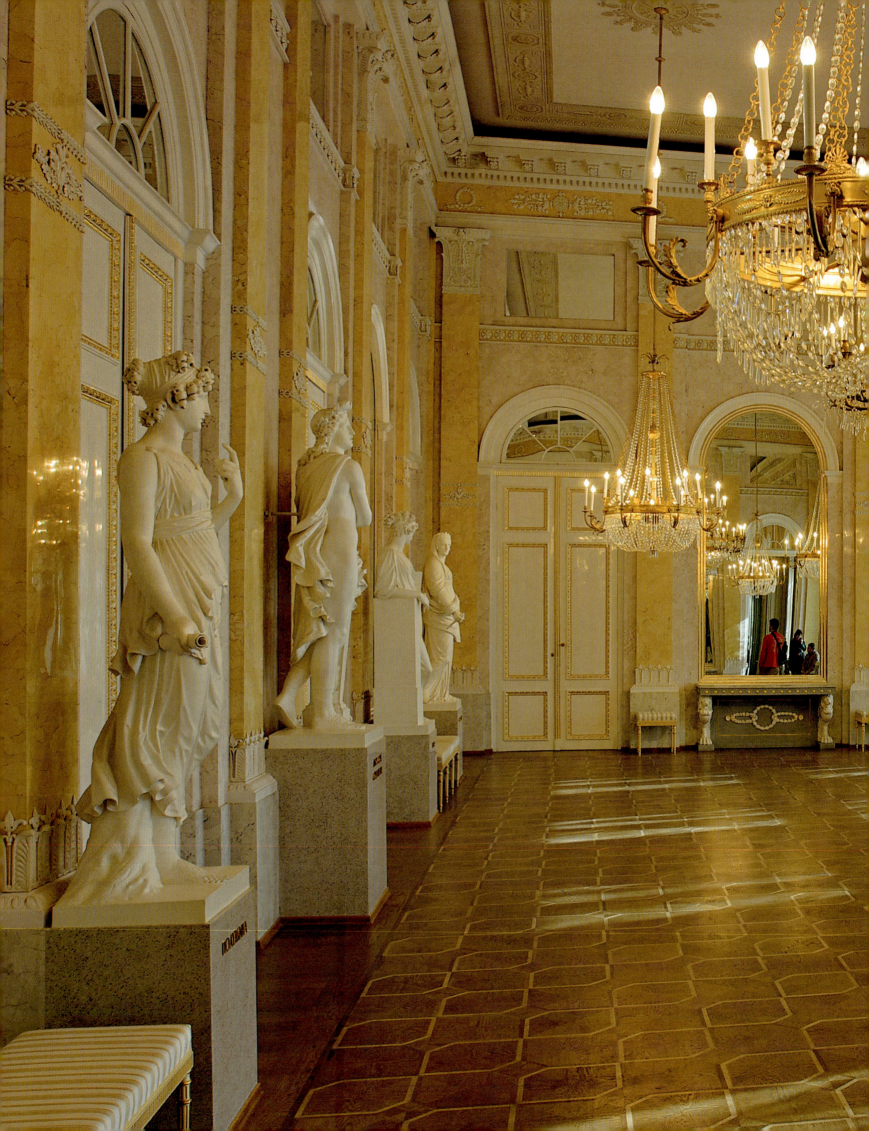

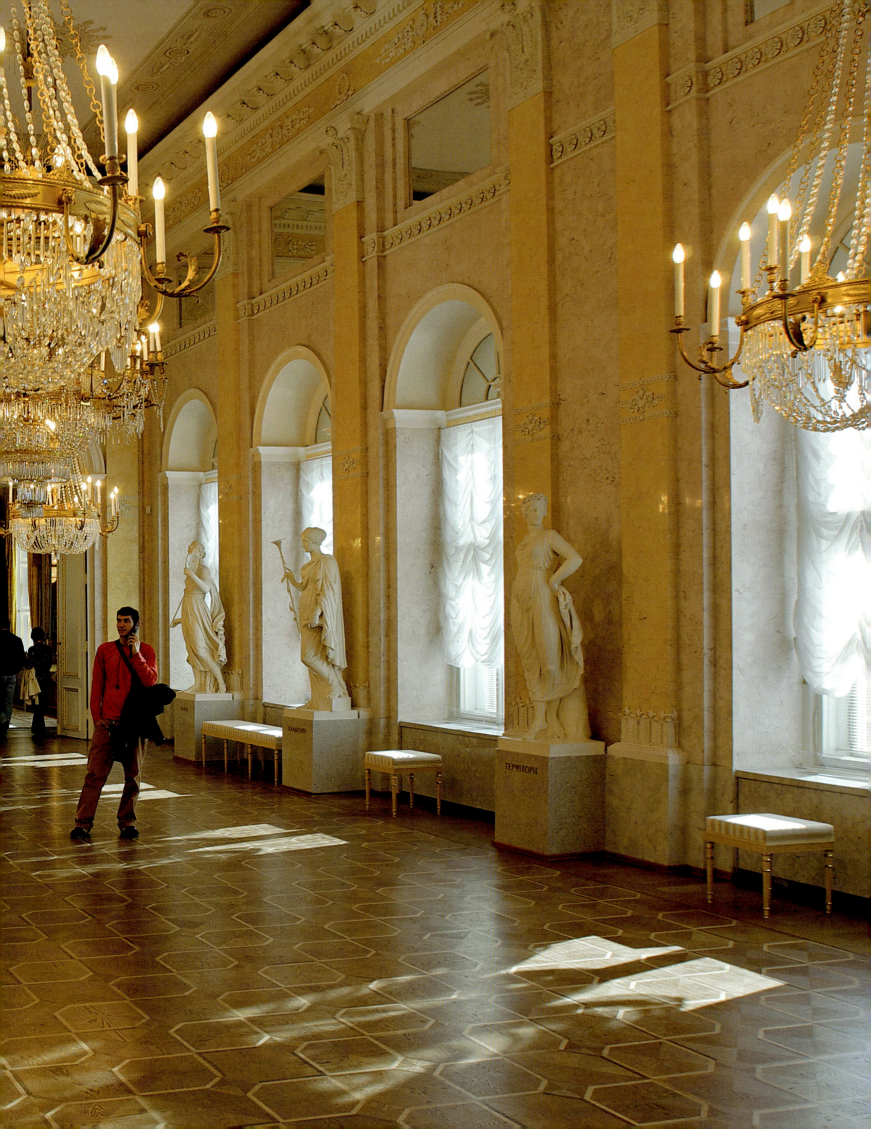

Page 52/53:
The Musensaal in the Albertina formed the nucleus of the palace and was both a dining room and the setting for lavish balls. Five magnificent chandeliers bathed the splendiferous hall in an orgy of light. The salon was named after its cycle of statues entitled »Apollo and the Nine Muses«.

Below:
A kind of filigree bishop's mitre crowns the tower of the church »Maria am Gestade«. The master builders Michael Knab and Konrad Ramperstorffer erected the »Gothic treasure casket« between 1330 and 1414.

Below:
The figure of a hussar on the roof of Kohlmarkt 1 tells of heroic deeds and the old glory of the Monarchy. Nowadays he looks down stoically on the hustle and bustle of the busy square.

Right:
The National Library is accommodated beneath an impressive dome in the Hofburg at Josefsplatz. The »puzzle« of the Hofburg consists of 18 tracts, 19 courtyards and over 2500 not always small rooms.

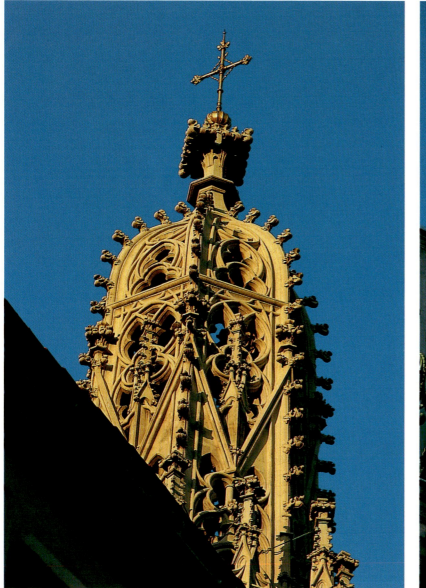

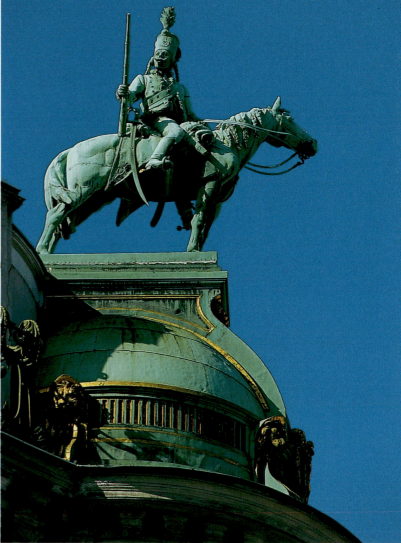

Right:
A golden coat of arms refers to the fact that here, at Judenplatz 11, the Bohemian Court Chancery used to have its seat. The Senior Court Engineer Fischer von Erlach designed the façade between 1708 and 1714.

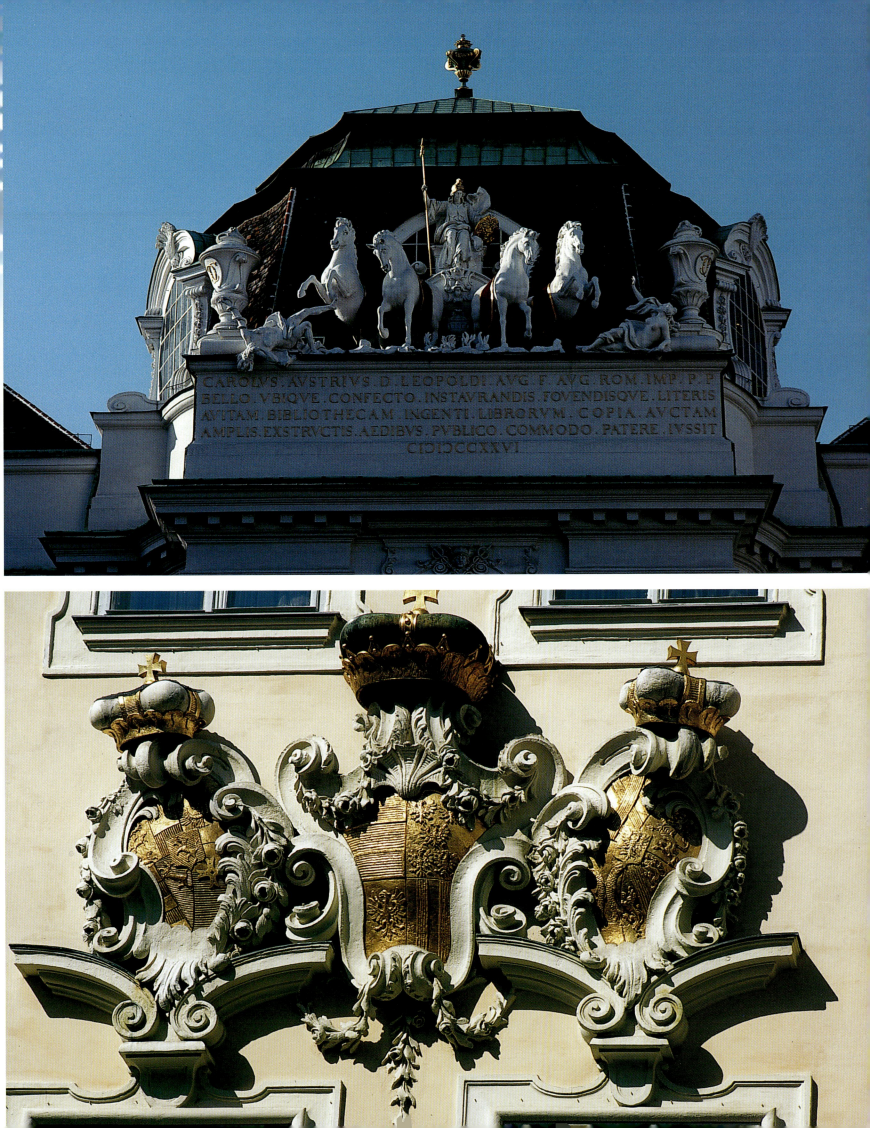

CAROLVS · AVSTRIVS · D · LEOPOLDI · AVG · F · AVG · ROM · IMP · P · P
BELLO · VBIQVE · CONFECTO · INSTAVRANDIS · FOVENDISQVE · LITERIS
AVITAM · BIBLIOTHECAM · INGENTI · LIBRORVM · COPIA · AVCTAM
AMPLIS · EXSTRVCTIS · AEDIBVS · PVBLICO · COMMODO · PATERE · IVSSIT
CIƆIƆCCXXVI

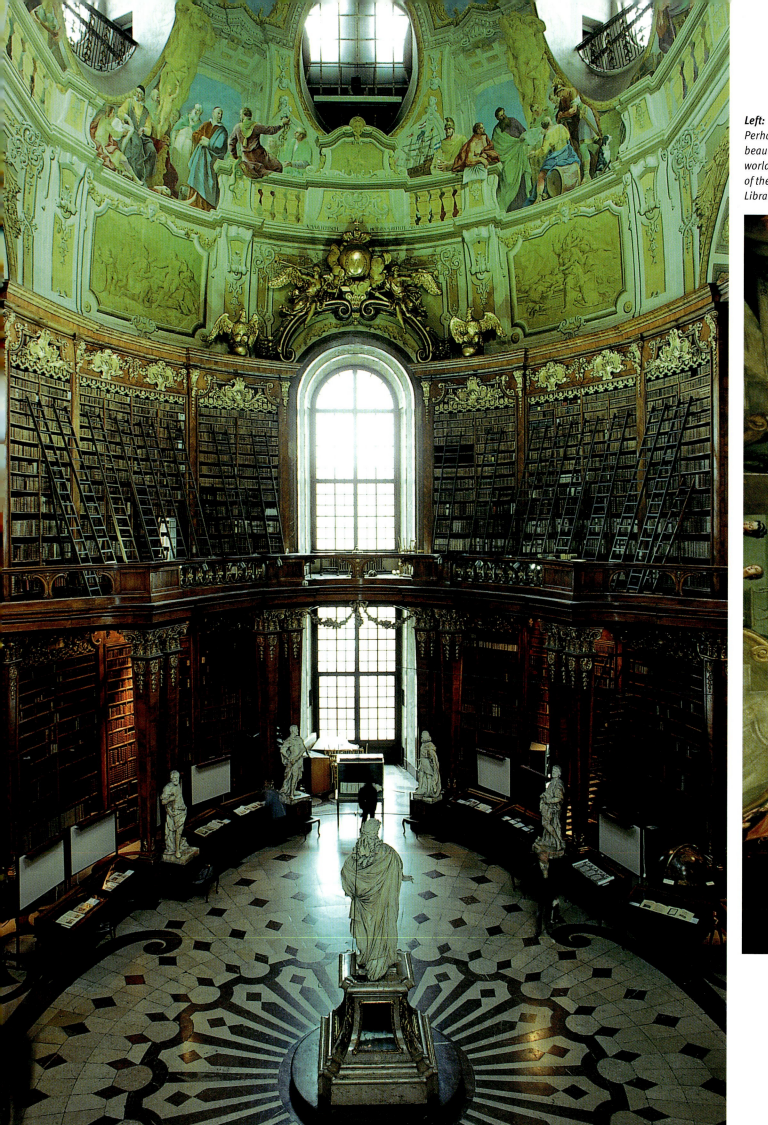

one of the most successful
rooms of the Baroque
period. The library
today possesses some
two million books and
40,000 manuscripts.

Below:
In the sumptuous Eroica
Hall in Palais Lobkowitz,
Beethoven conducted
precisely that »Eroica«
premiere for his patron
Prince Franz Josef Lobko-

witz beneath the allegories
of the arts which Jacob
van Schuppen had created
as frescoes. From 1735 on,
the palace was owned by
the eponymous Lobkowitz
family.

Page 58/59:
Vienna – the city in waltz
time. Johann Strauss
concerts, ballet perform-
ances and calls take place
in the »Kursalon« in the
Stadtpark.

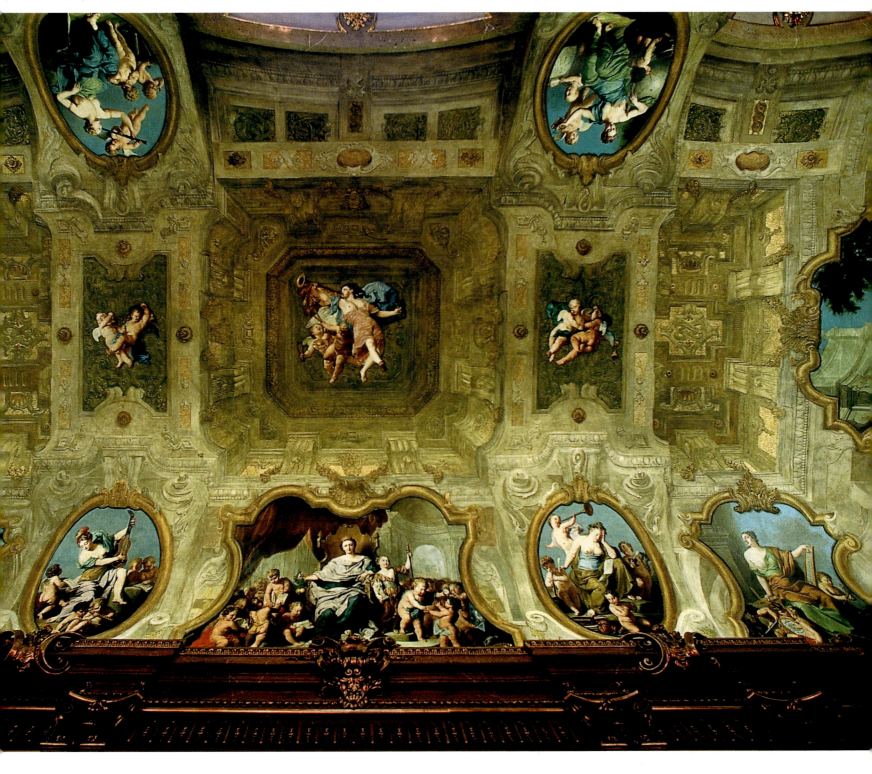

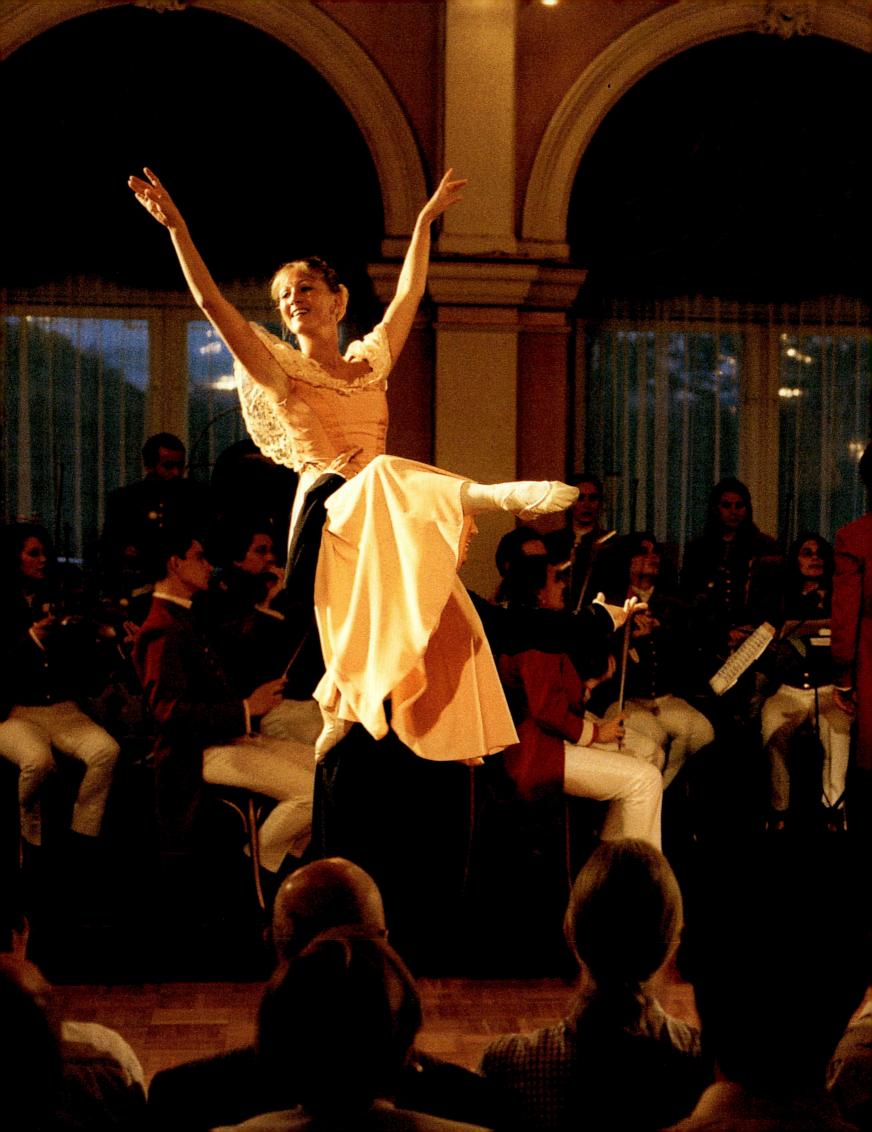

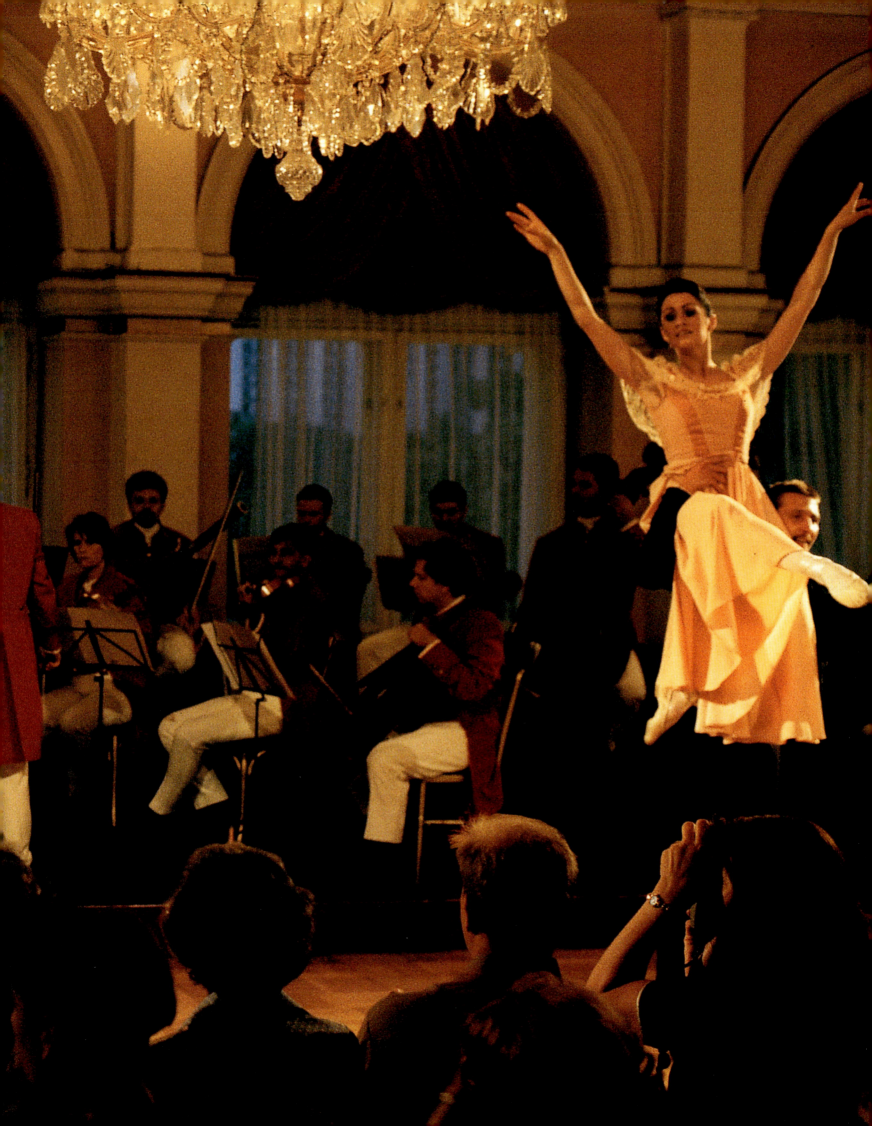

Bottom:

The shop interior of imperial and royal suppliers Knize is also by Adolf Loos and has remained unaltered to the present day. The gentlemen's outfitters is heralded as the founder of the first men's fashion label in the world and can boast crowned heads and international stars among its clientele. Oskar Kokoschka paid for his suits with paintings and even Marlene Dietrich had frock coats cut here for her stage shows.

Below:

You will find high quality jackets and shirts at the former court tailor's Knize & Compagnon.

Below:

You can have shoes made to measure at Rudolf Scheer & Söhne, purveyors to the Imperial and Royal Court.

Right:

An aura of the old imperial age still lies over the fairytale city of Vienna. Many former suppliers to the Imperial and Royal Court were able to safeguard their excellent reputation far beyond the borders of the country. For instance, J. & L. Lobmeyr, purveyors rich in tradition of exclusive glass chandeliers in Kärtner Strasse.

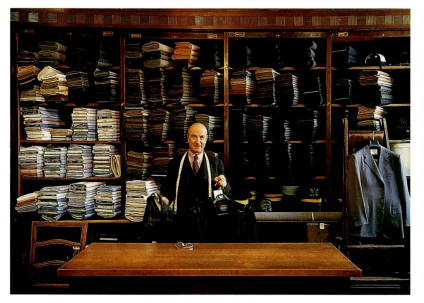

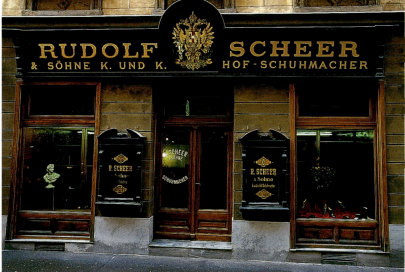

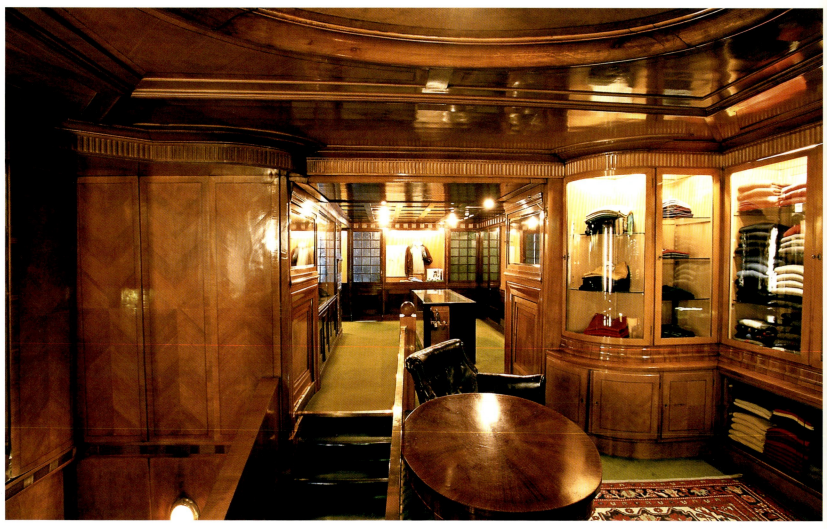

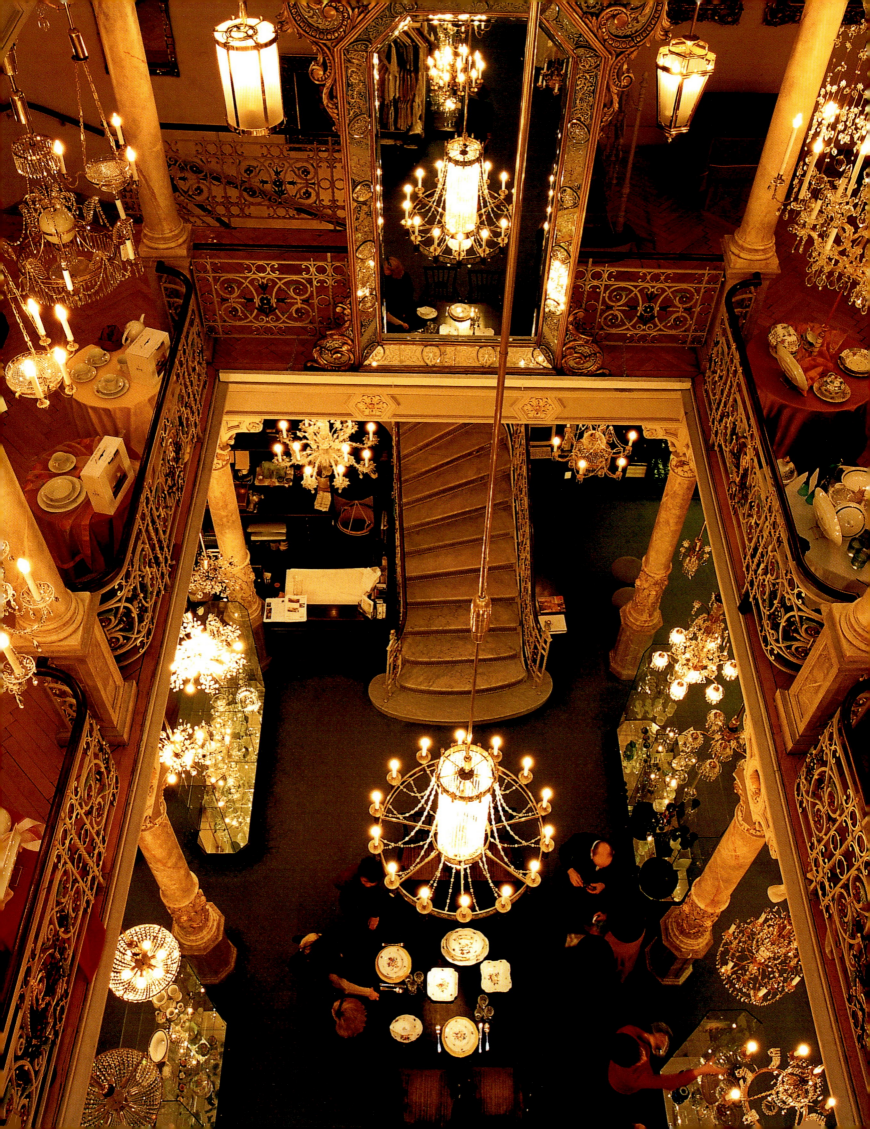

Left:
»Am Hof« (»At the Court«) – the name probably comes from the court of the Babenbergs who had a residence here and from the courtyard enclosing the complex of buildings. The column dedicated to the Virgin Mary has thrown its shadow at the centre of the splendid Baroque square since the end of the Thirty Years' War.

Below:
In front of the Schottenstift at Freyung stands the »Austria« fountain by Ludwig Schwanthaler with the personifications of the rivers Danube, Po, Elbe and Vistula, which were the main rivers in the age of the Monarchy.

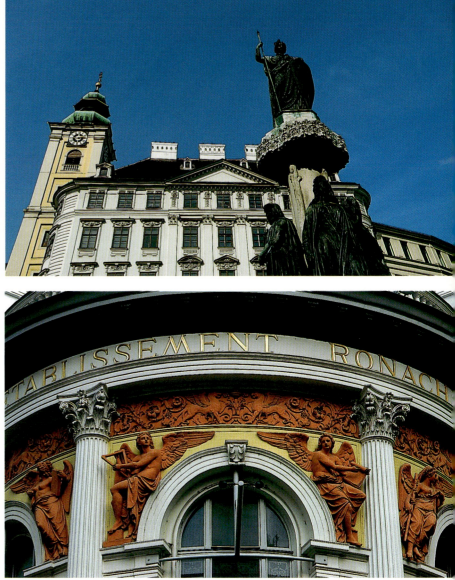

Above:
After the old Ronacher Revue Theatre closed its doors at Seilerstätte 9, Vienna was worried about its cabaret house. After years of uncertainty, financing was found for the expensive renovation of the »Etablissement« from 1888 and now musicals are given on the worthy stage here.

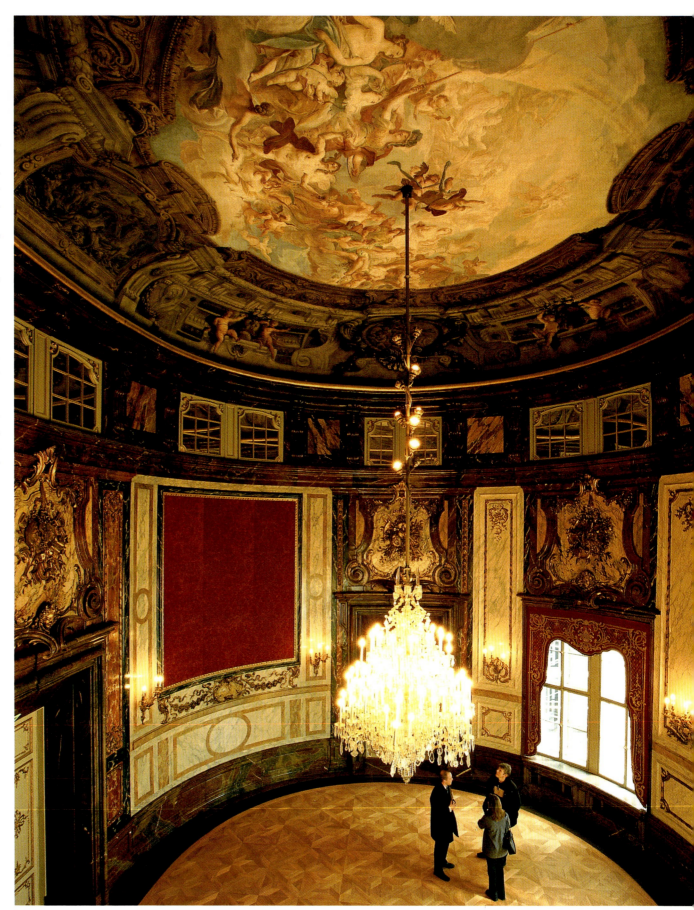

Right and right page:
Palais Daun-Kinsky was built in the years 1713–1716 by Johann Lukas von Hildebrandt and was his most sumptuous secular building after the Belvedere. The man who commissioned the work was Maria Theresa's father, Field Marshal Leopold Joseph Daun. It belonged to the counts of Kinsky from 1790 to 1986 and was extensively restored a few years ago. In the oval ball-room above the entrance hall (left page), often used for concerts, there is an allegorical ceiling fresco by Carlo Carlone. The walls of the room are clad in marble. The stylishness of its former owners is also manifest in the main staircase (right page), where the cycle of statues is by Lorenzo Mattielli. The cherubs are thought to have been fashioned by Joseph Kracker.

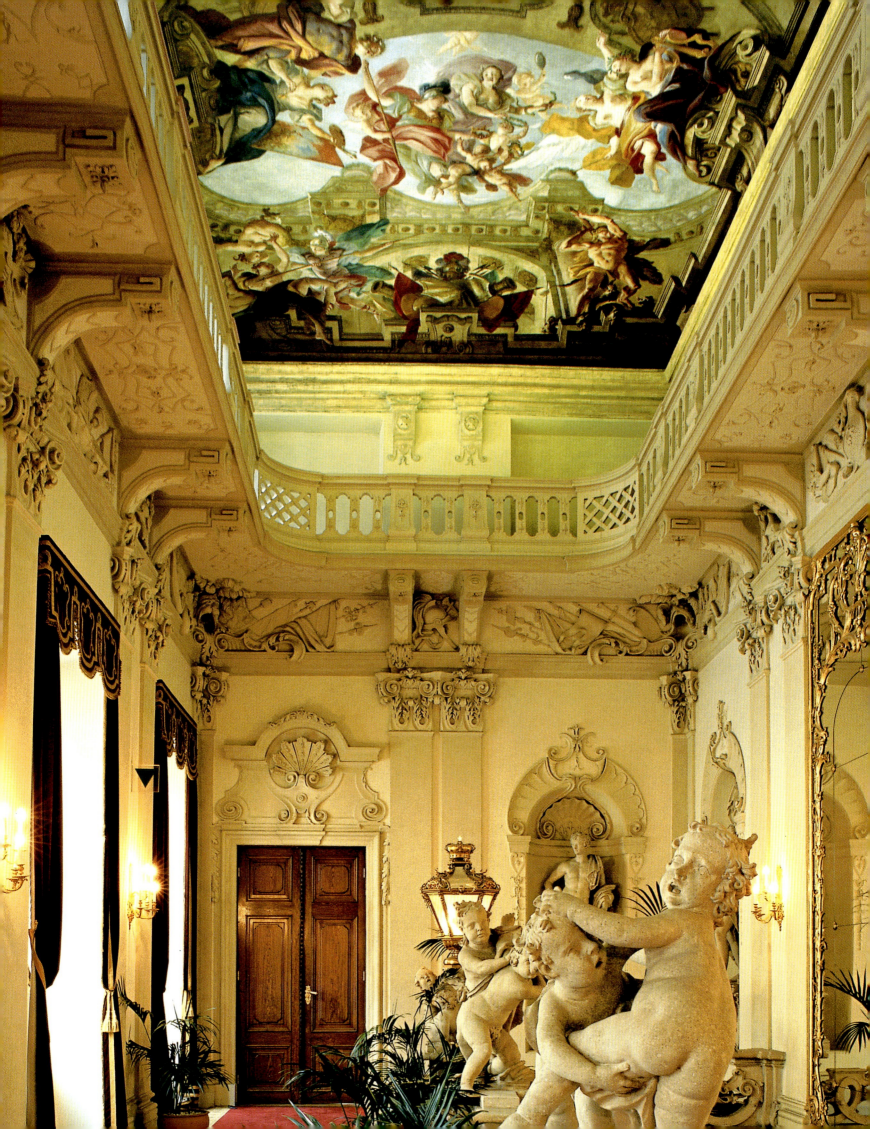

Operation Ringstrasse –
splendid buildings in a circle

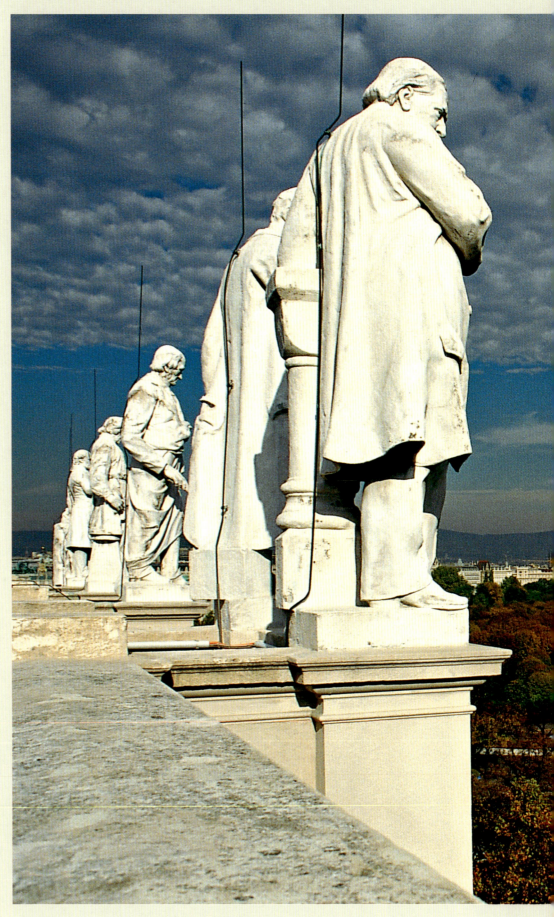

There where the Ringstrasse runs today lay, 600 paces wide, the glacis – a spacious belt of meadows, originally planned for military considerations. In fact, however, this area tended to be used for strolling and leisure. The first project for a »Ringstrasse« came from Ludwig Förster of Bayreuth. He called it »Wallstrasse« (»Rampart Street«) and thus was the first to notice a division of the city centre from the suburbs – in particular expensive Döbling, traditional, Biedermeier Josefstadt and Währing that has the best air quality in Vienna. The undertaking »Ringstrasse« lasted 54 years. It has probably paid off – the Parliament tells of Greek myths, the City Hall reminds of Gothic views of the world, the Burgtheater holds the classical playwrights, such as Schiller, Goethe and Grillparzer, in high esteem, the museums at Maria-Theresien-Platz house treasures from Rubens to Van Gogh and historical bone findings. The State Opera with its acclaimed performances proves the fact the Vienna is still the city of music, as also do the Konzerthaus and the Vienna Musikverein.

The guest in Vienna discovers new, daring exhibitions of art in the Museum of Applied Art (Museum für Angewandte Kunst). Of course, the Kunsthalle at Karlsplatz should also be visited; the »Secession« and the »20's house« as the Viennese are wont to casually call the Museum of the 20th Century (Museum des 20. Jahrhunderts). Completely in the trend of the new age. The Museum Quarter in the 7th District has set itself the task of interweaving the old and the new into a harmonic whole. There is so much art in this city that it appears difficult to see all the treasures during a short visit. But you should visit Vienna more often anyway. The city will be waiting for you ... just simply come again!

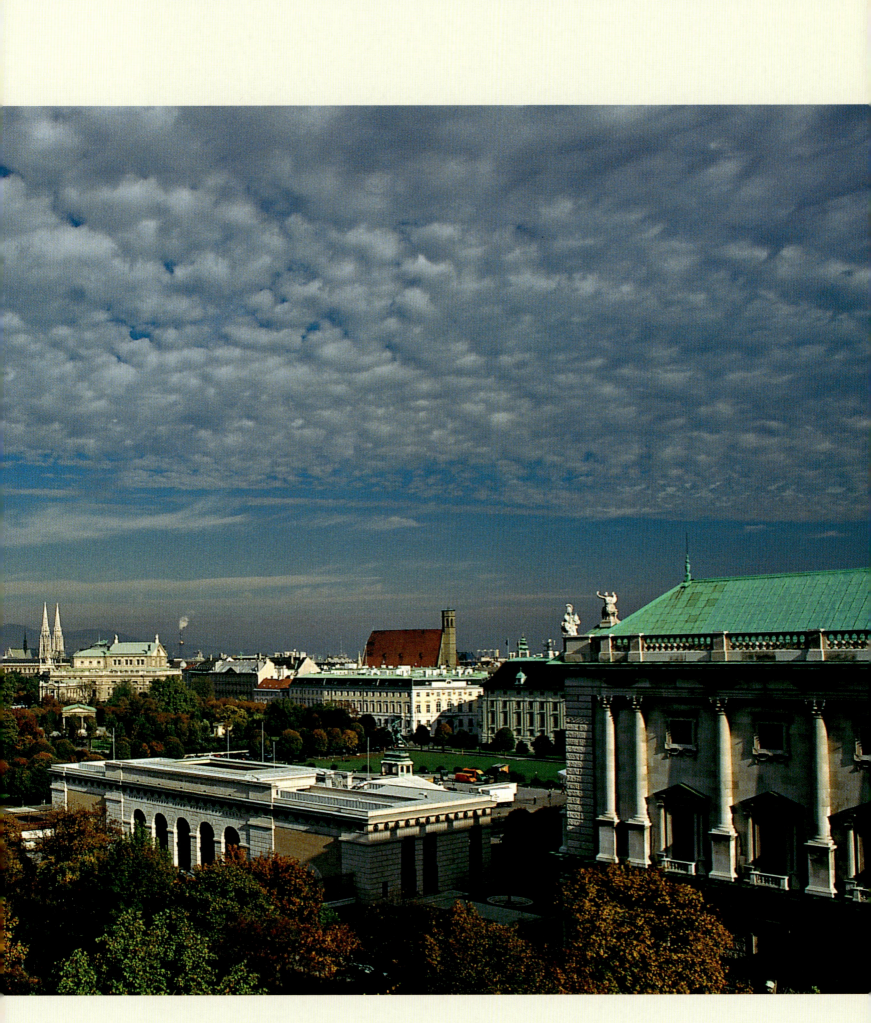

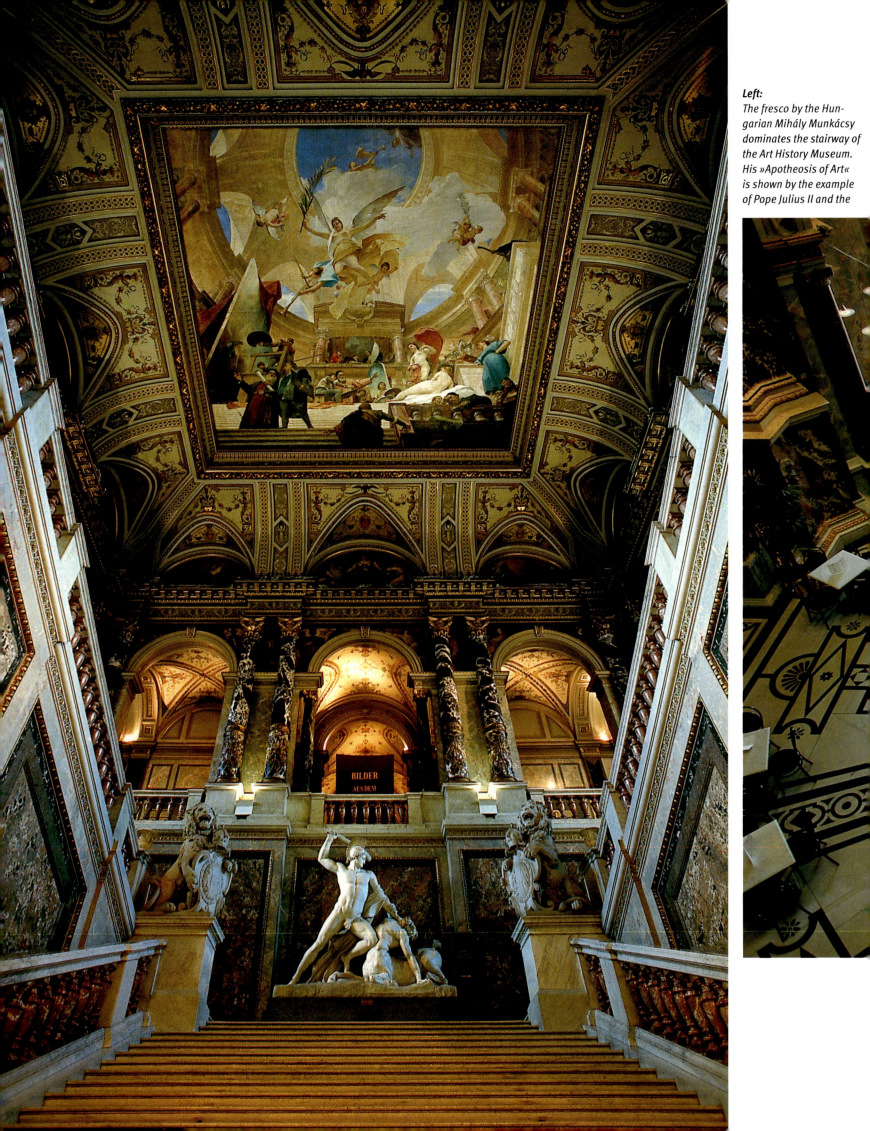

Left:
The fresco by the Hun-
garian Mihály Munkácsy
dominates the stairway of
the Art History Museum.
His »Apotheosis of Art«
is shown by the example
of Pope Julius II and the

Renaissance artists portrayed there. Such great names as Hans Makart, Ernst and Gustav Klimt as well as Franz Matsch collaborated on the small along the sides.

Below:
If you are exhausted by the rich collections of the Art History Museum, you can recover in the café beneath the dome where art lovers chat and discuss the works they have seen.

Page 70/71:
What does Claus Peymann, the former »Scandal Director« of the Burgtheater miss most about Vienna?

The aromatic coffee of course and – quite simply the Burgtheater. The building was constructed by Carl Hasenauer to plans by Gottfried Semper.

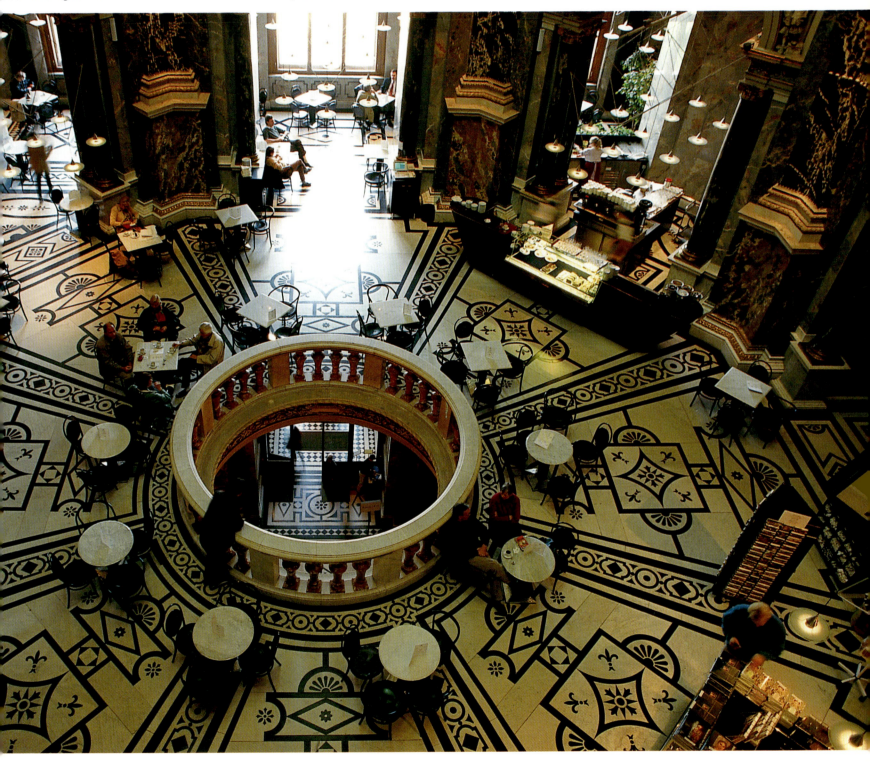

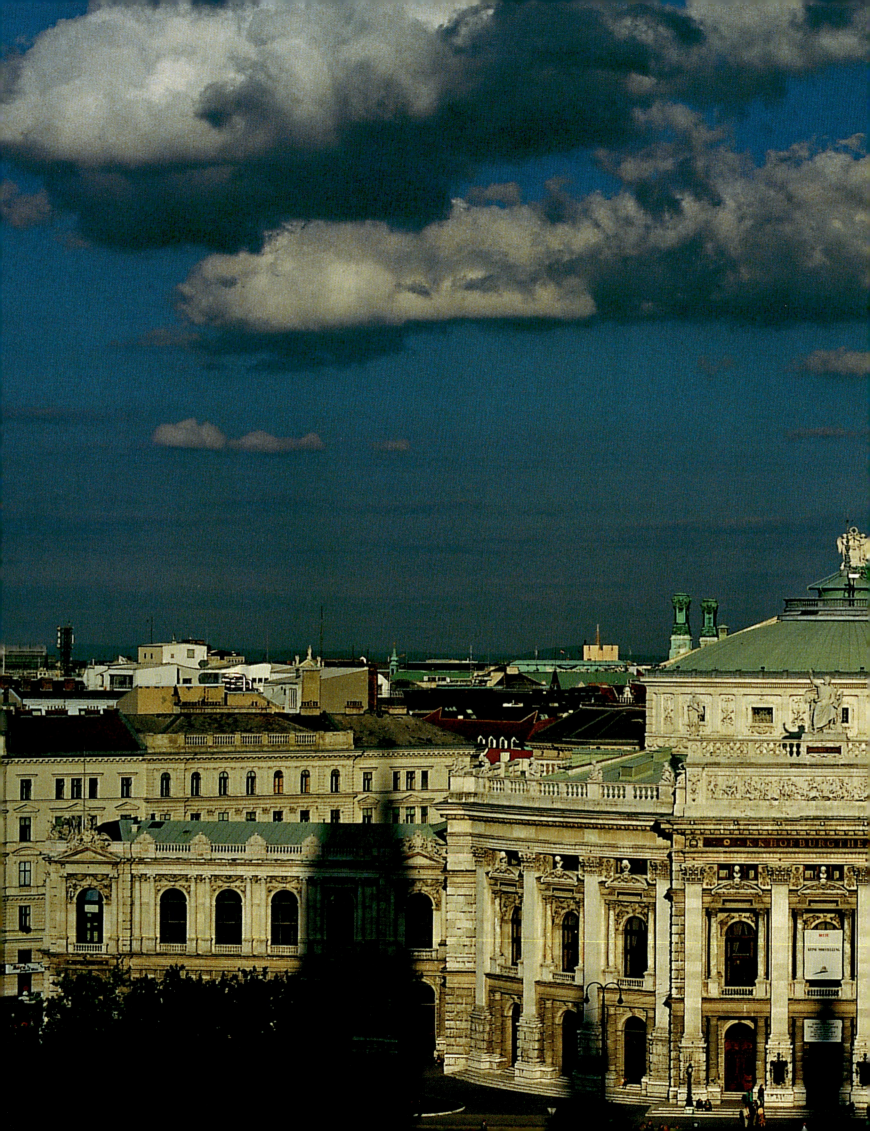

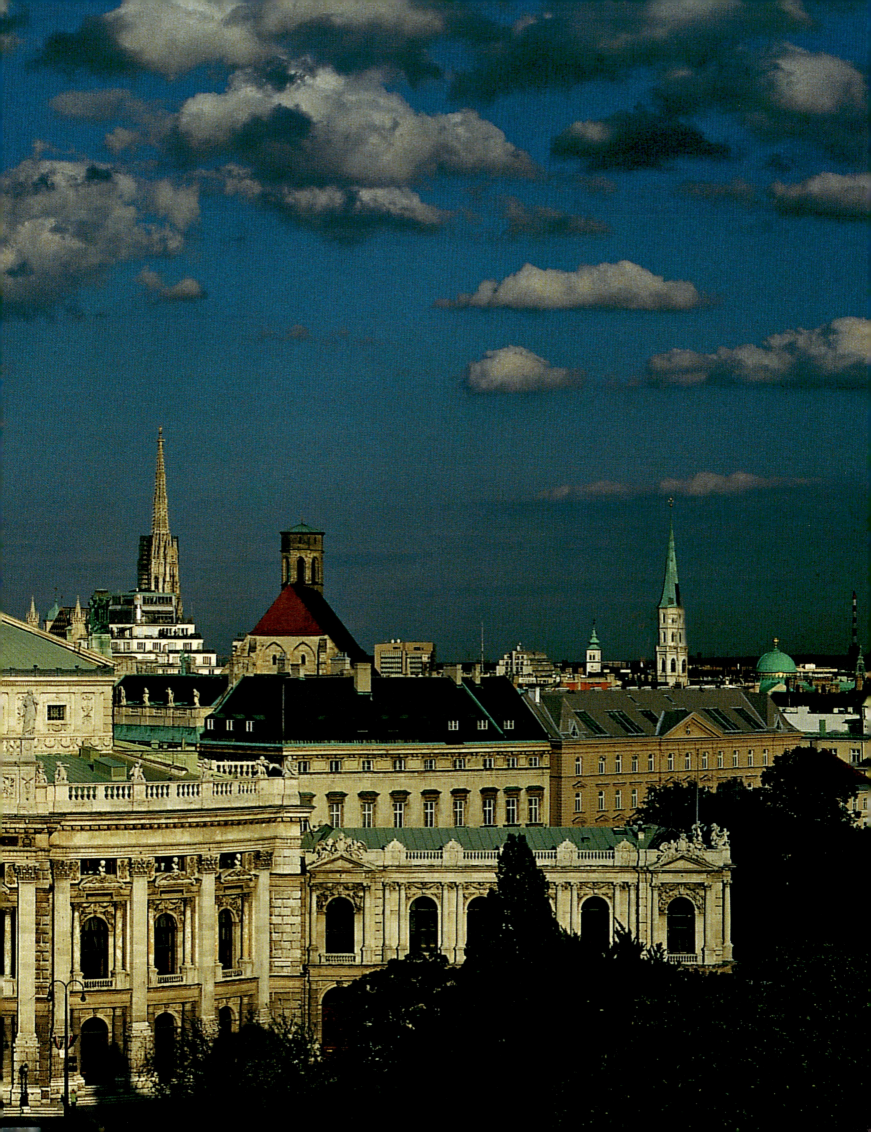

ABOUT THE KING OF THE WALTZ AND THE LOVE OF MERRIMENT

If other cities were planned with a serious expression, Vienna probably came into being to the rhythm of a waltz on an ivory-coloured sheet of music. Every few steps you find a commemorative plaque or a monument to a famous musician: Anton Bruckner at Dr.-Karl-Lueger-Platz, Ludwig van Beethoven with a serious expression seated on a stone throne at Beethoven-Platz, the opera reformer Christoph Willibald Gluck in the direct vicinity of Karlsplatz and in front of the church of Mary Help of Christians (Mariahilf) Joseph Haydn, who was not a real Viennese, but without whose help the Viennese music scene would have been much poorer. Josef Lanner, Franz Lehár, Gustav Mahler, Arnold Schönberg, and so forth... Opera, operetta and waltz belong, quite as a matter of course, to everyday life in this city. Although Strauss, Mozart, Schubert and Lanner have long since found their repose, the melodies, which do not allow any Viennese to sit still, live on in a freshness which is un-paralleled.

The »forefathers« of the waltz – the dance was even banned for a short time on account of its erotic effect – were called Josef Lanner, a famous dance violinist of the Biedermeier period, and Johann Strauss father. It was only through these two that the waltz became a genre of its own. The sons, Johann, Eduard and Josef Strauss, then chose this melody to be an essential element of the Viennese operetta. They succeeded with this to such utter perfection that waltz music soon found its way into art music and Chopin, Brahms and Berlioz took pleasure in this style. Johannes Brahms expressed his respect in a particularly original manner in that he scrawled on the sheet of music of the »Blue Danube Waltz« the remark: »Regrettably not by me!«

Right down to today, people most like to dance waltzes at the numerous Viennese balls. During the Opera Ball, which takes place annually in the opera on the Thursday before »Fasching Sunday« (the climax of the pre-Lentan Carnival season), the stage and the stalls are converted into one huge dance-floor for one night, more than one hundred pairs of debutantes in long evening gowns and with their partners in evening dress open the ball in the presence of the federal president with the left-wheel waltz. Special experts impress their friends with a left-wheel waltz, performing it on a space of just forty times forty centimetres – the most daring even dance this »Rag waltz« on a table. A subscription ticket for the Konzerthaus,

Musikverein or the State Opera is a matter of course for many Viennese. Here they do not dance, but listen attentively. Emperor Francis Joseph I laid the commemorative final stone for the Musikverein in the Börsendorferstraße in the city centre before the turn of the 20th century. The New Year's Concert of the Vienna Philharmonic, that is broadcast world-wide annually, resounds in that building's breathtakingly decorated Golden Hall. The Vienna Konzerthaus was not constructed until 1913, also under Francis Joseph. Today it is the home of the Vienna Symphony Orchestra which gives its concerts here each year. Of course, the public feels most elegant in the Vienna State Opera. It was constructed in the years 1861 to 1869 as the former »Court Opera Theatre« and opened with a performance of Mozart's »Don Giovanni«. None less than Gustav Mahler, Richard Strauss, Herbert von Karajan, Karl Böhm and Lorin Maazel were directors here.

Only one of many – Franz Schubert

Inseparably linked with one another: Vienna and Franz Schubert who let himself be inspired by this city and its inhabitants to compose over 600 (!) Lieder which are still sung today by »Heurige« singers. We have him to thank for the »Trout quintet« and other chamber music works. If the »Schubertiades« are interpreted in serious works on the history of music as musical evenings, this only corresponds in part to the truth. Because as the Viennese's recollection knows, the »Schubertiades« consisted to over eighty percent of impetuous drinking bouts in Grinzing, Nussdorf and Neustift which young Schubert »survived« together with his writer friend Franz Grillparzer, the painter Moritz von Schwind and the conductor Franz Lachner. Like many of his fellow musicians, Schubert also found blissful inspiration at the »Heurige«.

72

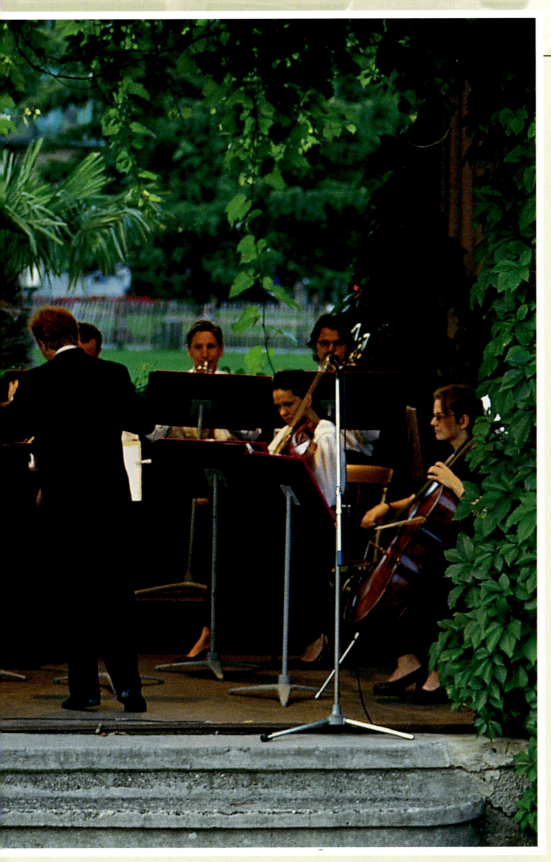

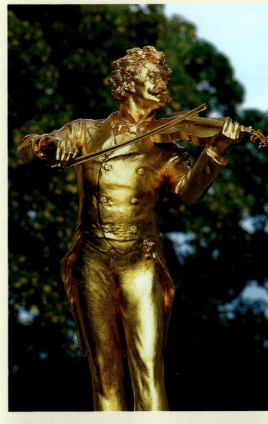

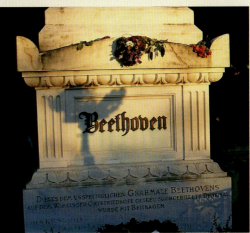

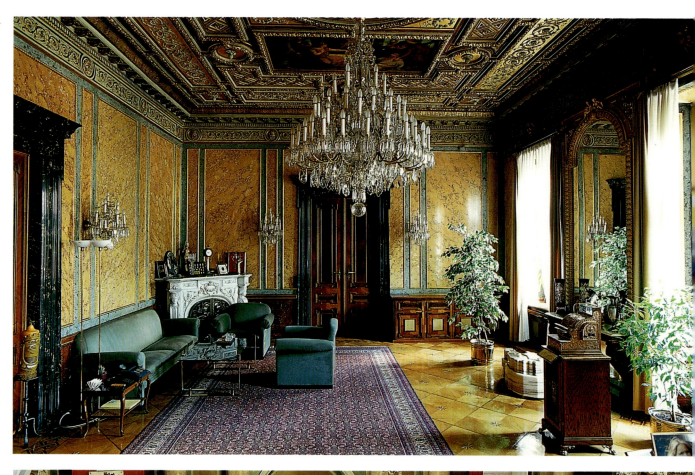

The former grand hall of the Palais Ephrussi has been preserved in all its splendour with frescoes and crystal chandeliers. Today the rooms for representation of Casino Austria are here. Regrettably they are not open to the public.

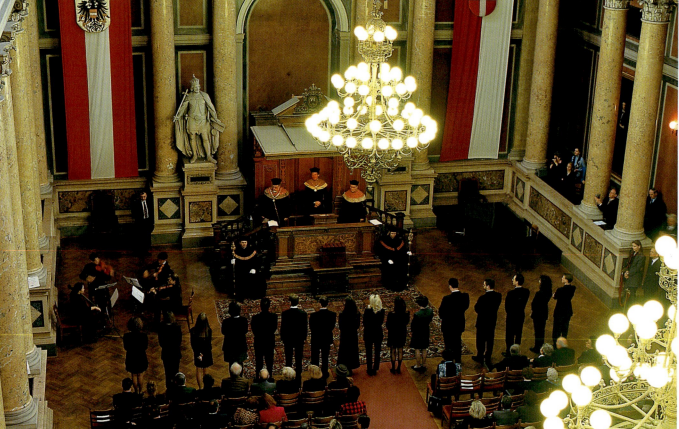

The award of the title of doctor in the grand hall of the University at Schottenring is not just an intellectual achievement, but also a feast for the eye. The »Alma Mater Rudolfina« is one of the oldest universities in the German-speaking countries.

The grand hall of the former Vienna Stock Exchange with its calm interior architecture is a much sought venue for events.

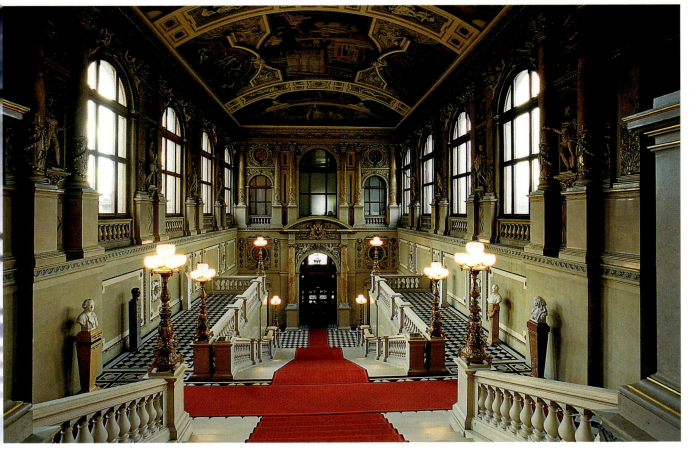

In the Burgtheater you can enjoy the imposing entrée with its sumptuous Baroque interior decoration. The frescoes are by Gustav and Ernst Klimt as well as Franz Matsch.

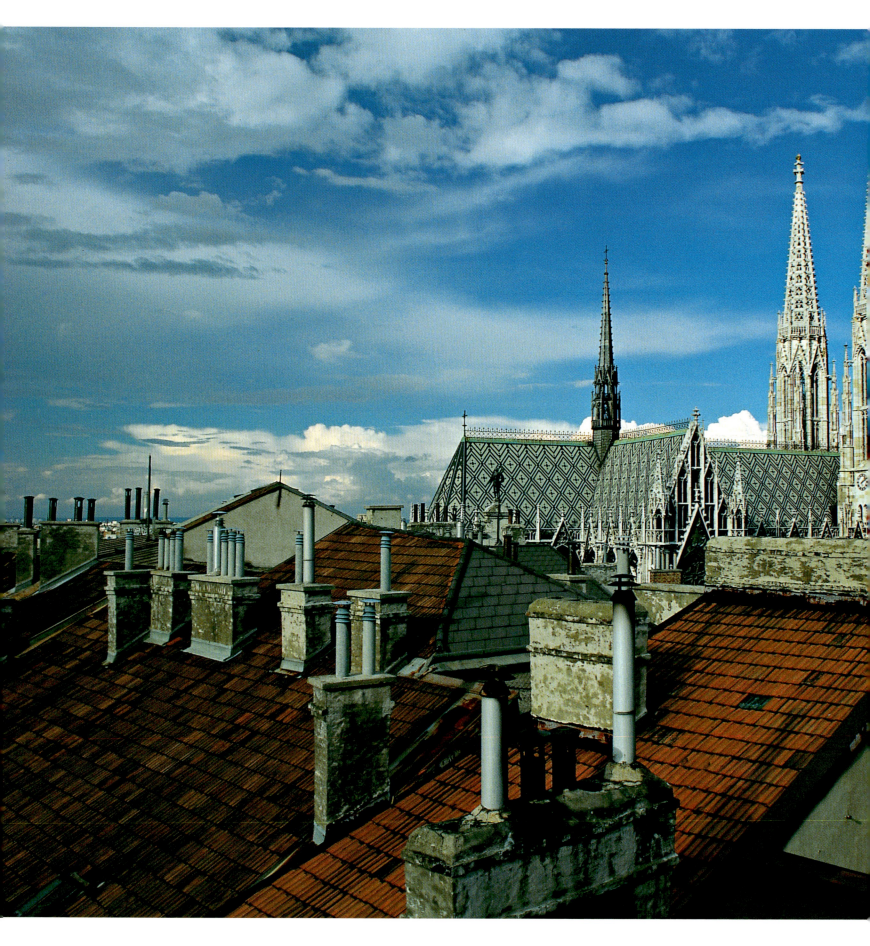

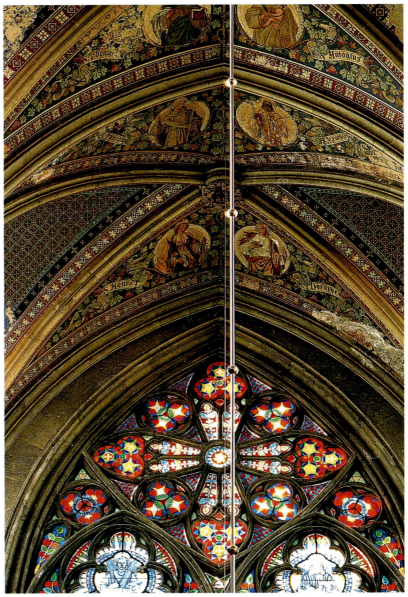

Left:
Above the roofs of Vienna: the Votivkirche with its 99 metre high spires. The neo-Gothic first work by Heinrich Ferstels was constructed between 1856 and 1879 in thanksgiving for the failure of an assassination attempt on Emperor Francis Joseph in 1853.

Above:
Planned as a »sacral Pantheon of the Monarchy«, the windows and frescoes inside the Votivkirche »Of the Divine Saviour« are marked by the topic of national ecclesiastical history, here in the south side aisle.

Below:
Vienna is different.
Numerous festivals
which enliven the city
throughout the summer
prove tolerance and
pleasure in exuberant
celebrations.

Whereas, in days of yore, Emperor Francis Joseph would ride through the Outer Castle Gate daily in order to go »home« to Schönbrunn, today it is only the fiacres and taxi cabs which may drive along this fashionable route.

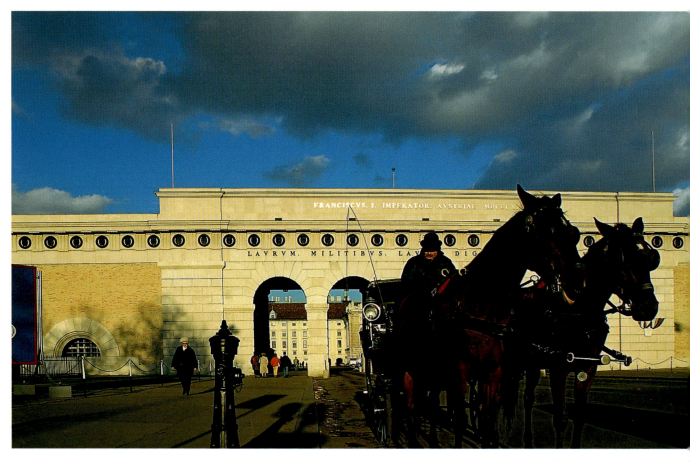

Sometimes on a Sunday morning you are lucky and there is little traffic in the Ringstrasse in front of Parliament so that the ride with the fiacre is quite peaceful.

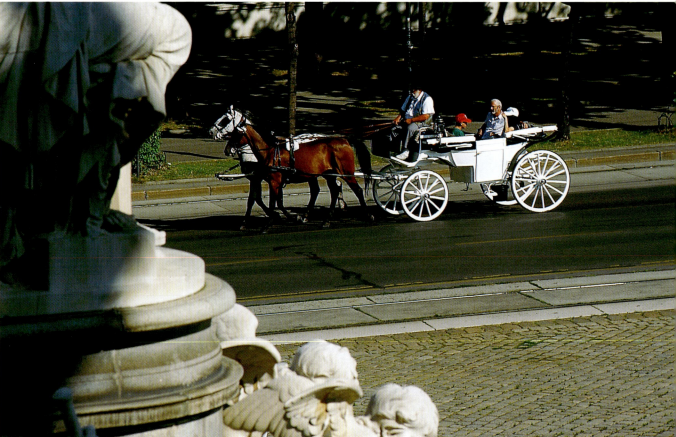

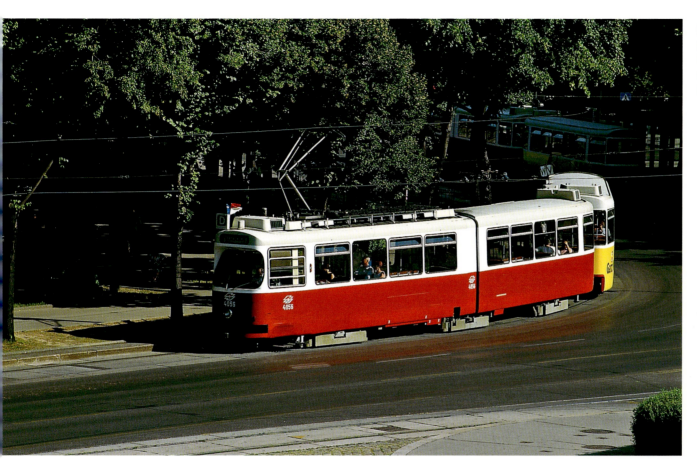

The tramcar is painted in the same colours as the Vienna flag: white and red (here in the curve of Dr. Karl Renner Ring).

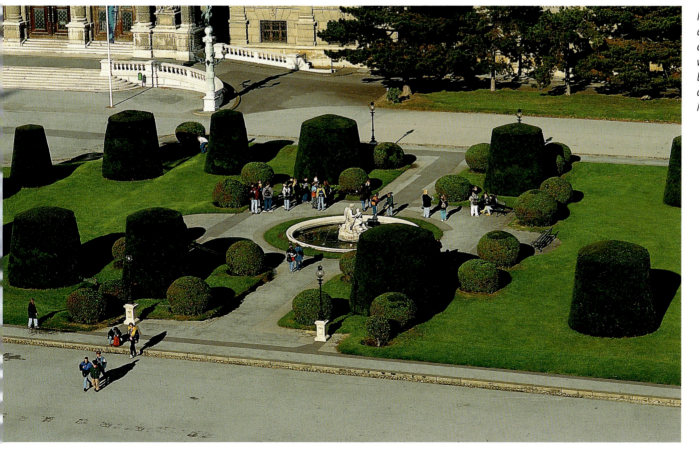

In addition to the fountain, a monument in honour of Empress Maria Theresa was erected in the square between the Art History and Natural History Museums.

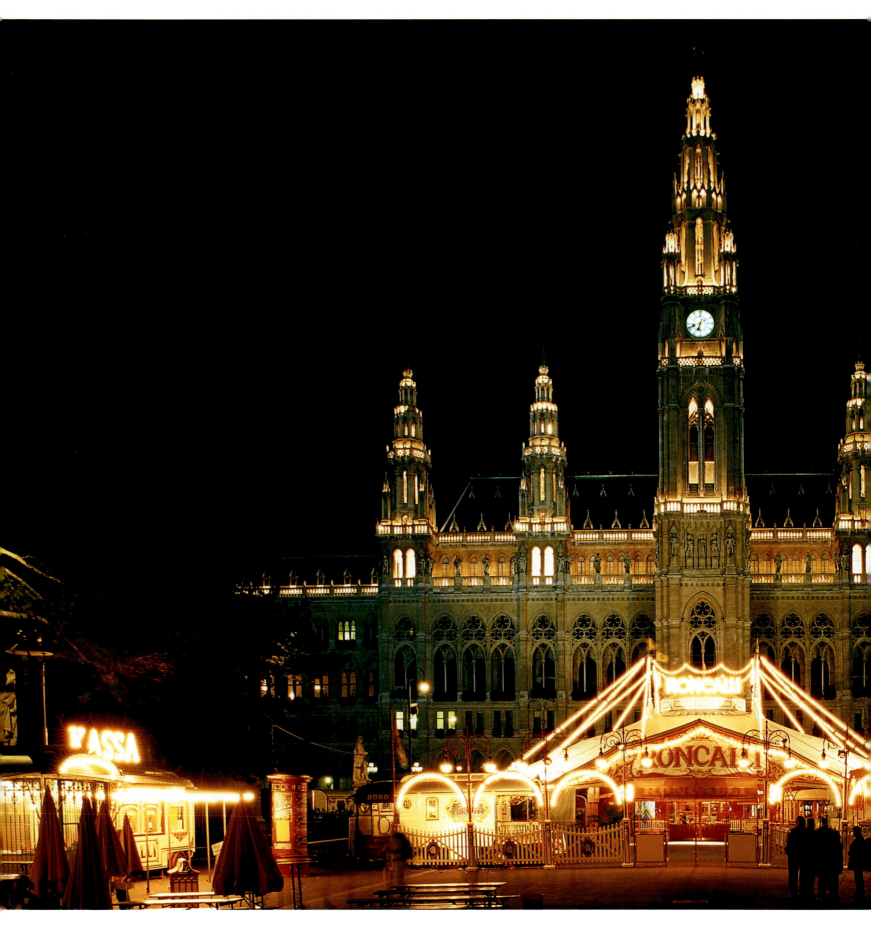

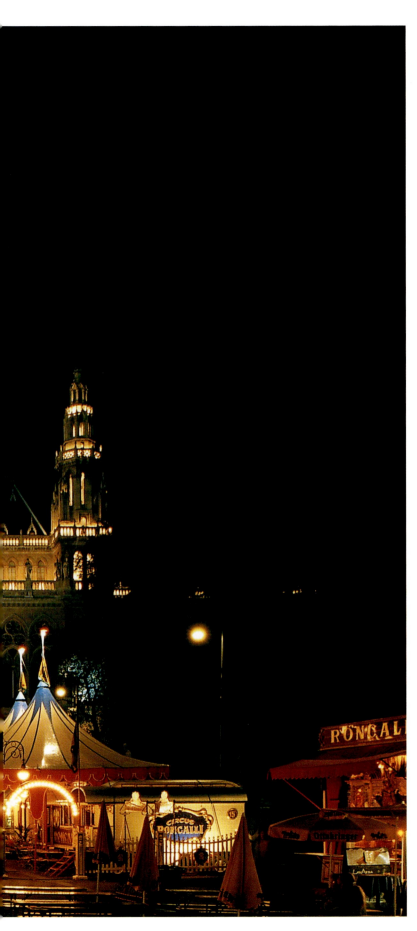

Left:
Five spires decorate the neo-Gothic façade of Vienna City Hall. With a height of 98 metres the dominating central tower is, it is true, one metre shorter than the spires of the Votivkirche, but then the statue at the top outdoes the church. The square in front has become a focus of the Viennese event scene: here with a festively illuminated circus tent.

Below:
Ideal framework for the Young Citizens' Ball: the great hall of Vienna City Hall. Festively decorated, the hall reveals a tremendous perspective effect.

Page 84/85:
The view into the counter hall of the Post Office Savings Bank shows Otto Wagner's endeavour to recollect the essential: »Nothing that is not useful can be beautiful.«

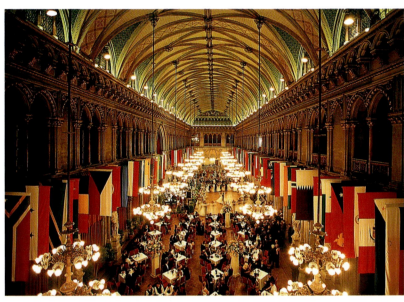

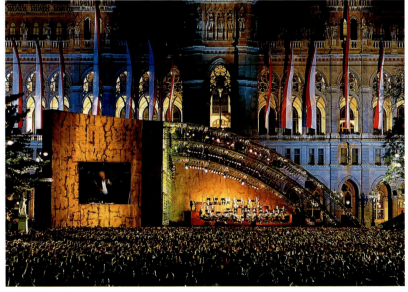

Above:
The City Hall is also a splendid backdrop for concerts of the Vienna Festival, here at the opening in 2001 – there is always something going on at Rathausplatz.

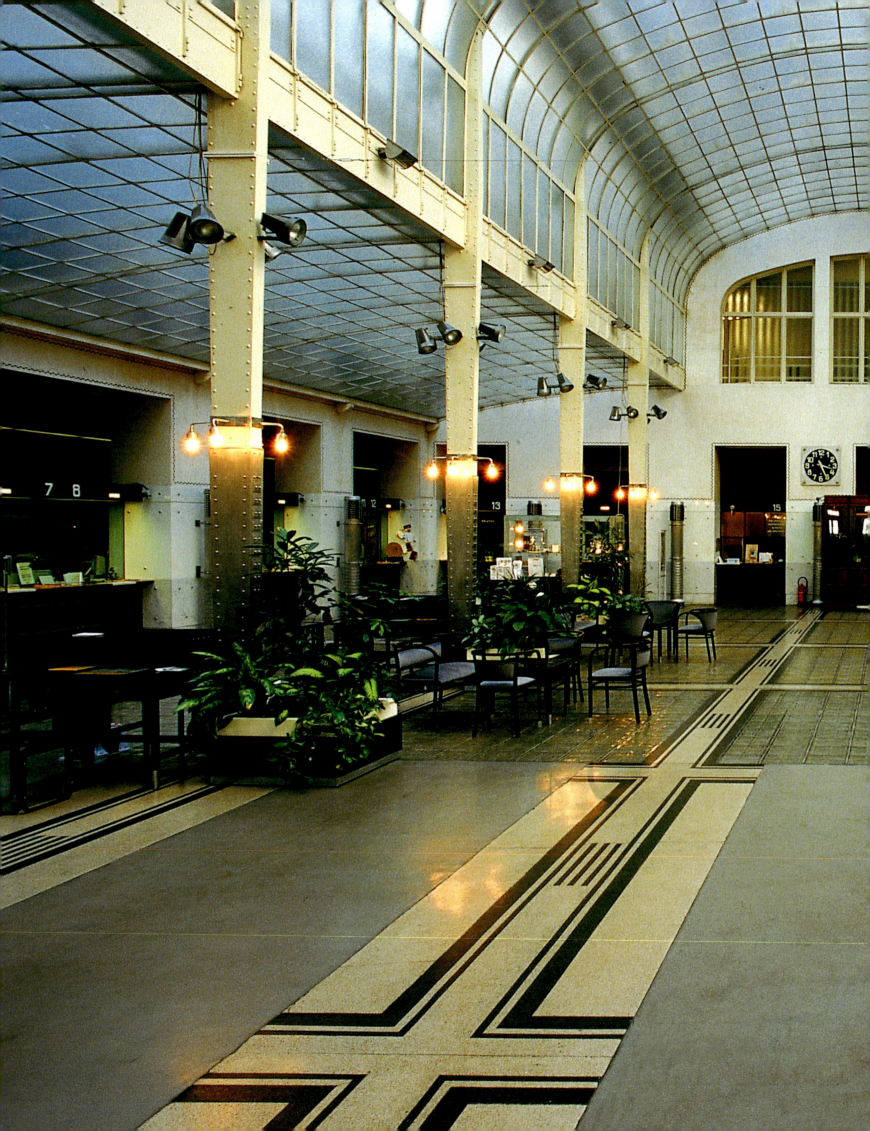

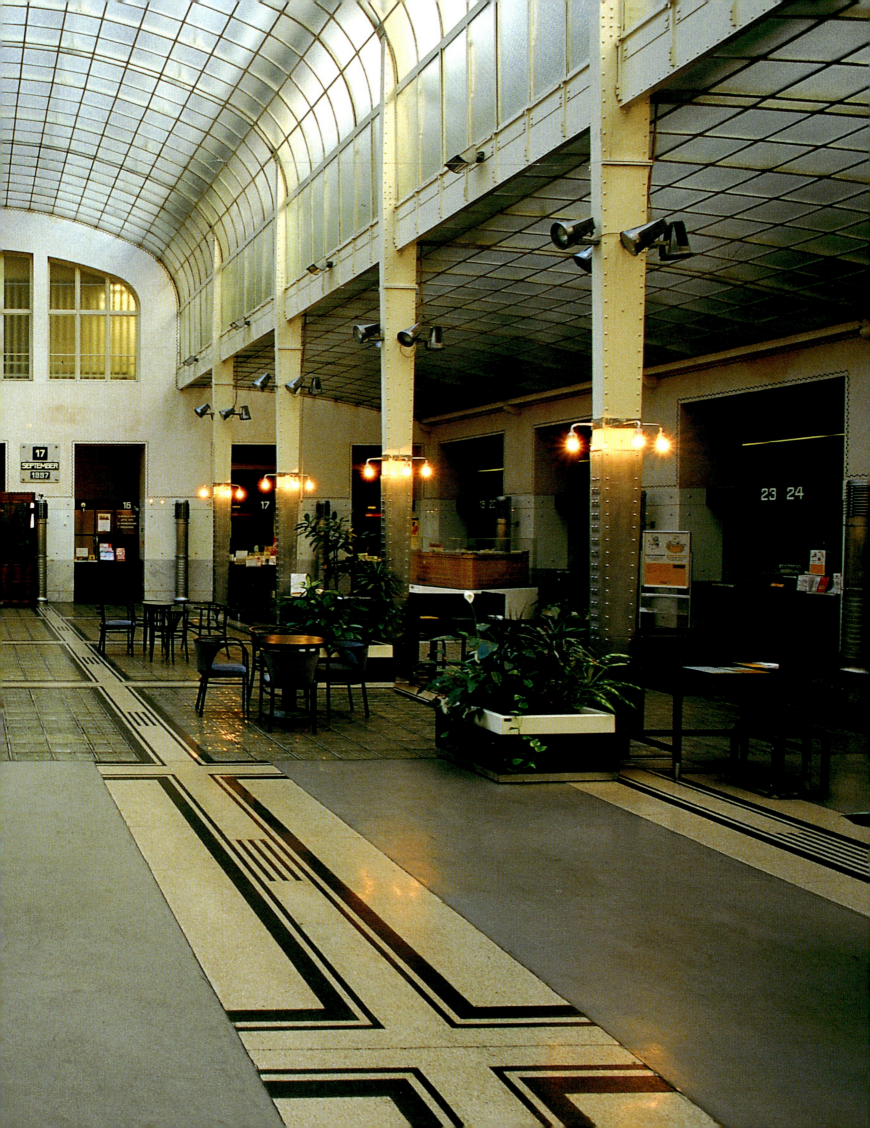

Jugendstil – a Viennese »classic«

I n Vienna you need eight eyes and six hands«, Empress Maria Theresa observed, thinking perhaps also of the city's impressive buildings and monuments. If you just stroll through Vienna, the architecture first gives pleasure through its refreshing variety: Parliament with its Hellenistic-Roman forms, the Gothic City Hall, the Renaissance-like Opera House, cosy, Biedermeier-like dwelling houses, elegant, Classicist façades, there is scarcely a direction of style which cannot be admired here. The Viennese would thus not need to further get worked up about a further building which included alien elements, if this »Critique of the self-created« were not one of the Viennese's favourite hobbies. It is therefore no wonder that the form of the Secession, a museum for »young« art was followed with particular consternation. There was something »new«, something that did not divulge its roots and, in addition, was borne by a group of committed artists who declared themselves at the top of their voices as being »Art nouveau« artists and who did not want to know anything more of artists' »normal« tradition. Vienna was not, it is true, the only starting point of this new »Art of youth«, because similar trends were beginning to appear in the whole of Europe. However, Vienna produced outstanding architects, designers and painters in this field and developed into a kind of centre of Jugendstil. Although the period of Jugendstil was so short (1890–1910), it was style-shaping and forward-looking, particularly for architecture.

»Golden head of cabbage« – and the most elegant urban railway in the world

The Secession at the intersection between the Naschmarkt and Karlsplatz, as the representative exhibition building of that time, is still the place for provocative exhibitions. This new, daring, cubic form reappeared later in many

designs, whether in a Klimt painting or a silver teapot by Josef Hoffmann. If the building reminded the Viennese of an Assyrian tomb, they were even more sceptical about the decorative dome – a golden foliage structure in spherical form. But humorous as the Viennese are, in the course of time they have come to accept and finally like the dome giving it the amusing nickname »golden cabbage« – today, of course, every Viennese is proud of the outstanding achievement by the architect Josef Olbrich.

The name »Secession« itself comes actually from Munich when a »new« group of artists seceded there in 1892. Vienna only followed this trend later – aroused and inspired by an artist whose works became world famous: Gustav Klimt. Initially still captivated in the old-fashioned style of Hans Makart, he then painted touching, extremely bold pictures, with gold leaf and, above all, the ornament playing an important role. However, Klimt was not always respected. When he completed the ceiling fresco for the old university building in Vienna around the turn of the century, the public was not prepared to show this work the recognition which it had deserved. In 1904, Gustav Klimt resigned from the Secession which he had co-founded and from then on painted in seclusion.

The Austrian Otto Wagner made Vienna a present of 36 splendid urban railway stations in this new style. A wonderful achievement, particularly in view of the fact that Wagner liked to take care of every detail himself, although he had staff of over a hundred. If the visitor to Vienna lets himself be seduced to an acknowledging nod at most, of course, by the lovely floral lines and forms, and now by the colours that have become brilliant again through restoration, connoisseurs know of Wagner's truly pioneering ideas. For instance, in the case of Karlsplatz station: by using prefabricated sheets in a steel angle frame, he anticipated the prefabricated form of construction still common today.

Jugendstil fans will find something of the brilliance of this short, stormy decorative period in all districts of Vienna, but probably most frequently in the first, fourth, seventh and eighth districts. So, it's quite simple: march off along Lerchenfelderstraße, Josefstädterstraße, Kärtner Straße, Kohlmarkt and Graben, holding your head up and keeping your eyes open!

Left:
Otto Wagner's urban railway station Friedensbrücke on the Danube Canal line looks almost like the entrance to a Turkish bath.

Above:
Otto Wagner designed such stylish buildings as the stations for the Vienna Urban Railway that they have been carefully restored and, such as here at Karlsplatz, been transformed into inviting cafés.

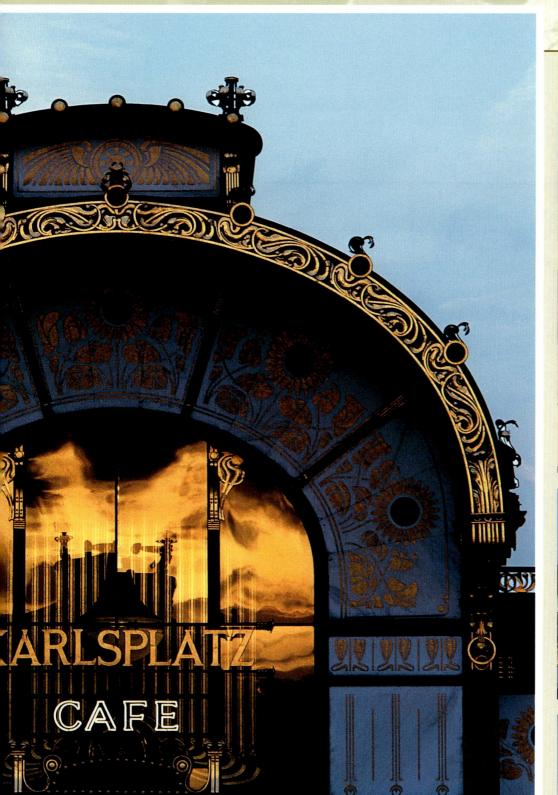
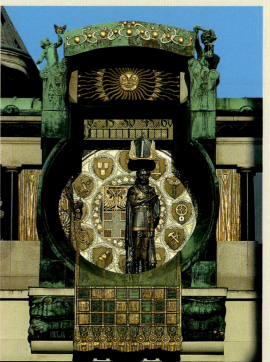

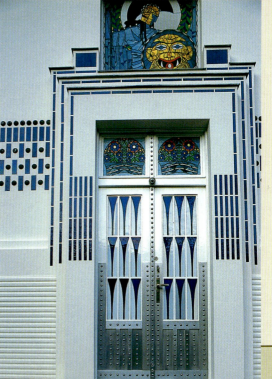
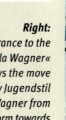

Right top:
The carillon of the Anker Clock at Hohen Markt in the Inner City does not just entice with cheerful sounds, but also with an interesting spectacle. At each hour, a different figure moves to the centre of the dial. The creator of the clock in 1911 was Franz von Matsch.

Right centre:
The Post Office Savings Bank is a timelessly beautiful and practical building which Otto Wagner realised between 1904 and 1906. An original feature of the functional building are the 1700 rivets which hold the marbles and granite slabs of the façade in their place.

Right:
The entrance to the »Second Villa Wagner« already shows the move away by Jugendstil architect Otto Wagner from the round form towards squared stone masonry and a restrained colour scheme.

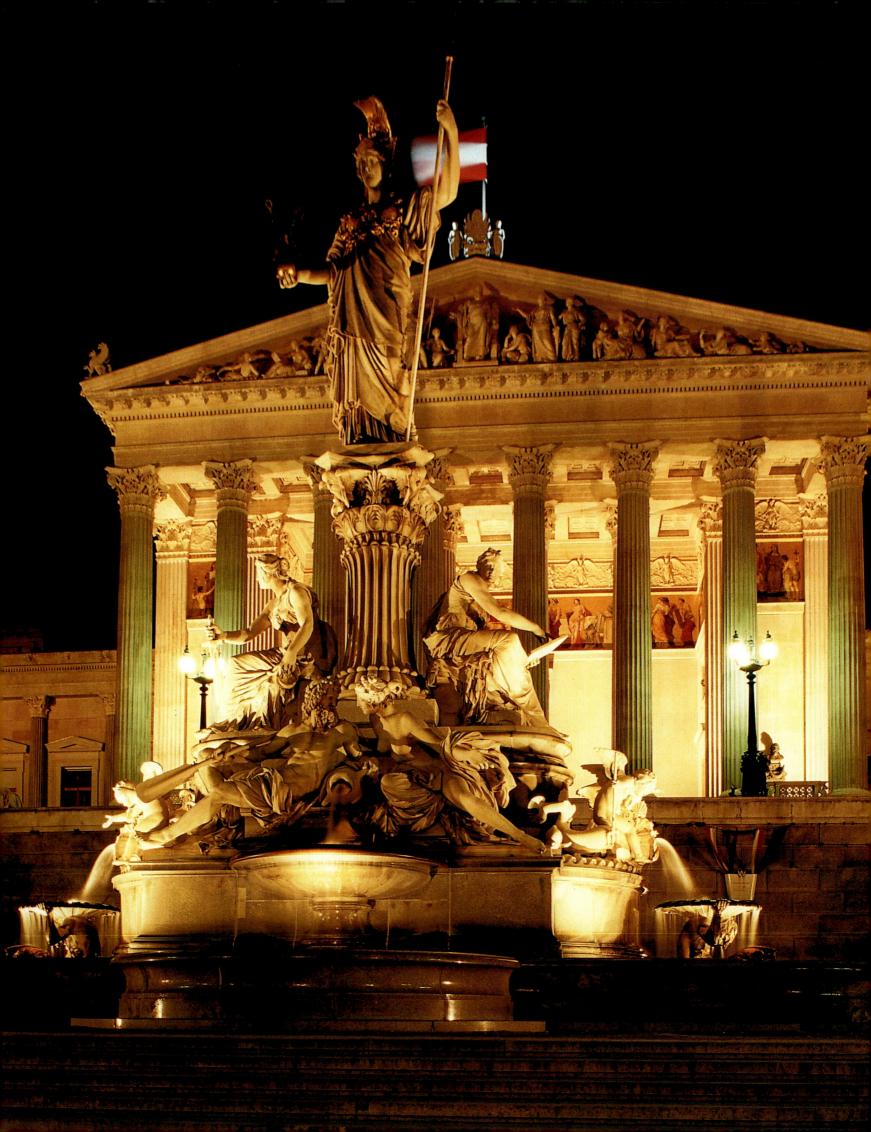

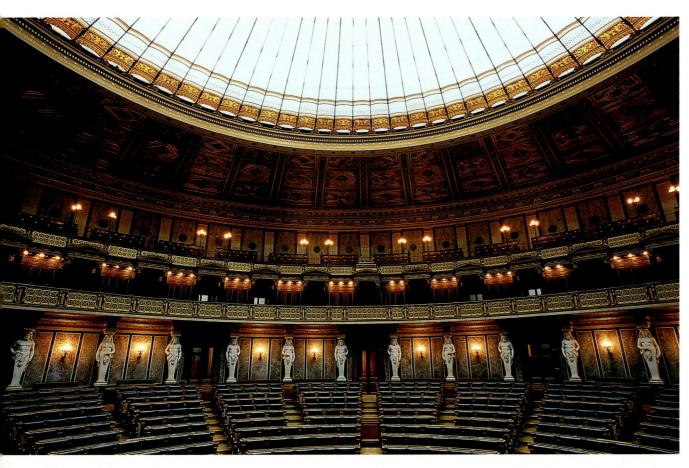

Left page:
The Greek goddess Pallas Athena as the symbol for wisdom and justice watches in front of the Parliament constructed in Greek style. The Danish architect Theophil von Hansen may well have had the »Dream of Greek democracy« before him when he constructed the building between 1873 and 1883. The design for the Athena fountain is also by him.

The grand chamber of the Parliament, the former House of Deputies, almost reminds one of a Greek theatre.

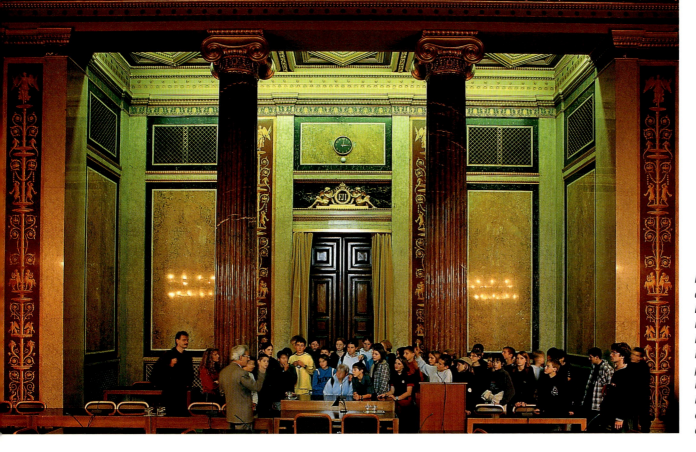

Interested schoolchildren are guided through the Budget Hall of the Parliament by members of Parliament. Under the impression of the mighty pillars, one would not imagine that nowadays it is probably mainly economy measures that are discussed here.

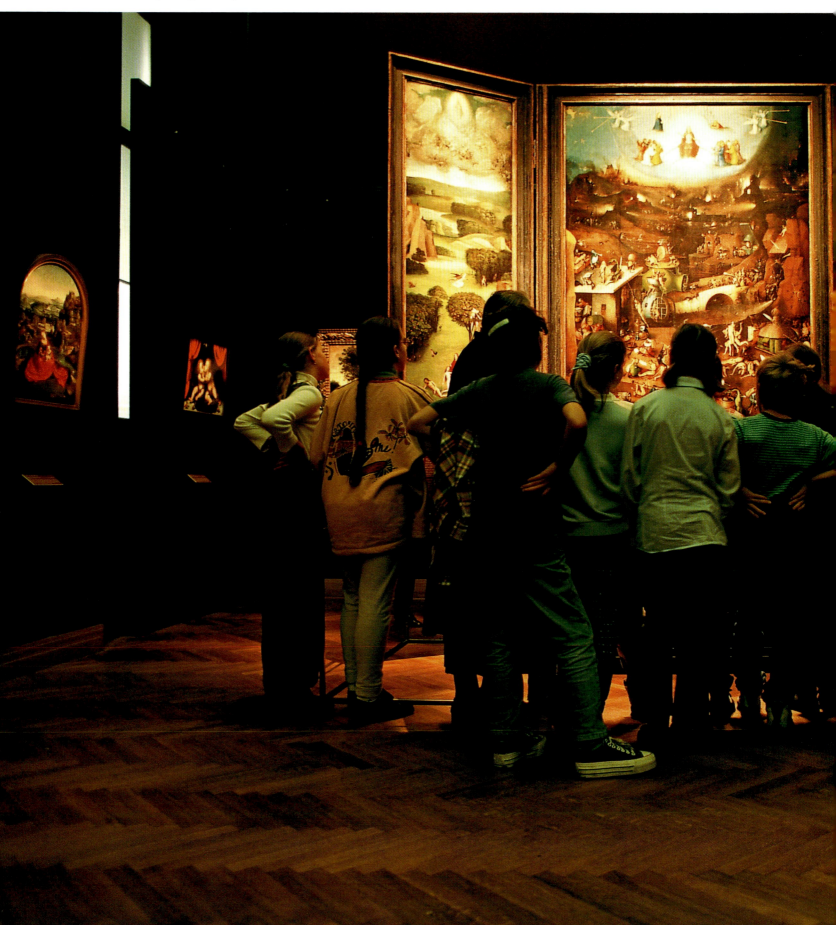

Below:

The Academy of Fine Arts, one of the oldest art academies in Europe, possesses an extremely valuable collection of paintings. One of the most important works is the triptych »Last Judge-ment« by Hieronymus Bosch from the year 1594, the only large work by the painter in Austria.

Right top:
The master class for painting works at the Academy of Fine Arts at Schillerplatz from which many important artists emerge.

Right centre:
The Austrian Museum for Applied Art was founded in 1863 as the Austrian Museum for Art and Industry.

Right bottom:
Vienna breathes art: in the picture gallery of the Academy of Fine Arts, paintings by, among others, Peter Paul Rubens impress visitors.

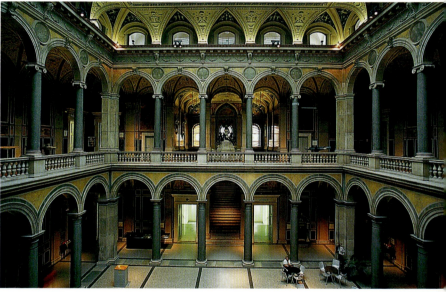

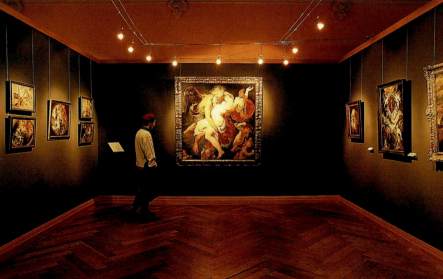

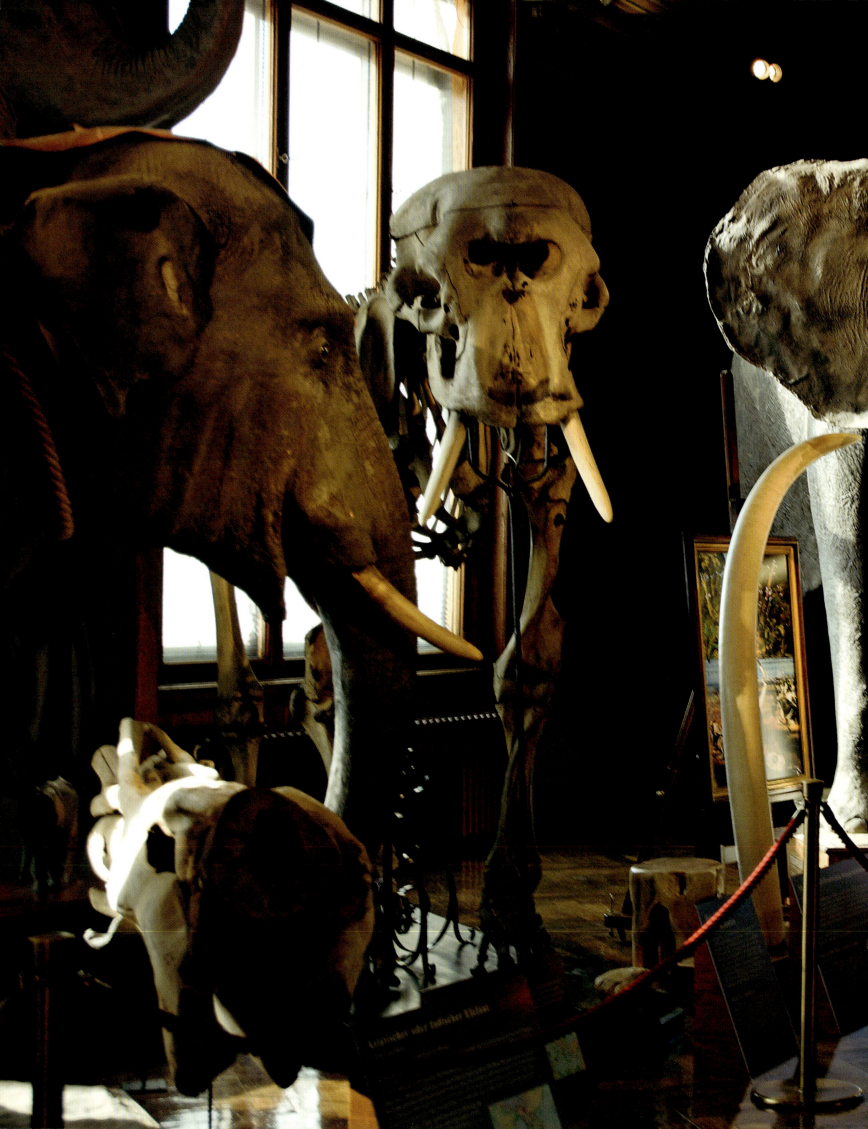

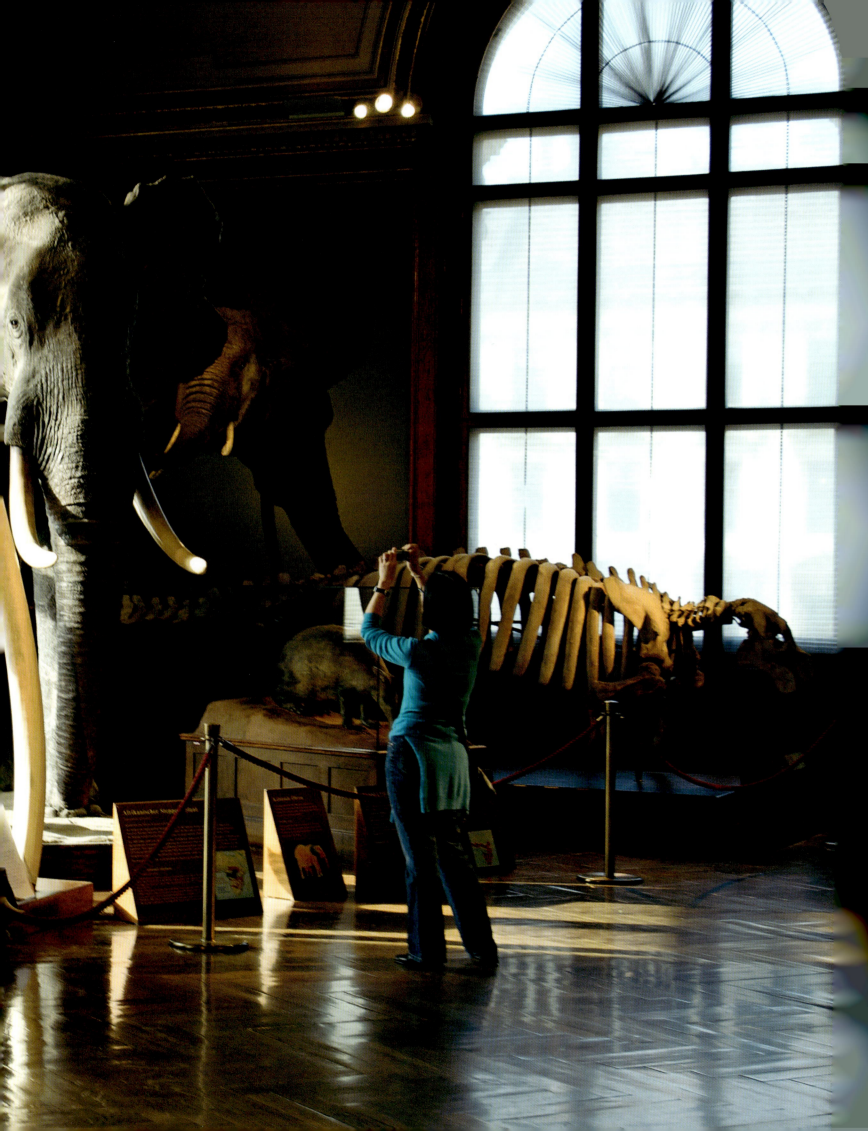

Page 92/93:
In the zoology department, one of the eight departments of the Natural History Museum, in Room 24 you can examine stuffed elephants close up. The »Natural History Cabinet« of Emperor Francis I of Lorraine formed the basis for the collection in 1748.

In the Dinosaurs Hall in the Natural History Museum, the visitor first becomes really aware of the dimensions of these extinct creatures, although palaeontology is just one of many subdivisions of the famous collection.

One particular highlight of the natural history museum are the rhinos in their special glasshouse, silent witnesses to the collection's long history.

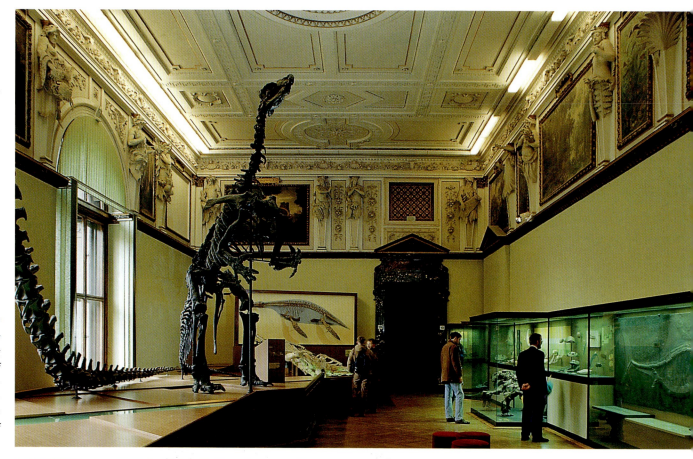

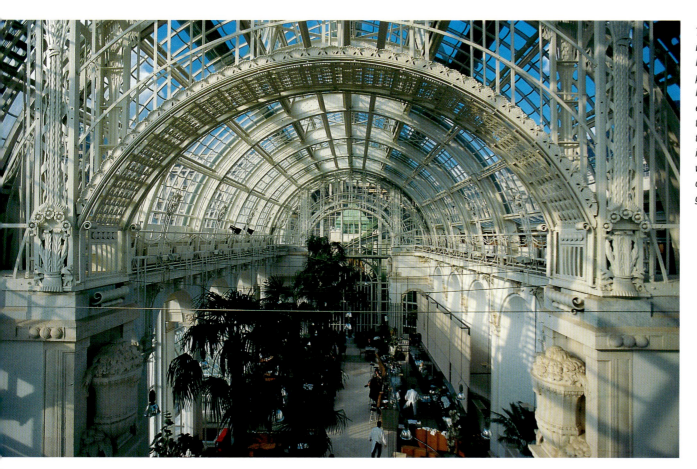

The modern café-restaurant in the Palm House has become a popular meeting point. Friedrich Ohmann erected the building, that was influenced by the Secessionist movement, in the palace gardens which were originally designed as the imperial gardens.

In the unusual architecture of the Palm House of 1902, even today high green plants grow above the guests drinking their coffee.

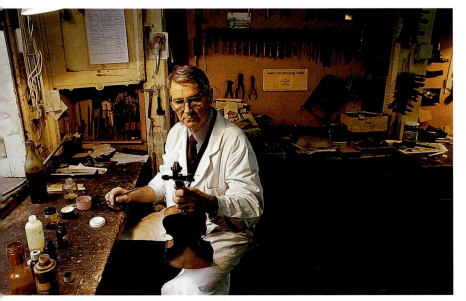

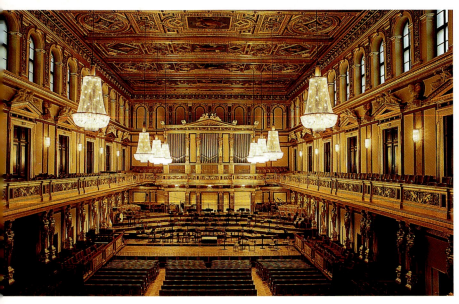

Left top:
The coffered ceiling in the Golden Hall of the building of the Wiener Musikverein is also responsible for the famous sound in this hall, The echo is said to last a little over two seconds when the hall is full.

Left centre:
In painstaking and detailed work Otmar Lang produces the violins of the Vienna Philharmonic which are then to be heard in the State Opera.

Left bottom:
Theophil von Hansen created the Golden Hall of the Musikverein with outstanding acoustics. Apart from the coffered ceiling suspended from a steel construction, the hollow space beneath the stalls, much wood and sculptures without an interior, contribute to the richness of sound at concerts.

Below:
No visitor to Vienna should miss this feast for ears and eyes: the State Opera at Opernring is famed for its performances and scandals. The architects Eduard van Nüll and August von Siccardsburg erected the monumental building.

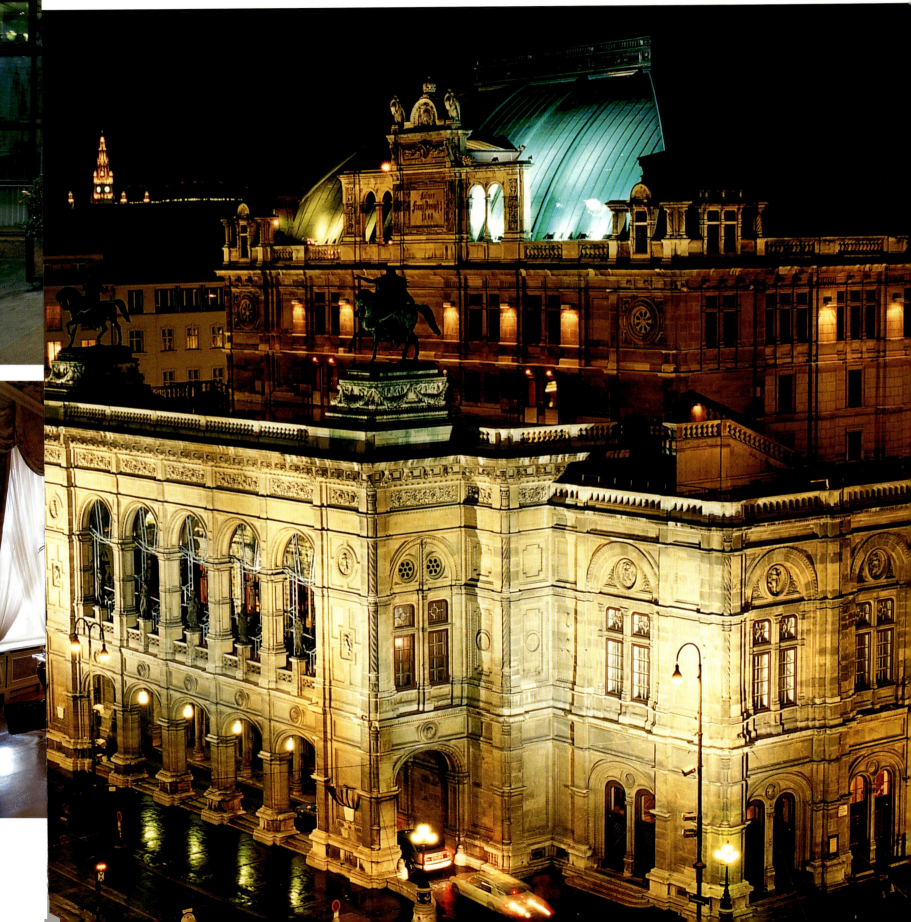

Outside the Ring –
green meadows and castles

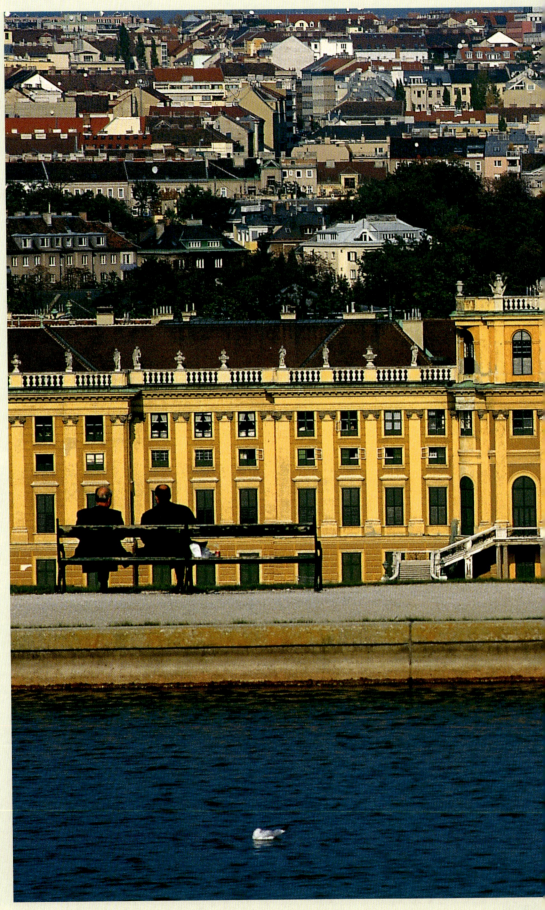

View from the Gloriette in the park towards Schönbrunn Palace, the summer residence of Emperor Francis Joseph. The façade, that was begun by Fischer von Erlach and completed by Nikolaus Pacassi, is painted in what is known as »Schönbrunn yellow«. The name of the palace comes from a spring in the Hapsburgs' former hunting preserve: the »Schöne Brunnen« – »Beautiful Fountain«.

Alfred Auer remarked about one of Vienna's largest green lungs, the Prater, that it was not a landscape, but an Austrian emotional state. One may see this as a charming compliment to the Austrians because even today the Prater is a successful mixture of fitness and lazing around. Originally laid out as a hunting ground for the Hapsburgs, it was, however, handed over to the people – to the great delight of the Viennese and the displeasure of the nobility – by Emperor Joseph II on April 7, 1766. Horse races and a carnival of flowers were held along the four and a half kilometres length of the Hauptallee (Main Avenue), even the World Exposition was celebrated here in 1873, on the occasion of which the Rotunda, a spectacular exhibition building, was constructed. A colourful kaleidoscope of sensations unfolds before the eyes of the beholders over 6,143,984 square metres: the Ernst Happel and Dusika stadiums, the Freudenau and Krieau racecourses, the Wasserwiese allotment estate, the winter harbour, the Heustadlwassser lake, the Lilliput railway which whistles its way on its narrow tracks through poplar woods.

Augarten Park in the 2ⁿᵈ district is also worth a visit, after all on the portal of the main entrance is inscribed: »A place of amusement dedicated to all people by their appraiser.« The appraiser, who else could it be, was the enlightened monarch and friend of his people who had hundreds of lime trees planted and park benches erected. Impressive areas of green are also to be found on the Ringstrasse in the Volksgarten with the Greek Temple of Theseus and in the Burggarten which allows visitors to sun themselves on the meadows. In the contrast to this, the park grounds of Schönbrunn Palace are only open unrestrictedly to squirrels and butterflies. Two-legged visitors are requested not to walk on the lawn, but just to look – and so it remains impeccably beautiful, the Schönbrunn lawn.

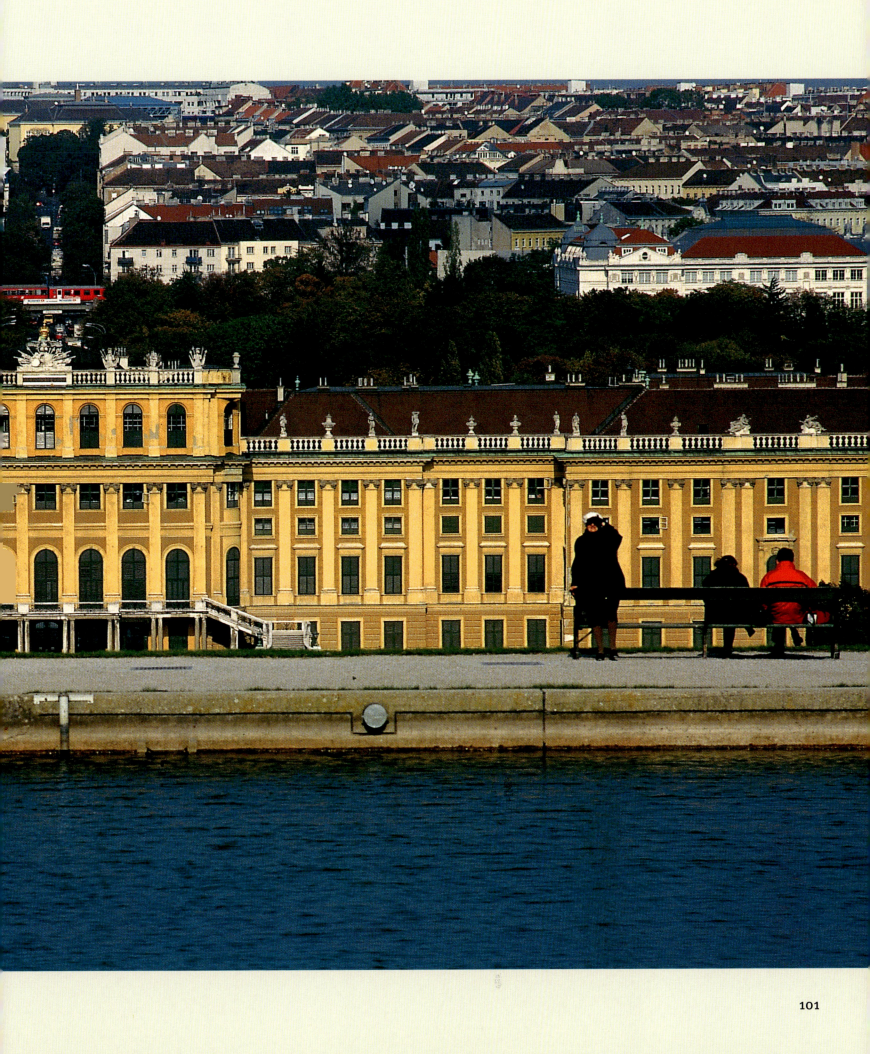

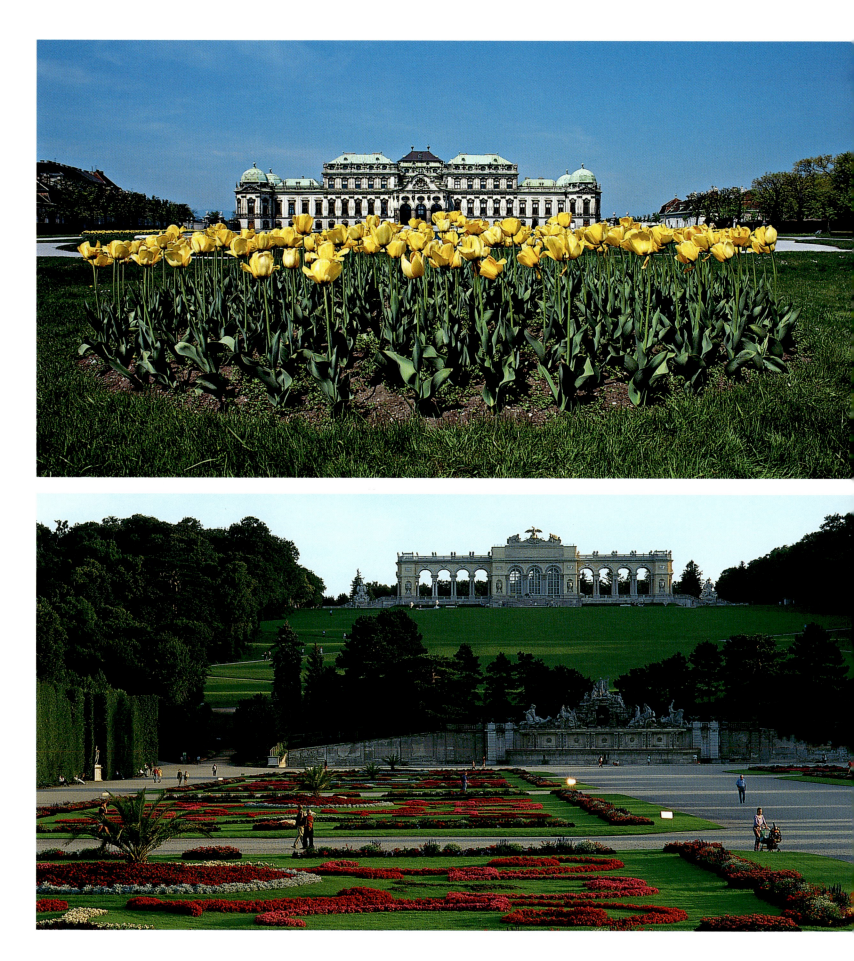

Below:
The figures of the Naiad
Fountain in Schönbrunn
Palace Park are by Johann
Babtist Hagenauer.
The fascinating gardens
were opened to the public
already in 1779.

Left:
Prince Eugene of Savoy
had a summer residence
constructed for himself
by Lukas von Hildebrandt
behind the glacis with

a residential and repre-
sentation palace. The
representation building,
the Upper Belvedere, is
the eye-catcher on the
rising grounds.

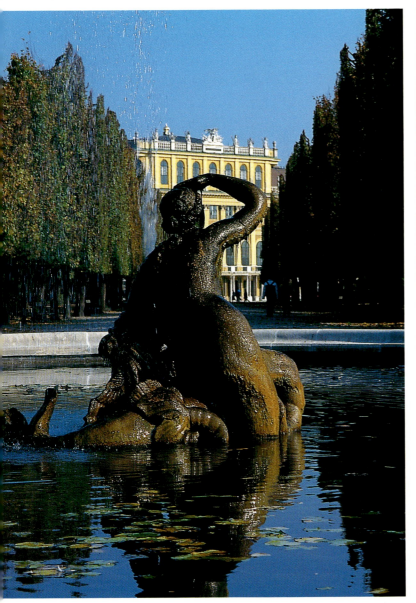

Left:
Schönbrunn Palace Park
is among the loveliest
Baroque gardens in the
world. The Gloriette on the
rising ground opposite the

palace is monument to a
victory over the Prussian
King Frederick and, as an
open hall building, forms
an airy counterpart to
the palace.

Above:
Even the gate hall
of Belvedere Palace is
designed for representa-
tion purposes. Lukas von
Hildebrandt completed
the luxury structure of
the Upper Belvedere.

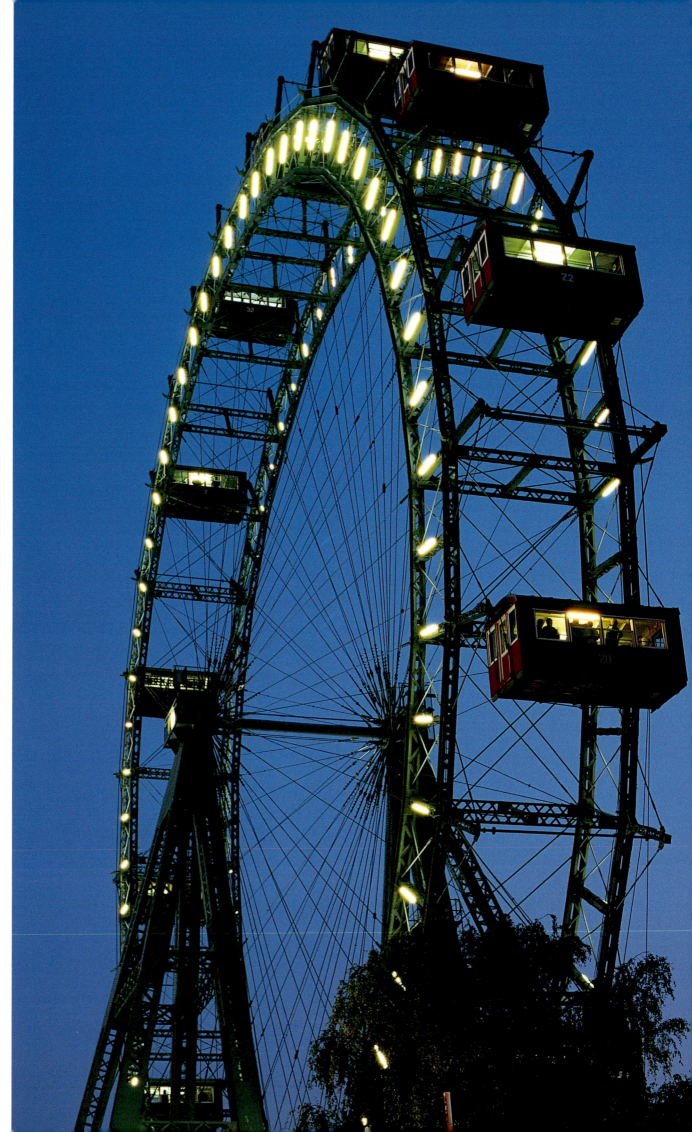

Right:
Although the big wheel by English engineer Walter Basset from 1897 was originally equipped with considerably more cabins, Vienna's sizeable and unusual landmark is still impressive with its 61 metres height, and the panoramic view from the gondolas truly memorable.

Viennese originals are to be found at the most unlikely places; a regular guest in front of the »Gelsenbar« in the Prater.

Also an Eldorado for modern music: Jazz on Sunday morning is to be found in Augarten in summer.

A leisurely chat with the earthy landlord of the »Gelsenbar« is one of the enjoyments in the Prater.

At the summer cinema festival »Cinema under the Stars« in Augarten, not only can you see highlights on the screen, food and drink are also provided for your well-being.

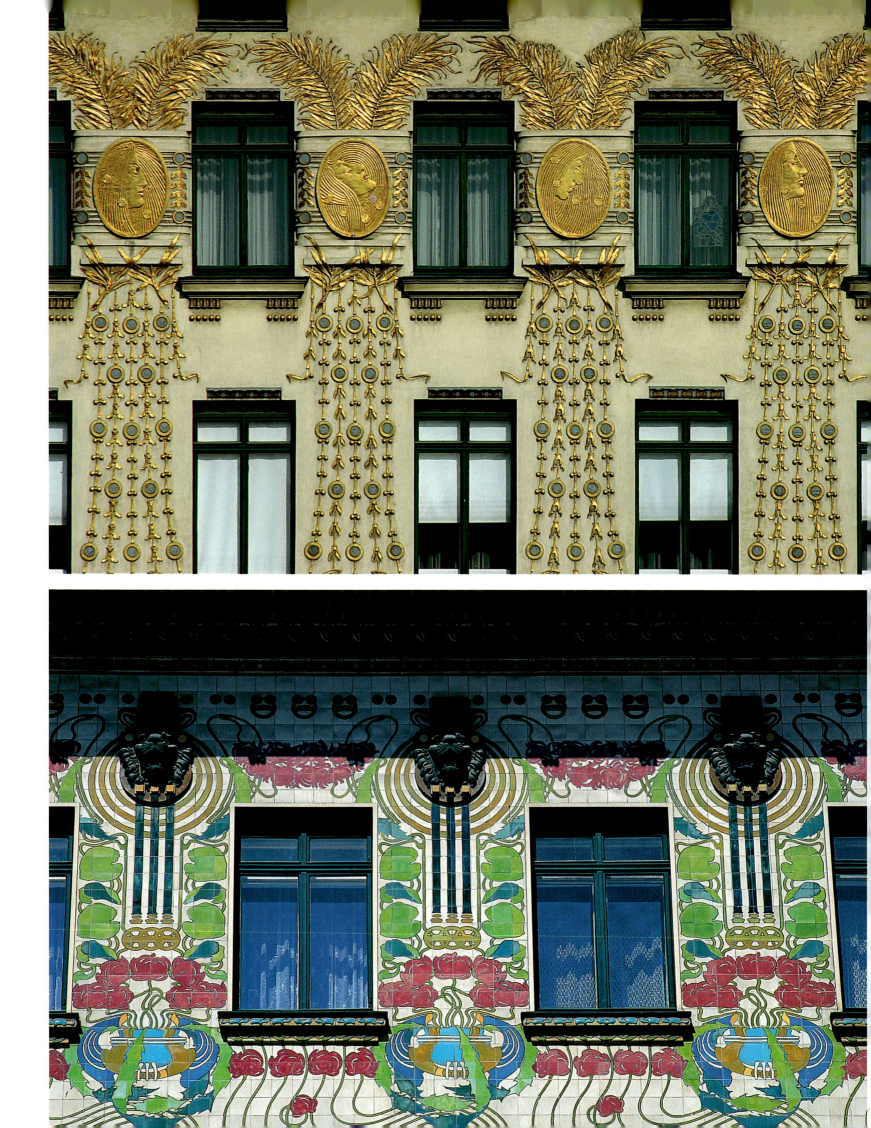

Left:
On the Linke Wienzeile in the 6th District, most Jugendstil façades have survived and been restored with much love.

Thus, for instance, the façade of house No. 38 by Otto Wagner. The golden medallions with women's heads are by Kolo Moser.

Below:
The Linke Wienzeile offers two works by Otto Wagner: the apartment buildings with the numbers 38 and

40 with their striking floral decor. It was once planned to improve the street into a luxury boulevard to Schönbrunn.

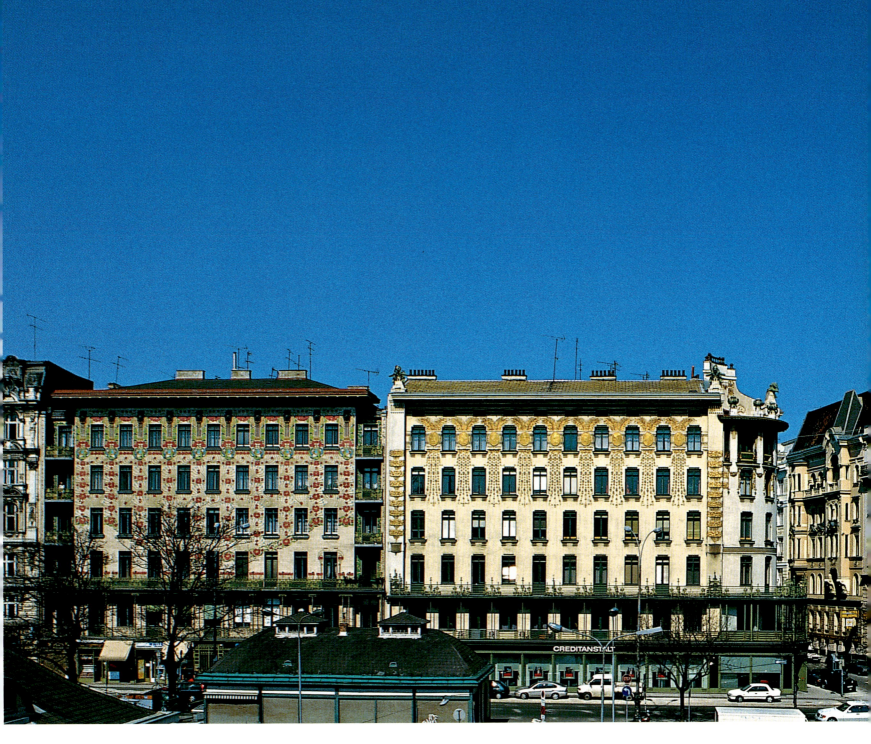

Left:
The Majolica House has the number 40 and is also by Otto Wagner from the

year 1898. Alois Ludwig designed the floral tile decor.

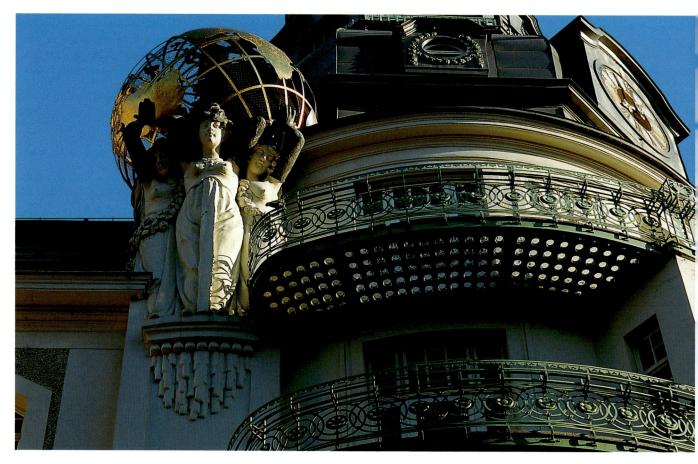

The playful side of Jugend-stil becomes apparent in the »Palais des Beaux Arts« at Löwengasse 47 in the 3rd District.

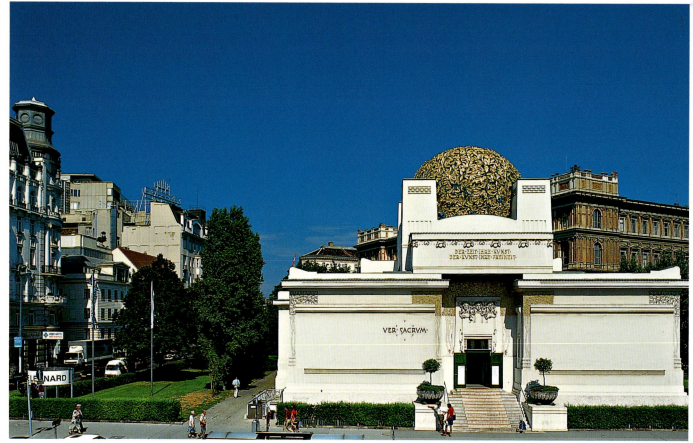

The first exhibition building of the »new, wild« artists, who were taking their leave of tradi-tional form, was called »Secession«. The golden laurel dome of the building at Friedrichstrasse 13 was affectionately nicknamed »cabbage« by the Viennese.

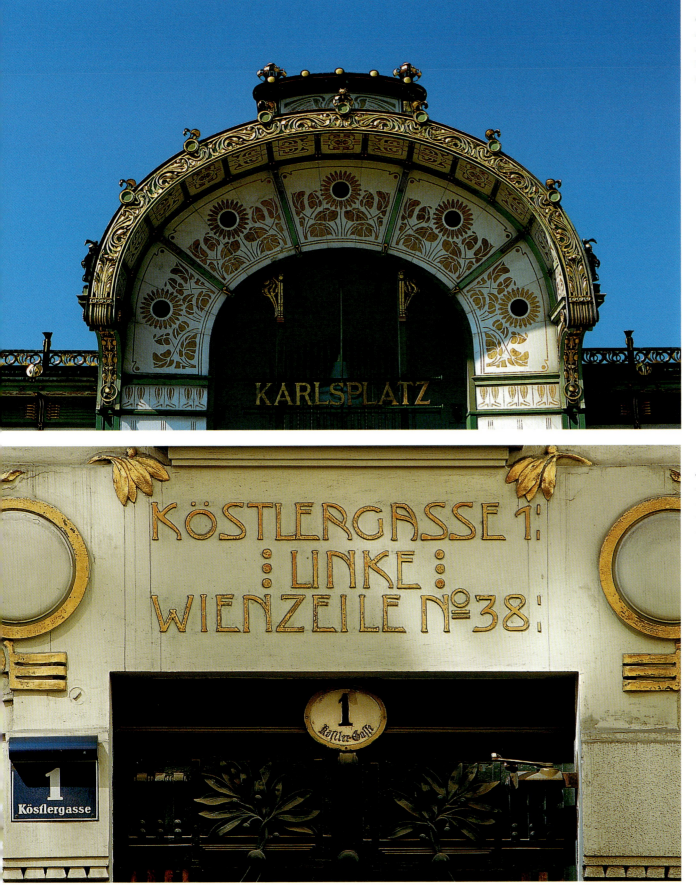

The urban railway stations are among Otto Wagner's most important works. Karlsplatz station welcomes with cheerful sunflower ornaments.

The special typography of Jugendstil finds its expression here at Otto Wagner House number 38 on the corner of Linke Wienzeile and Köstlergasse in the 6th district.

Page 110/111:
You can enjoy a splendid view of the Danube Canal from the Ringturm looking west.

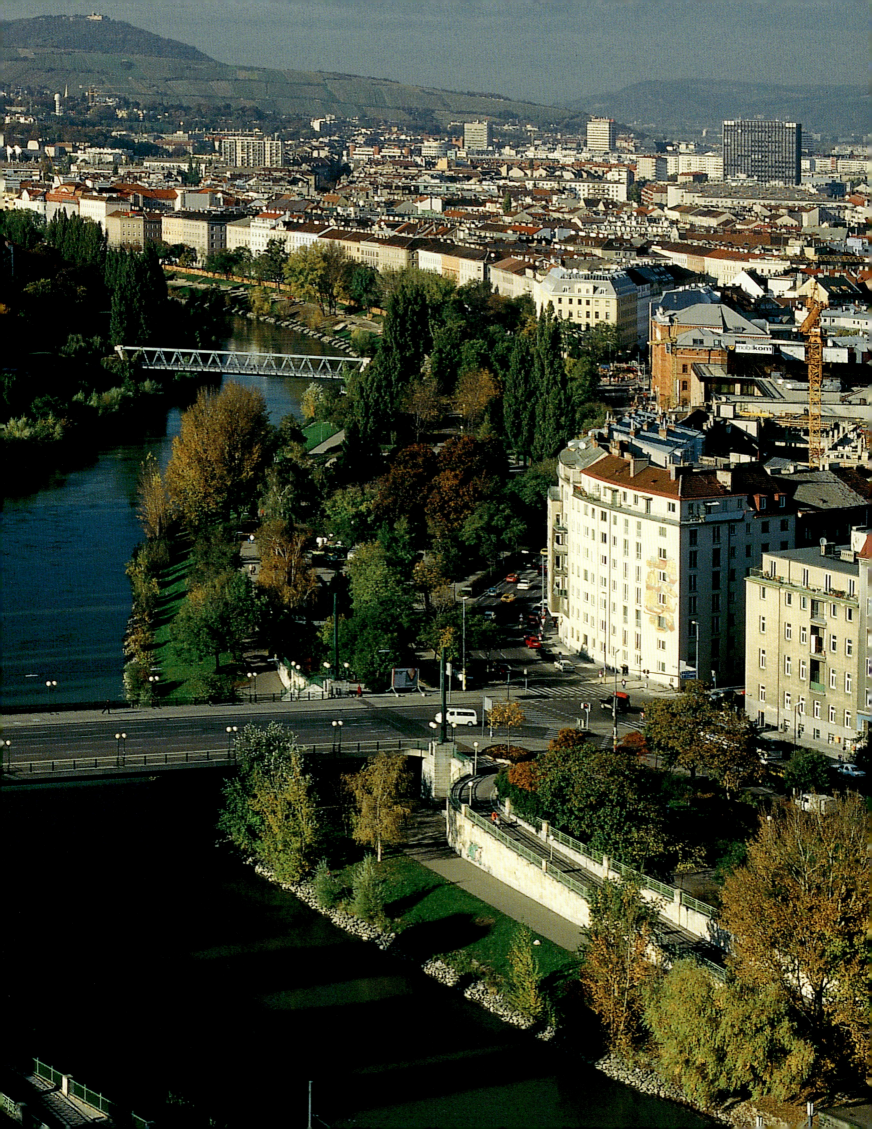

Below:
The convinced
environmentalist
Friedensreich Hundert-
wasser also designed
the façade of Spittelau
district heating plant.

Below:
Friedensreich Hundert-
wasser designed the
façade of the Hundert-
wasser house in Löwen-
gasse in a fairytale,
fantastic style.

Right:
The KunstHaus at Untere
Weissgerberstrasse 5
in the 3rd district was
created by Friedensreich
Hundertwasser himself.

»Round« corners, clear
colours, such as red, blue
and yellow, playful patterns
and asymmetrical rooms
shape the overall impres-
sion of the museum.

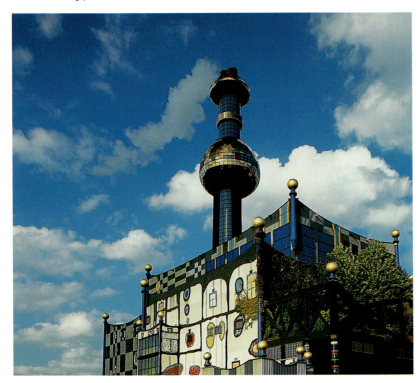

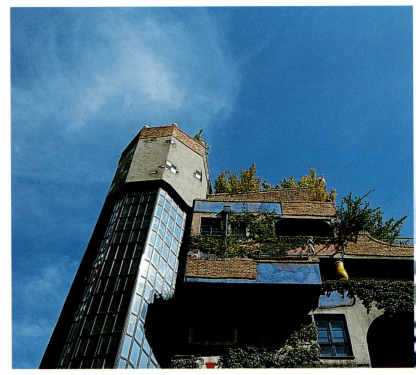

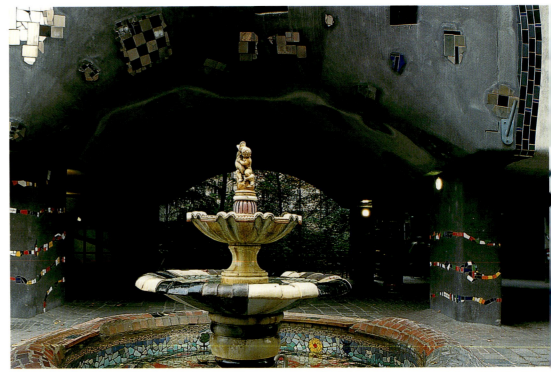

Hundertwasser the artist
gives his fantasy a free run
down to the last detail.

A foundation contributes
to the quality of life in the
Hundertwasser house.
Originally a pilot project
by the Vienna Municipal

Housing Department for
»dwellings fit for humans«,
the house is today an
architectural attraction
for visitors.

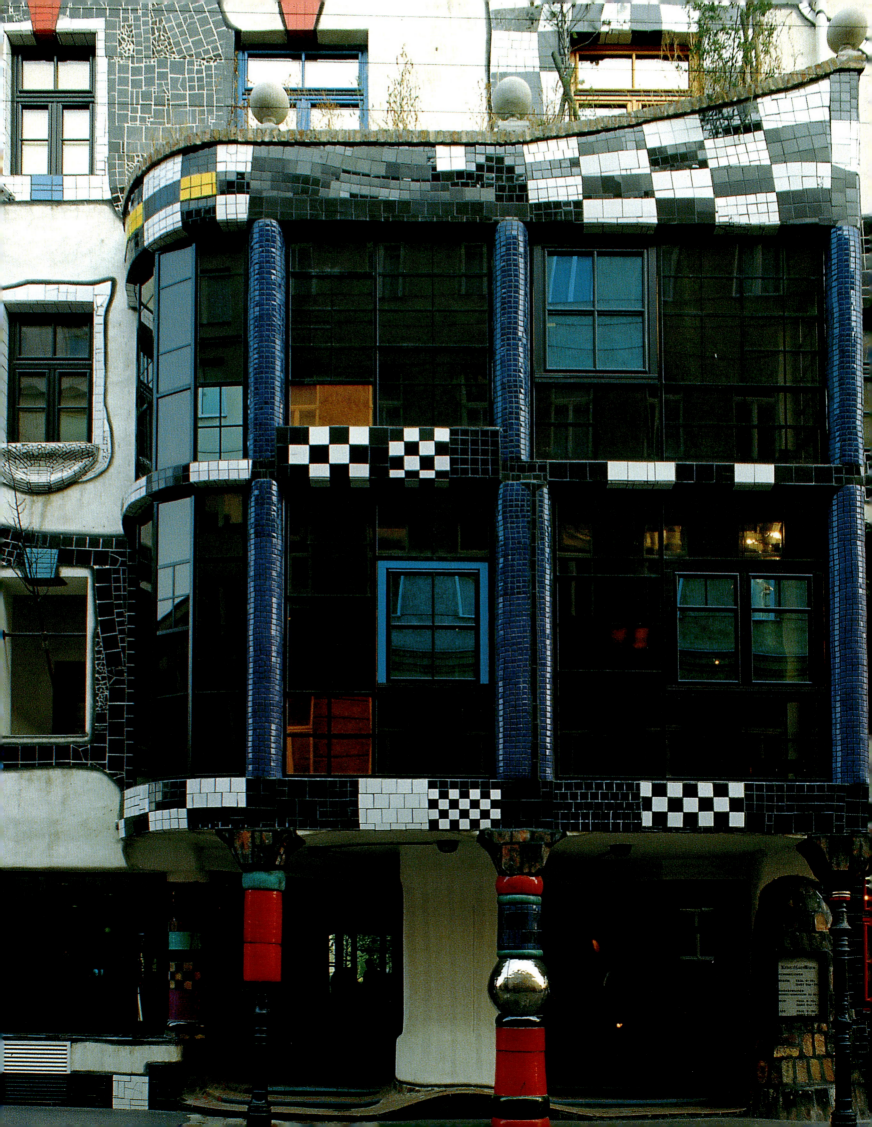

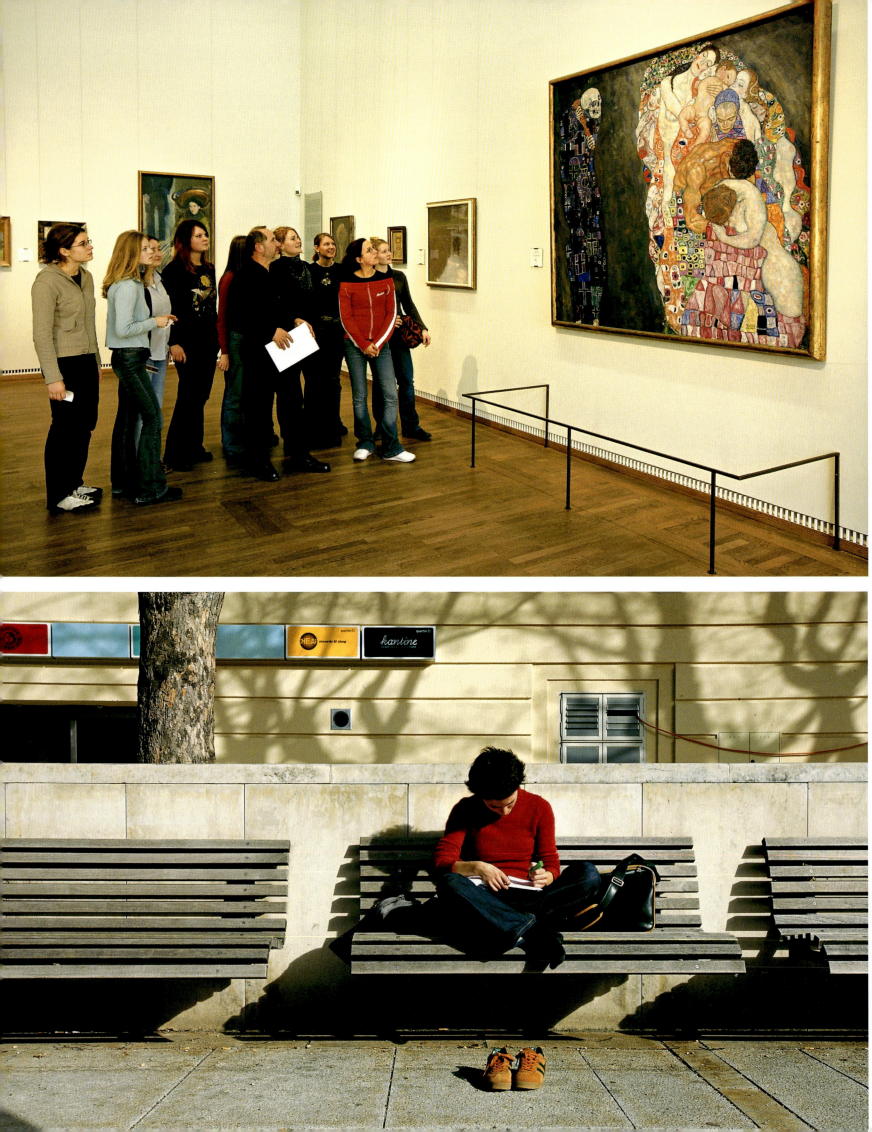

Left:
The Leopold collection collates over 5,000 examples of modern Austrian art under one roof, including the biggest Egon Schiele collection, many first-class pieces by Gustav Klimt, Oskar Kokoschka, Richard Gerstl and Albin Egger-Lienz and paintings and graphics by Herbert Boeckl, Hans Böhler, Anton Faistauer, Anton Kolig, Alfred Kubin and Wilhelm Thöny. Here, visitors are admiring the famous Gustav Klimt work »Tod und das Leben« (Death and Life).

Below:
Alongside the Leopold Museum and Kunsthalle Wien, the grey yet striking, basalt-clad cube of the MUMOK (Museum Moderner Kunst or modern art) is one of the main architectural accents of the museum quarter. The collection includes works by Andy Warhol, Pablo Picasso, Joseph Beuys, Jasper Johns, Roy Lichtenstein and many other contemporaries.

Page 116/117:
Prince Johann Adam Andreas I of Liechtenstein (1657–1712) was one of the biggest builders of the age. In Vienna there are no less than two palaces attributed to him: the Stadtpalais or city palace on Bankgasse and the Gartenpalais or garden palace on Fürstengasse. Gartenpalais now accommodates the Liechtenstein Museum and the private collections of the artistic prince, including over 30 canvases by Rubens.

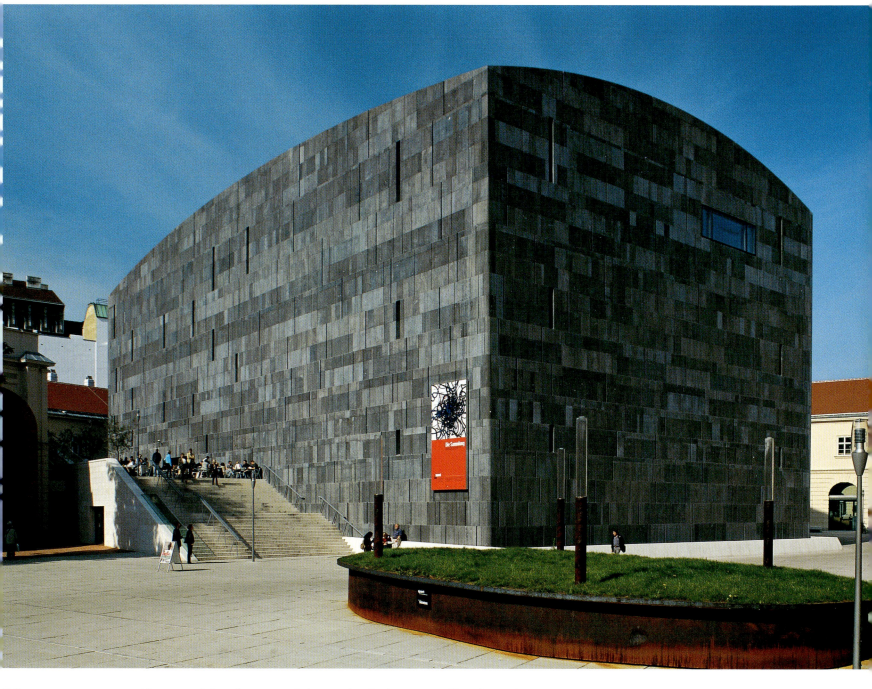

Left:
The Museum Quarter (MQ) is a unique ensemble of museums in the centre of Vienna, consisting of the capital's museum of modern art, Leopold Museum, Kunsthalle Wien and also countless institutions and initiatives. The central courtyard of the MQ has become something of an outdoor living room where people meet, contemplate art – or simply relax.

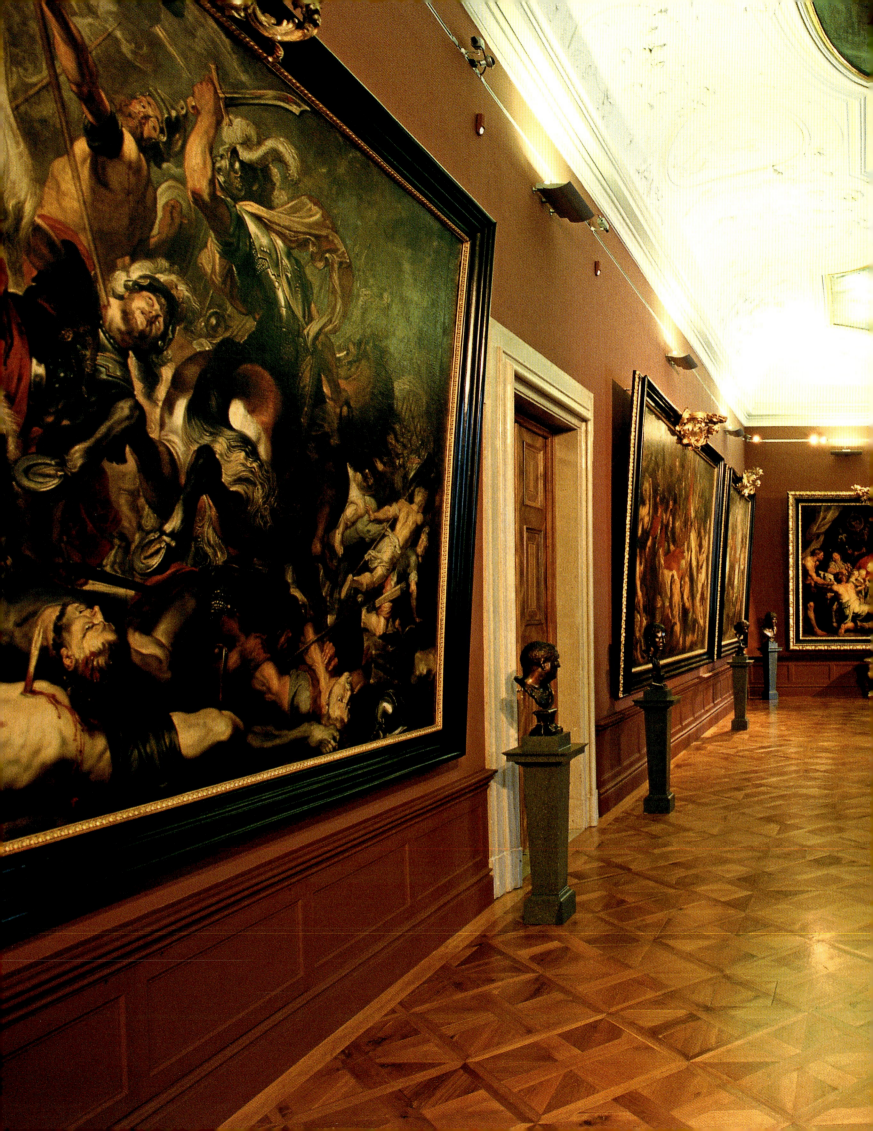

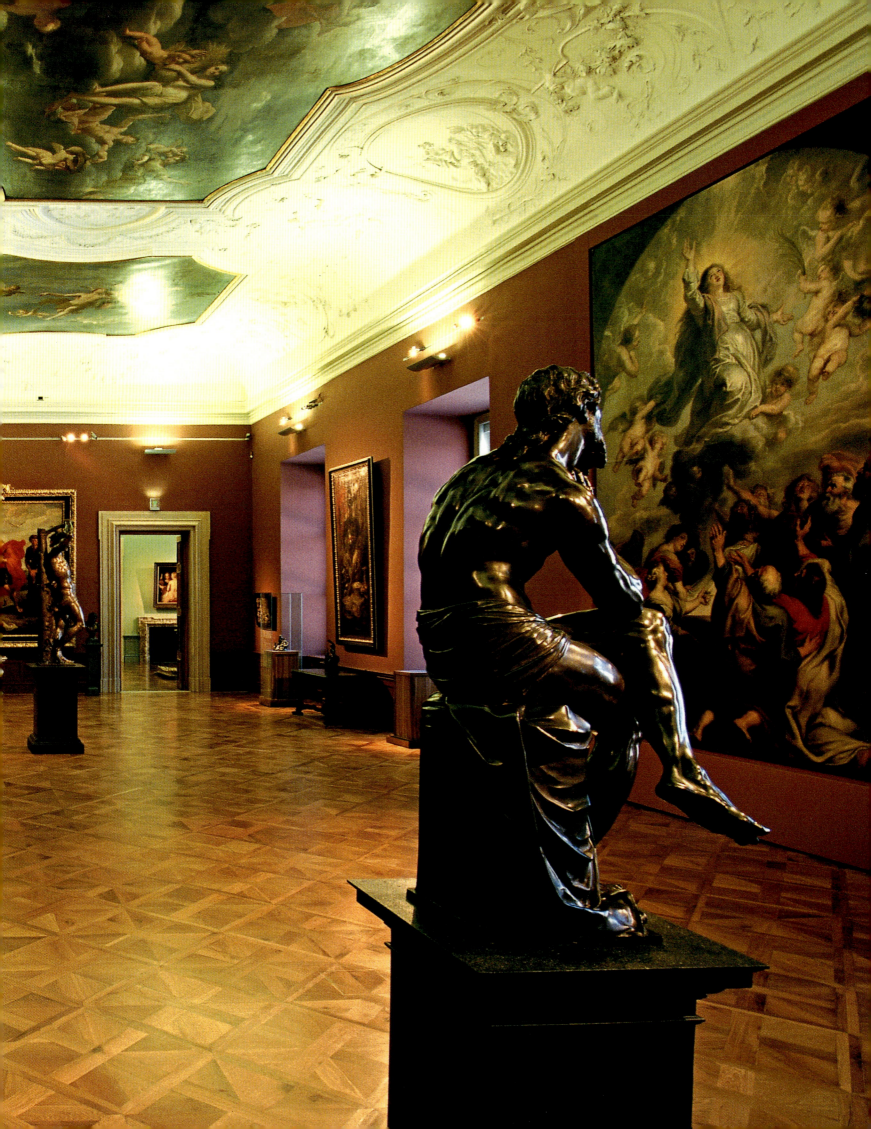

Photos below:

Naschmarkt was originally a farmers' market and is now popular for its international array of victuals, with everything from fruit to fish from all over the world. Naschmarkt also has a good range of eateries.

A new market bylaw now allows the cafes and kiosks to stay open until midnight, allowing the market to hum pleasantly until the clock strikes twelve, especially in the summer.

Below:

Every Saturday, the flea market then takes place at Naschmarkt. All those looking for nostalgic souvenirs will get their money's worth here.

Right:

Old Viennese impressions: House in Haidgasse in the 2nd district.

Far right:

The architecture of the Karl-Marx-Hof in Heiligenstädter Strasse follows the precepts of social welfare building of 1929. Over 1300 mini-apartments are accommodated in a one kilometre-long, monumental dwelling block.

Above:

Gherkin Leo: one of the many originals at the Naschmarkt offers passers-by a salt gherkin to nibble.

Right:

Leopoldstadt was once a flourishing Jewish quarter after Emperor Ferdinand II had moved them there from the Inner City in 1624. Around 1938, about 180,000 Jews lived in Vienna, after 1945 there were only 2,000 still, today there are some 7,000 who do not, however, necessarily live in this district.

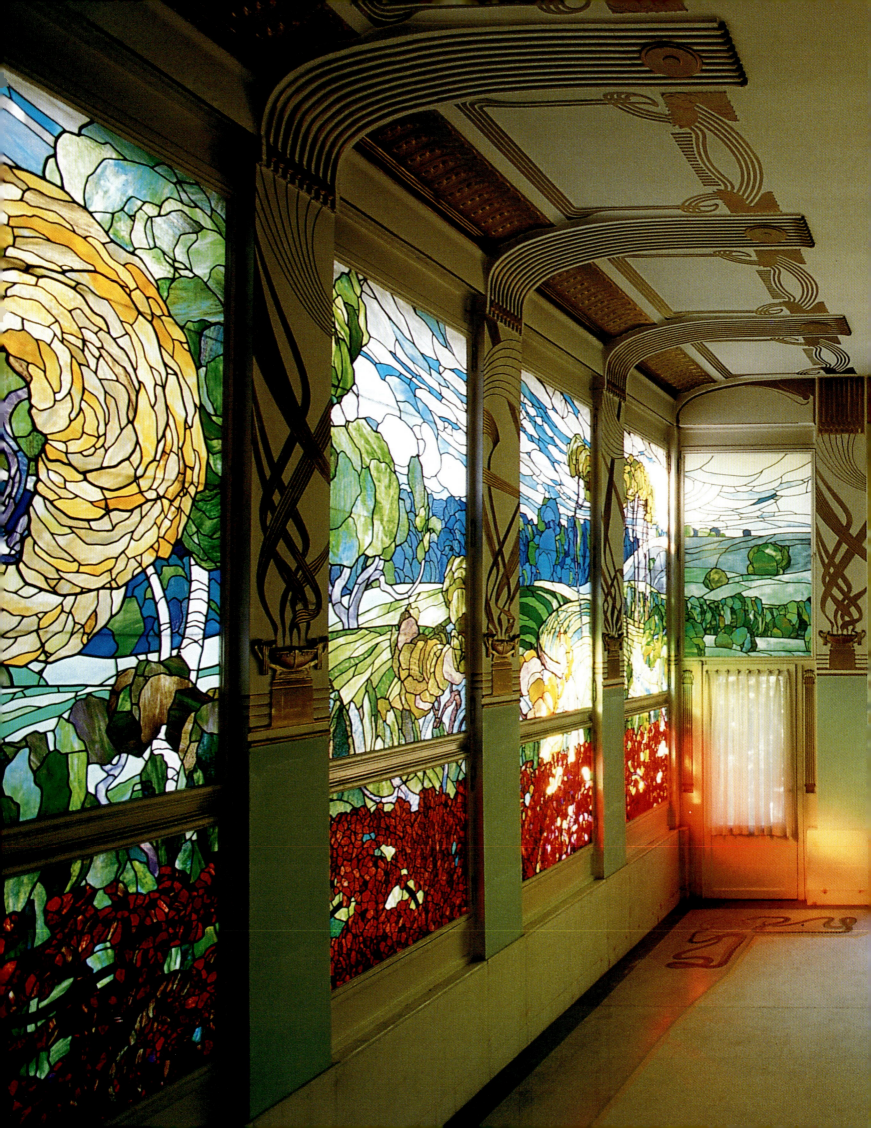

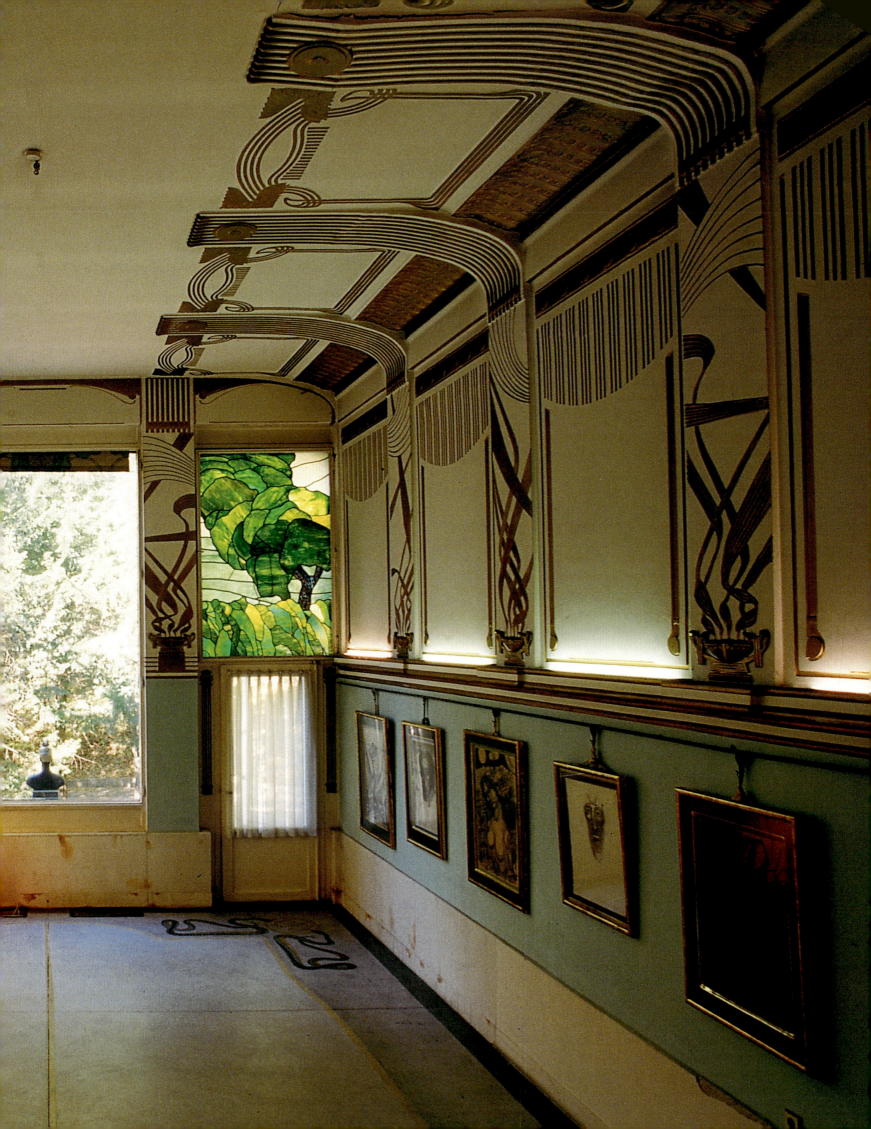

Page 120/121:
The »First Villa Wagner«
was constructed still under
the banner of Historism
in 1888. However, Adolf
Böhm designed the studio
windows in the forms
of Jugendstil.

Right:
The first Otto Wagner
Villa is today a museum
belonging to Ernst Fuchs,
co-founder of the Viennese
School of Fantastic Realism.
»The renovation and recon-
struction of the splendid
work by the brilliant archi-
tect Otto Wagner were my
first apprenticeship«, Fuchs
writes about the works
lasting from 1972 to 1986
on the villa constructed in
1888. Ernst Fuchs dis-
covered old drawings by
Otto Wagner and amal-
gamated these plans with
his individual visions.

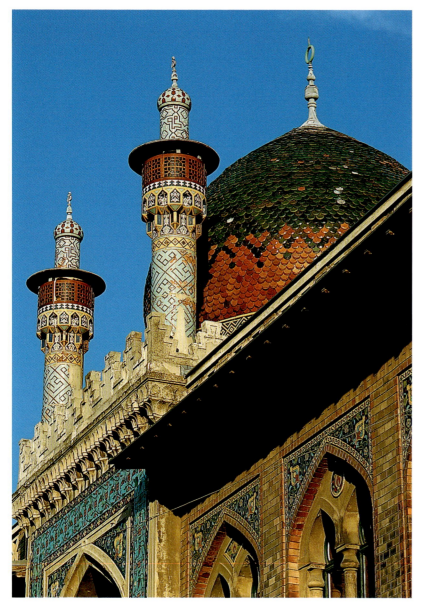

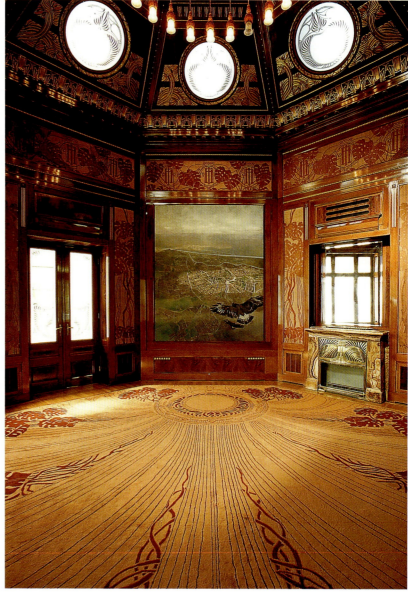

Above:
The observer of the insect
powder factory Zacherl
in Döbling – a Jugendstil
building by the Mayreder
brothers from 1892/1893 –
feels himself transported
for distant worlds.

Above:
The central interior
of the court pavilion
became a particular
»delight« of Viennese
Jugendstil through Otto
Wagner's ingenious
lighting arrangements.

Right:
Where once the urban
railway passed the Court
Pavilion, constructed
completely in Jugendstil,
the underground railway
now races past.

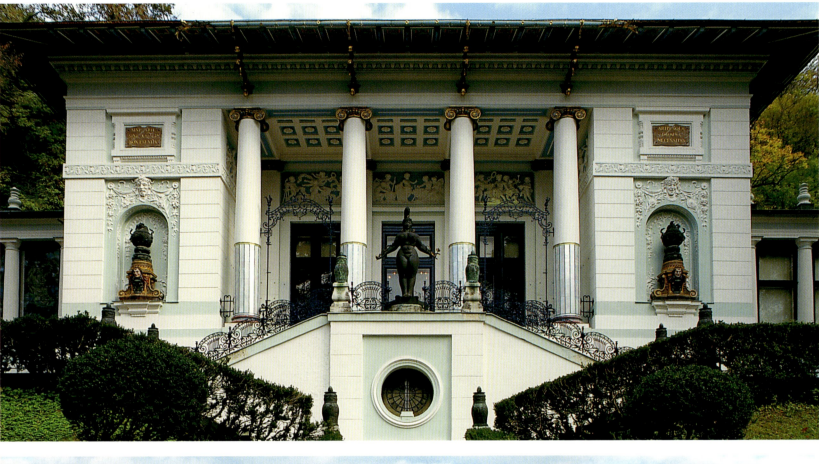

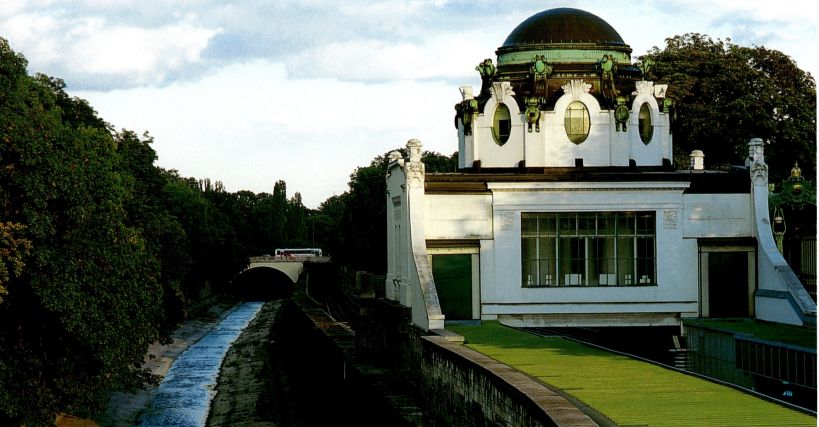

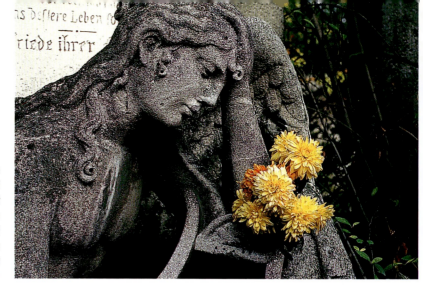

Below:
This grave of honour in the Central Cemetery recalls the composer and main representative of the classical Viennese operetta, Karl Millöcker, who composed »The Beggar Student« among other works.

Right and far right:
Sorrowing angels and phantoms lost in thought transform cemeteries into veritable enchanted gardens and recall the dead at the St. Marx Cemetery.

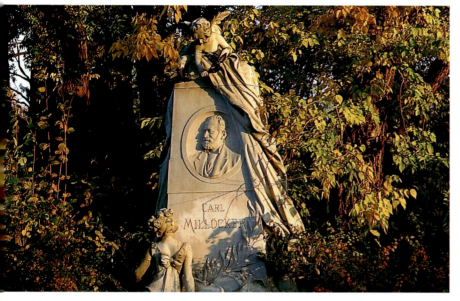

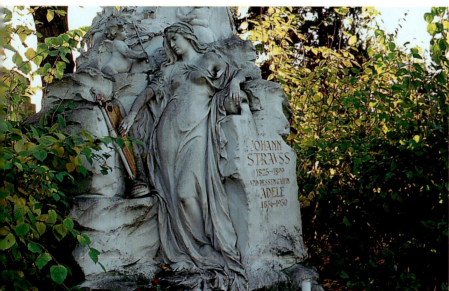

Above:
The Viennese cemeteries are of melancholy beauty. Many famous sons of the city have found their last resting place in the Central Cemetery: the tomb of honour of Johann Strauss son.

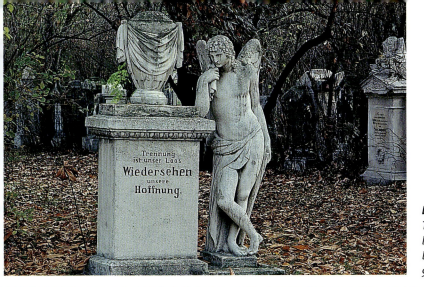

Page 126/127:

Below:
The oldest Jewish cemetery lies idyllically and in silent beauty in Seegasse in the 9th district.

Visible for miles around, these gasometers have been the local landmark of Simmering for over one hundred years. After being rebuilt by several architects of renown, Gasometer City now offers a range of unusual, stylish and extravagant residences. The photo shows Gasometer B, the redesign of which was undertaken by the architectural group Coop Himmelb(l)au.

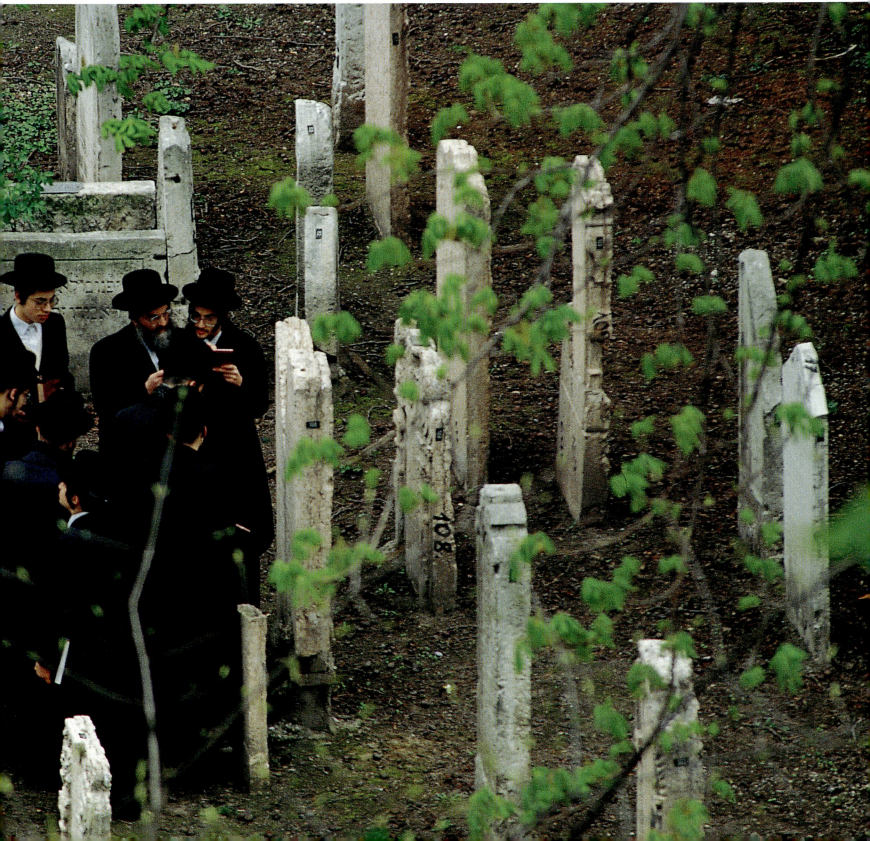

THE »HEURIGEN« – WHERE NEW WINE AND OLD SONGS CELEBRATE TRADITION

When the day's work has been done and the air has been heated up by the summer sun, many a Viennese has only one thought: out into the green, find a seat in one of the »Heurige« (new wine) garden taverns and wash down everyday cares with a glass of »Grüner Veltliner« (»green« i.e. white Valtelline wine) beneath a flowering chestnut tree. On the long wooden benches, placed close by the simple tables, many an acquaintance or even friendship can be made. The communication is exuberant, the typical »Wiener Schmäh« (Viennese snide humour) is in full swing – laughter is at home here. The wine relaxes your feelings and your bones tired from work – soon you are on familiar terms with your neighbour at the table and discussions on »God and the world« bring moments of blissful pleasure. The Viennese's love for his »Heurige« is simply not to be stopped and not infrequently ends in a real »Remasuri« – a kind of exuberant tipsiness when, as the journalist Christian Hauenstein so aptly remarked »nobody knows so exactly any more what's what. Then it swarms with 'Negeranten' (scroungers who do not want to pay) and one is at all events the 'Teschek' (namely the one who then has to pay for the others)«.

From leisurely »wine biting« beneath the walnut tree

On November 11, not only does the obligatory Martinmas goose come onto the table, but on that day the year's »new wine« is served for the first time – a young, sparkling, low-alcohol wine which has been able to mature for a summer under Vienna's sun.

When the Viennese speaks of »Heurige«, he can mean three things: firstly, the »Heurige« mentioned above where you drink – mainly outdoors – a glass of wine with »Soletti« (salt sticks) and »Liptauer« (a mildly spicy cheese spread), secondly the very drinkable wine itself or the potatoes which he likes to eat here as a salad with onions and chives. The guarantee for actually being served with the wine that really does come from the vines in the vineyards behind is a bundle of pine twigs, the »Buschenschank«, hanging over the entrance. This custom explains the vintners' call in the Viennese wine distracts Döbling, Grinzing, Sievering, Neustift, Nussdorf or also Dornbach: »Ausg'steckt ist!« (»It's stuck out«). They would call out this good news through the narrow lanes of the small suburbs – so the Viennese would know that the time had come to savour the new wine – to »bite« it as the locals

still say. The wine is generally ordered by the »Viertel« (quarter litre); together with a large bottle of soda water, mineral water or ordinary tap water. If in earlier times guests would bring their food with them – whether boiled eggs, sausage salad in a jar, ham sandwiches and cheese rolls – to the »Heurige«, this is no longer approved today. And even if in the meantime one can order »Schnitzel« (escalope of veal) and »Tafelspitz« (boiled fillet of beef) at the »Heurige«, even beer, tea or coffee – the favourite is still wine (Grüner Veltliner, Riesling and Müller-Thurgau). The traditional basis for a good drop is a piece of »Sur-« or »Kümmelbraten« (roast pickled meat or roast meat with caraway), »Paradeiser« (tomatoes), cucumber or potato salad. To follow »Mannerschnitten« or the famed »Pischinger-Torte«. You select this at the counter and then balance it on a tray along in part very potholed garden paths. The waitress only brings the drinks – she has enough to do with that when once again everywhere is packed and half Vienna is longing for a »G'spritzten« (half wine/half soda water).

The »Heurige« had its heyday in the Biedermeier period. The Viennese found the greatest pleasure in organising what was known as a »Landpartie« (an outing into the country), thus a hike into the vineyards surrounding Vienna. After such strenuous walks, they were, of course, thirsty and thus the outings usually ended at a »Heurige« where there would be singing, dancing, swaying to the music, chatting and sometimes drinking a little too much so that one could easily take home a »Fetz'n« (state of inebriation) or at least a »Schwül« (tipsiness) as a souvenir.

The genuine »Heurigenmusik« had its origin in 1878 when the brothers Johann and Josef Schrammel with the guitarist Anton Strohmayer played their typical »Schrammelmusik«. The quarter was completed by Georg Dänzer who played the piccolo clarinet. The Schrammels were soon famous world-wide and played in international concert halls. And where did the probably most famous zither tune in the world, the music to the film classic »The Third Man« come into being? In fact at a »Heurige« between two glasses of »Grüner Veltliner«.

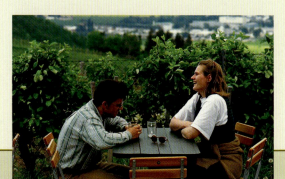

Left:
Anyone wanting to enjoy one of the loveliest views of Vienna in addition to the new wine, is at the right address at »Heurige Sirbu« at Kahlenberger Straße 210.

Above:
In the 19th district, many secluded »Heurigen« have survived. Such as »Heurige Mayer« at Pfarrplatz in Heiligenstadt. But around midnight it's then – just as in all other »Heurigen« – »Closing time!«

Right top:
Many a visitor to Grinzing feels himself back in old times. Even if there is one coach parked together with the next – the Grinzing zest for life is not so easily dispelled!

Right centre:
In peaceful Neustift am Walde, just after Pötz-leinsdorf, charming »originals« still run their small »Heurige« and successfully resist just thinking of profits.

Right:
In the 21st district is Stammersdorf, an inside tip for those who prefer genuine »Buschen-schanken«. Here there is only self-grown wine and a small, cold buffet.

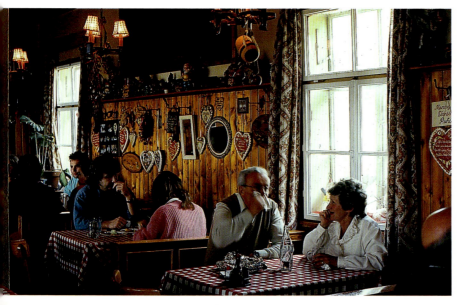

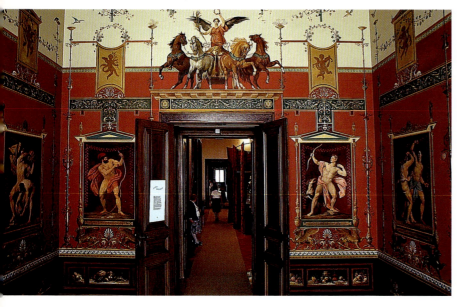

Left top:
After a long walk through the Vienna Woods, you can refresh yourself with a decent mug of beer at »Häuserl am Stoan« in Döbling.

Left centre:
Mountain bikers can really indulge themselves on Sofienalpe in the Vienna Woods. The Vienna Woods are the most northeasterly part of the Eastern Alps and a popular nearby recreational area.

Left bottom:
The painter Falkenstein painted Empress Elizabeth's gymnastic room in the Hermes Villa in Pompeian style.

Below:
When the sun invites people to make an excursion, Wilhelminenberg Castle is a popular destination. You can dine excellently in the restaurant and children and dogs play on the meadow. Anyone who wishes can stay the night in the adjoining hotel.

Page 132/133:
Kahlenberger Dörfl lies romantically nested closely against the vineyards. Kahlenberg (»Bare Mountain«) which used to be known as »Sauberg« (Sows' Mountain) on account of the wild boars, reaches a height of 484 metres.

Index

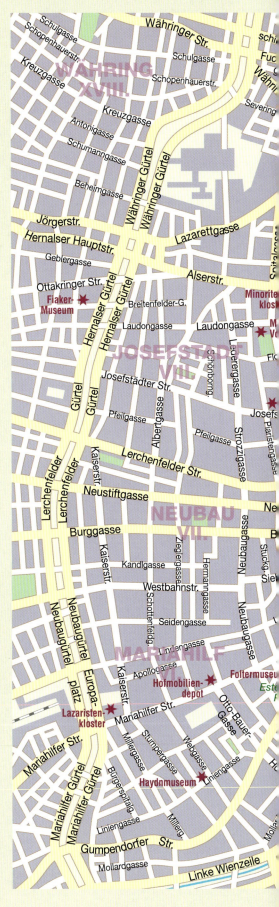

134

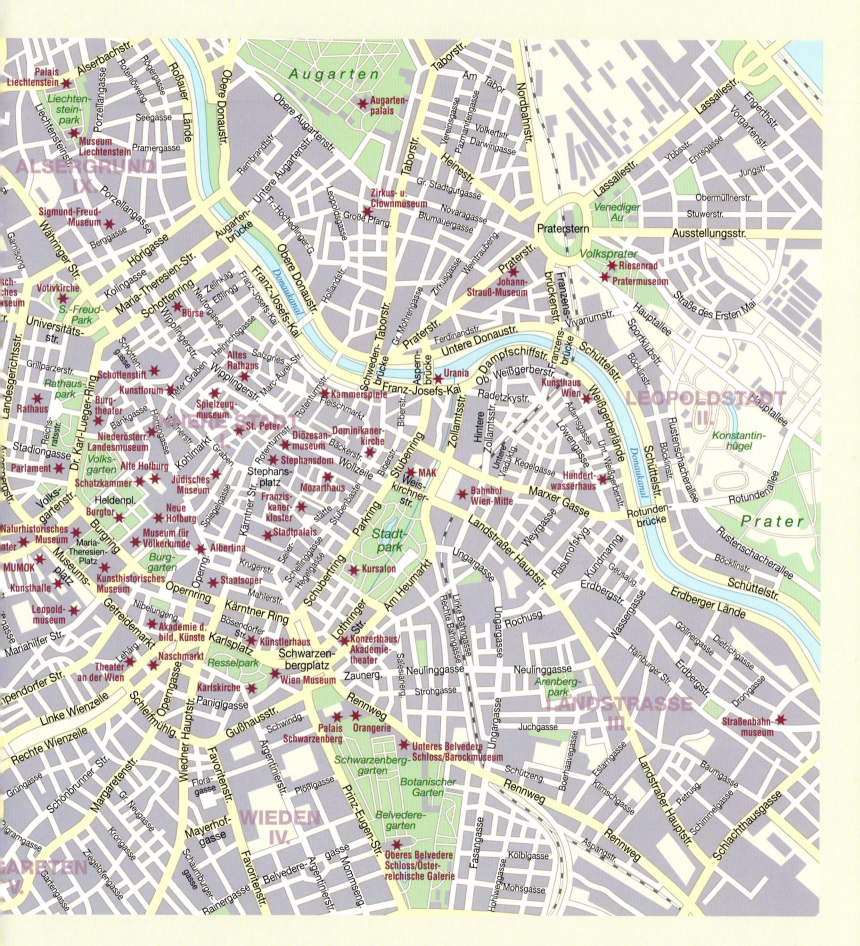

Palais
Liechtenstein
Liechten-
stein-
park
Museum
Liechtenstein
ALSERGRUND
IX.
Sigmund-Freud-
Museum
Votivkirche
S.-Freud-
Park
Universitäts-
str.
Rathaus-
park
Rathaus
Parlament
Volks-
garten
Schatzkammer
Heldenpl.
Burgtor
Naturhistorisches
Museum
MUMOK
Museums-
platz
Kunsthistorisches
Museum
Kunsthalle
Leopold-
museum
Theater
an der Wien
Alserbachstr.
Roßauer
Lände
Obere Donaustr.
Augarten

A u g a r t e n

Augarten-
palais

Zirkus- u.
Clownmuskeum

Taborstr.

Am Tabor

Nordbahnstr.

LEOPOLDSTADT
II.

Praterstern

Volksprater
Riesenrad
Pratermuseum

Venediger
Au

Ausstellungsstr.

Johann-
Strauß-Museum

Urania

Kunsthaus
Wien

Hundert-
wasserhaus

MAK

Bahnhof
Wien-Mitte

Marxer Gasse

P r a t e r

Konstantin-
hügel

Straßenbahn-
museum

INNERE STADT
I.

Burg-
theater

Kunstforum

Spielzeug-
museum

St. Peter

Niederösterr.
Landesmuseum

Alte Hofburg

Stephans-
platz

Stephansdom

Diözesan-
museum

Dominikaner-
kirche

Kammerspiele

Mozarthaus

Franzis-
kaner-
kloster

Neue
Hofburg

Museum für
Völkerkunde

Albertina

Stadtpalais

Burg-
garten

Kursalon

Stadt-
park

Staatsoper

Kärntner Ring

Akademie d.
bild. Künste

Künstlerhaus

Naschmarkt

Resselpark

Wien Museum

Karlskirche

Konzerthaus/
Akademie-
theater

Schwarzen-
bergplatz

Arenberg-
park

LANDSTRASSE
III.

Palais
Schwarzenberg

Orangerie

Unteres Belvedere
Schloss/Barockmuseum

Schwarzenberg-
garten

Botanischer
Garten

Belvedere-
garten

WIEDEN
IV.

Oberes Belvedere
Schloss/Öster-
reichische Galerie

GARTEN
V.

135

The founder of psycho-analysis, Sigmund Freud, lived and practised at Berggasse 19, where his nameplate is still preserved, from 1891 to 1938. The internationally much acclaimed Sigmund Freud Museum recalls the birth and the father of modern psychology.

Credits

Book design
www.hoyerdesign.de

Map
Fischer Kartografie, Aichach

Translation
John M. Deasy, Mainz

All rights reserved

Printed in Germany
Repro: Artilitho, Lavis-Trento, Italien – www.artilitho.com
Printed / Bound by Offizin Andersen Nexö, Leipzig
© 2009 Verlagshaus Würzburg GmbH & Co. KG
© Photos: János Kalmár
© Text: Dodo Kresse

ISBN 978-3-8003-4031-6

Photography:
János Kalmár lives and works as a freelance photographer in Vienna. He is the photographer of numerous copiously illustrated books. The main focus of his work are topics of cultural historical relevance, landscape and city portraits.

Author:
Dodo Kresse lives and works as a journalist and writer in Vienna. Besides her contributions to newspapers and magazines on the environment, nutrition and sustainability she has also had several reference books and novels published. As a specialist on Vienna her oeuvre includes several titles on the city.

Details of our programme can be found at
www.verlagshaus.com